A SENSE of YOSEMITE

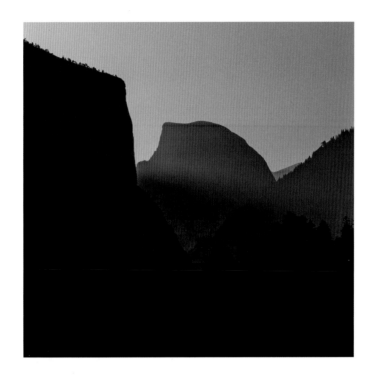

Yosemite Awakens. The first light filters past Half Dome at the start of a beautiful day in Yosemite National Park.

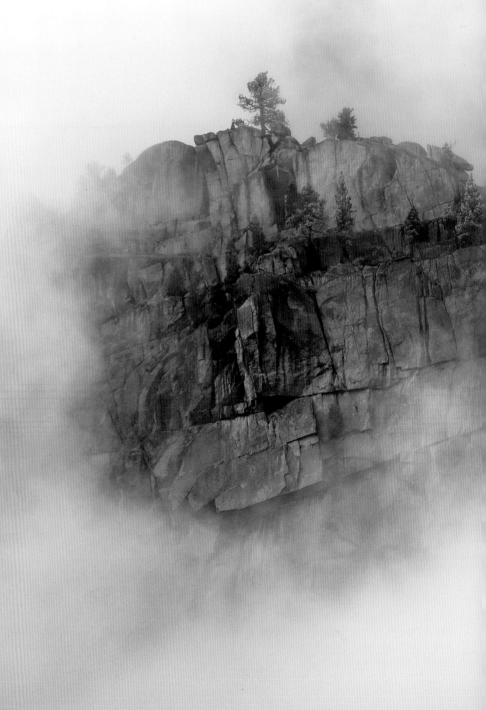

Falls through the Mist.
Spring storms bring new life to Yosemite. It isn't uncommon for the Valley to fill with fog—and photographers—as the rain subsides. Which way do I point my camera? Under these conditions my first thought is to find an iconic subject for my frame, such as Upper Yosemite Fall. Just wait a few minutes; the magic is about to begin.

A SENSE of YOSEMITE

PHOTOGRAPHS AND CAPTIONS BY
Nancy Robbins

ESSAYS BY
David Mas Masumoto

Yosemite Conservancy
YOSEMITE NATIONAL PARK

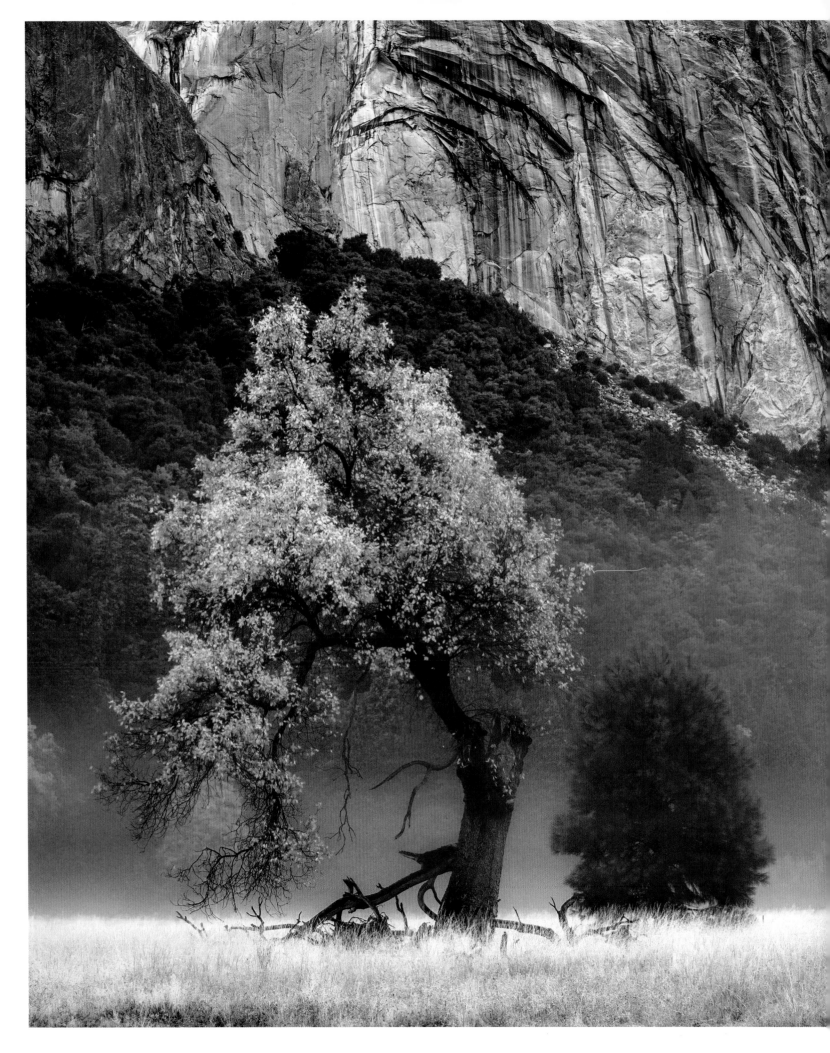

CONTENTS

Oak and Royal Arches. For me, this old oak is a symbol of life in Yosemite National Park. My first visit to Yosemite was in 1989 and was limited to half a day in the Valley. I photographed this tree with a mule deer in its shadow and Half Dome in the background. I was beyond thrilled—what luck for these subjects to align in this way! Since moving to the area in 2004, I've returned to the oak many times, season after season. As its branches fell, one by one, it kept offering me something new to photograph. Time was taking its toll, yet new leaves burst forth each year. The tree finally fell in the summer of 2015. Being an optimist, I think an acorn is taking root somewhere nearby. I'll be looking.

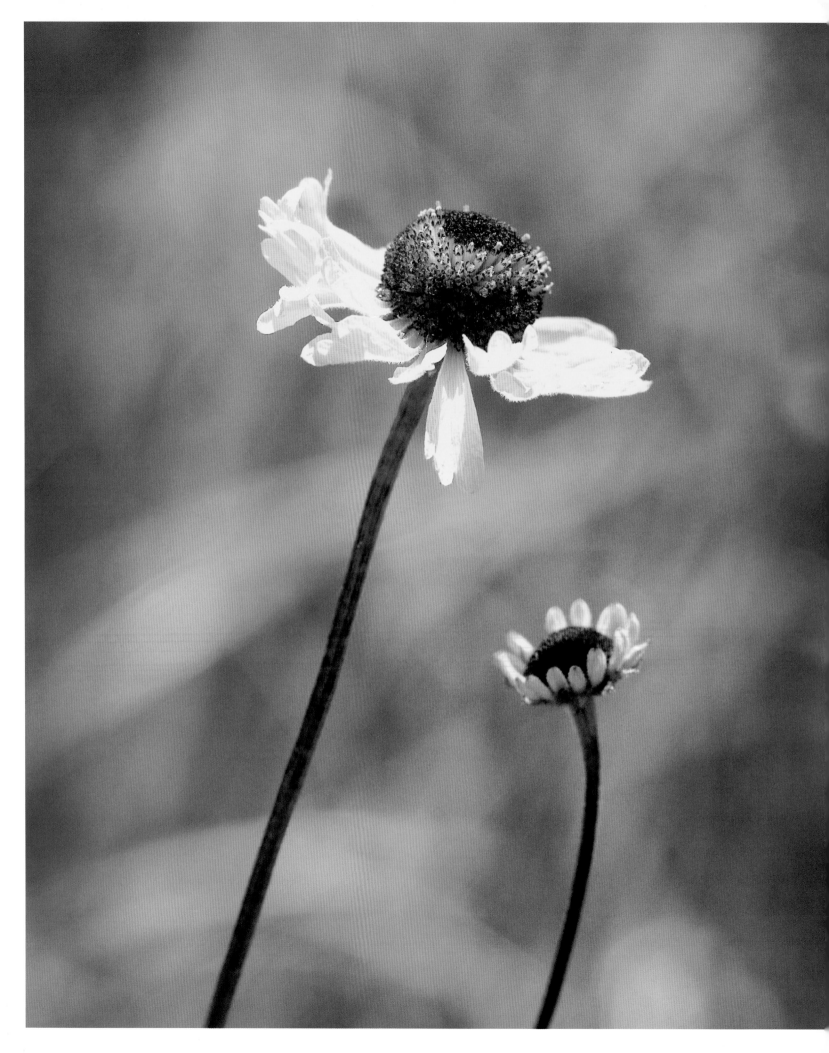

In memory of Mom and Dad

—Nancy

Bigelow's Sneezeweed.
I love a field of wildflowers.
I can spend hours looking
for the right juxtaposition
or relationship between the
elements in my viewfinder,
in this case Bigelow's
sneezeweed. This little duo
stood out. Safe in the shadow
of the larger bloom, the
smaller seemed to look up to
its protector with admiration.

PHOTOGRAPHER'S NOTE

I AM LUCKY to live and work within the boundary of magnificent Yosemite National Park. The birds and the trees are my nearest neighbors. Being outdoors reinvigorates my soul and restores life's balance.

The photographs in this book provide a sense of what I encounter every day when I walk out of my door. I'm usually carrying at least 20 pounds (9 kg) of camera gear, but discovery and adventure require no special equipment.

Originally, I moved to Yosemite to photograph people in the park. I couldn't imagine a more beautiful setting to capture a family portrait, a bride and groom, or a special event. All the while, my assistant, El Capitan, a 3,000-foot (900 m) reflector, washed its light over happy faces. Occasionally I'd step away into the park to photograph the beautiful scenery for my own pleasure. That's how I became a landscape photographer. I now make more portraits of trees and rocks than of people, but the techniques are the same. My photographs are for more than one family; they are for everyone.

Living beings in Yosemite can endure from mere hours to thousands of years. My time here is but a blip in this ever-changing, everlasting world of Yosemite. I have so much left to explore. I hope that these photographs, taken over my first twelve years in the park, will help preserve the beauty of Yosemite for generations to come. I see new things every day that weren't here yesterday and won't be here tomorrow. I hate to miss a single day.

—Nancy

Yosemite Falls and Half Dome. What started out as a few late night hours photographing with friends turned into a twenty-hour marathon up and down the Upper Yosemite Fall trail. The views were spectacular, the memories even better. When looking at the photograph, I am reminded that my best results are captured when going with the moment. And I didn't even have to get out of bed to catch the sunrise; I was already up.

Next spread: **Breaking Storm.** Photographs of Yosemite Valley from Tunnel View have appeared in books and on postcards for over one hundred years. This classic vista is probably the type of image that first comes to mind for most park visitors. On this particular day, the sidewalk was shoulder to shoulder with photographers, yet we each walked away with a different shot , our own distinctive vision. For the photograph "Ravens" (page 95), I zoomed in on the tree at lower right.

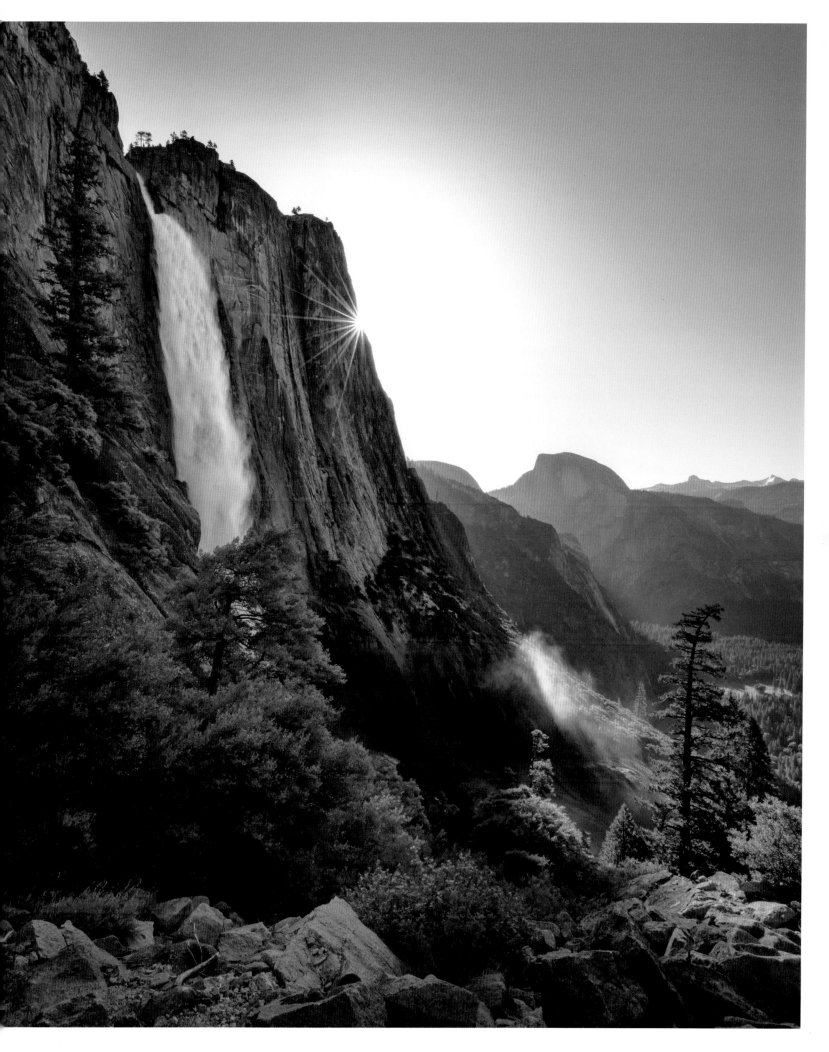

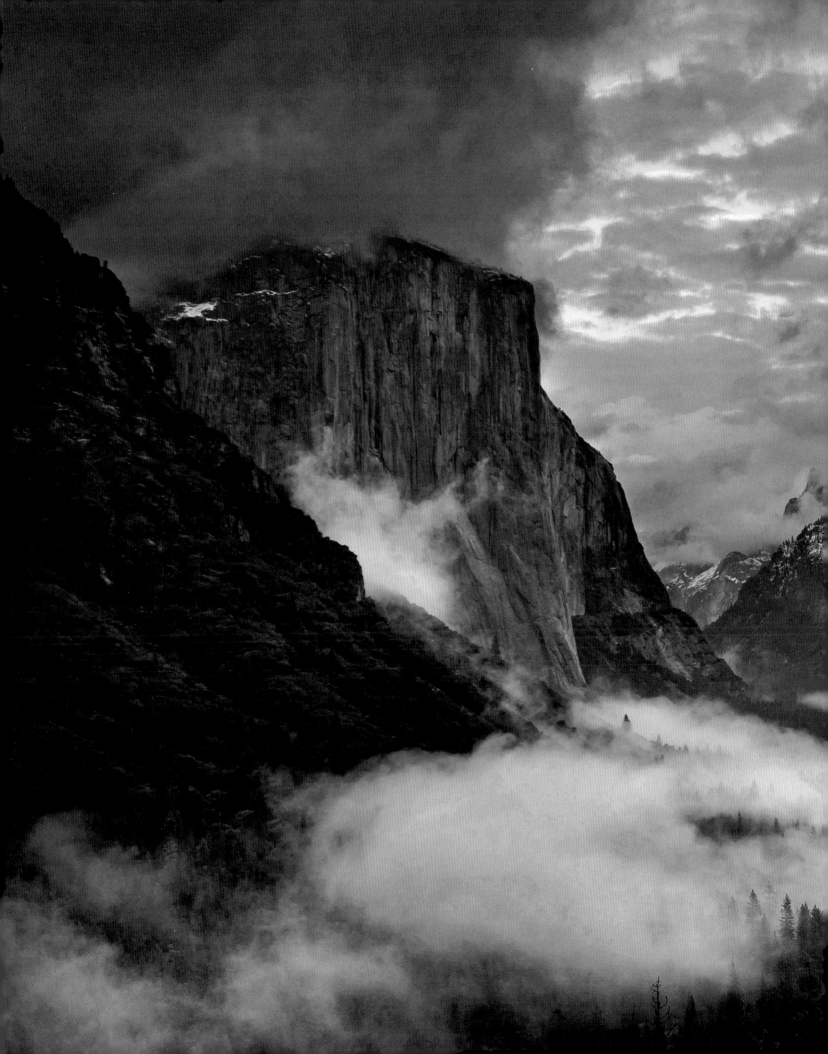

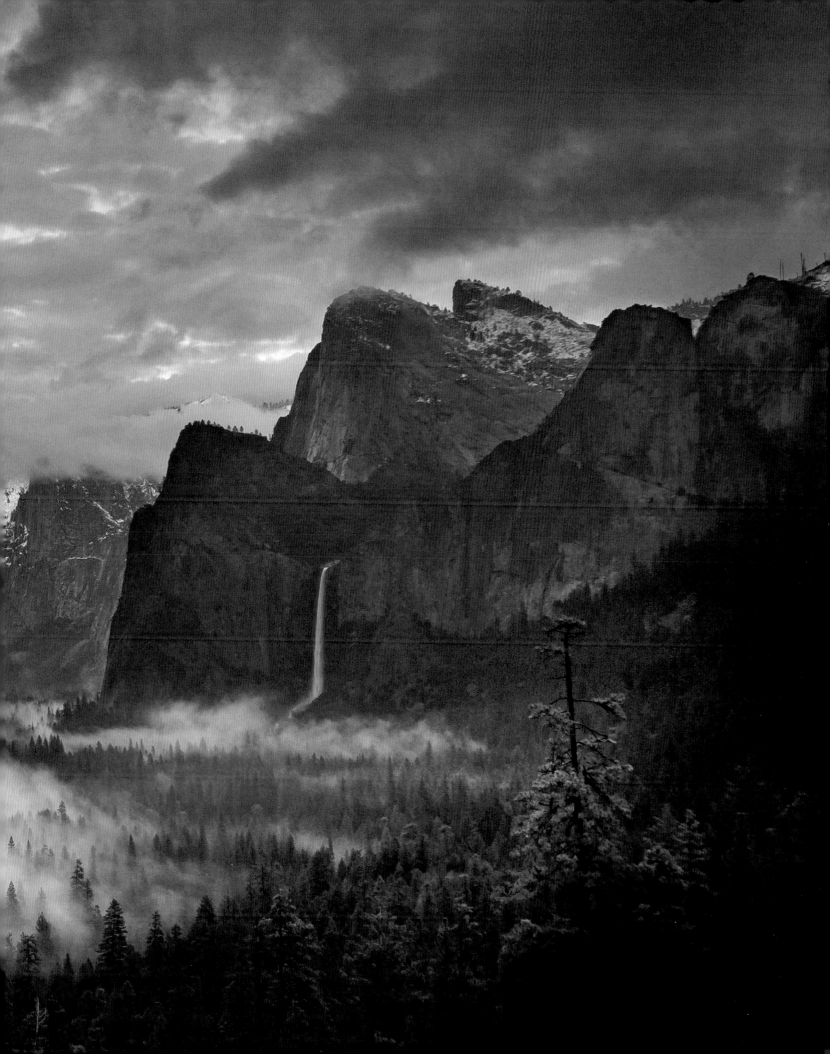

A FARMER VISITS YOSEMITE

I WORK IN THE SHADOWS of Yosemite National Park—the Masumoto Family Farm is ninety minutes from the park's South Entrance. I look to the Sierra Nevada ringing one side of our valley, dwarfing our little organic operation and my fields of peaches, nectarines, and raisin grapes. But we share a mutual landscape and breathe the same air; our fruit grows in the common sunlight.

I grew up visiting Yosemite, though not often enough. Springs and summers on the farm were filled with work and chores—fruits command high maintenance and are demanding crops. Often I'd pause from shoveling, straighten my back, feel the sweat trickle down my temples, and dream of the scent of pines and the sound of a waterfall. When our family did visit Yosemite, I couldn't help but see it through the eyes of a farmer. Life was abundant everywhere—not only in the dramatic panoramas of tree lines contrasting with the granite background but also in the small flora struggling to survive in the shadows.

I related to the obscure and the unassuming in this place, basking in nature while trying to carve out our own little places on this earth. An organic farmer, a day visitor, a hiker or backpacker, we form a relationship with Yosemite only by understanding our seemingly insignificant role as caretakers of this land while breathing in its grandeur.

When I farm, I get lost in the wonder of my trees and vines, amazed I'm able to scratch out a living, blessed by the bounty of the land. I understand the art of manipulation, urging my crops to grow fat. Humbled when things work well, I'm always aware nature grants me permission to do this work. Long ago, I realized I can't control life on my farm; I'm at my best with a strategy of cooperation. I find the same spirit alive in Yosemite. Others have carved a tiny trail we follow: a precarious path nature allows us to traverse. I lose myself in the splendor and emerge with a sense of humility.

A good farmer is humbled by nature. I am honored to walk this earth. I am grateful for the journey. Many thanks with each step.

—Mas

McGurk Meadow off of Glacier Point Road. From the lower elevations in March to the high country in August, the Yosemite wildflower display can last up to six months. At 7,000 feet (2,100 m), McGurk Meadow puts on one of the best performances in the park, with only Mother Nature tending to her fields of lupine and paintbrush. Of course, we can also play a part by staying on the trails and not walking in these delicate meadows.

Next spread: **Foothills in Smoke.** Smoke spills from the flames of an active fire, revealing the ridges and valleys of the Sierra foothills—layer after layer, reaching to the great San Joaquin Valley and beyond.

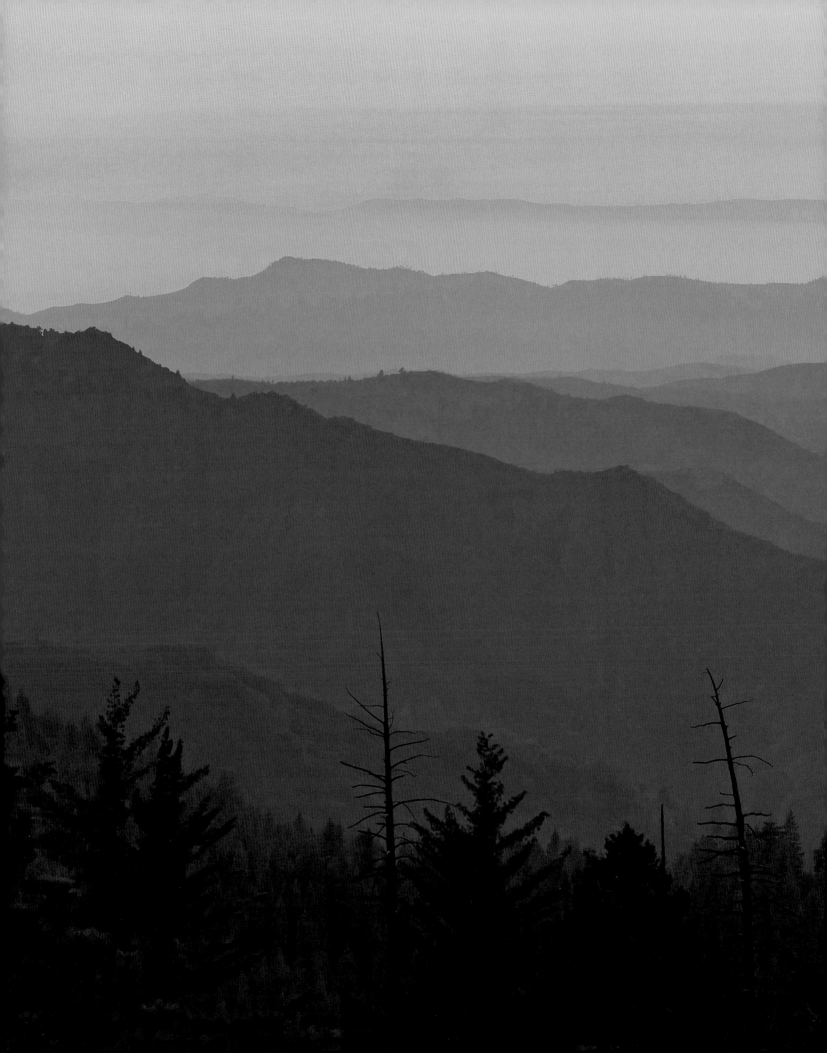

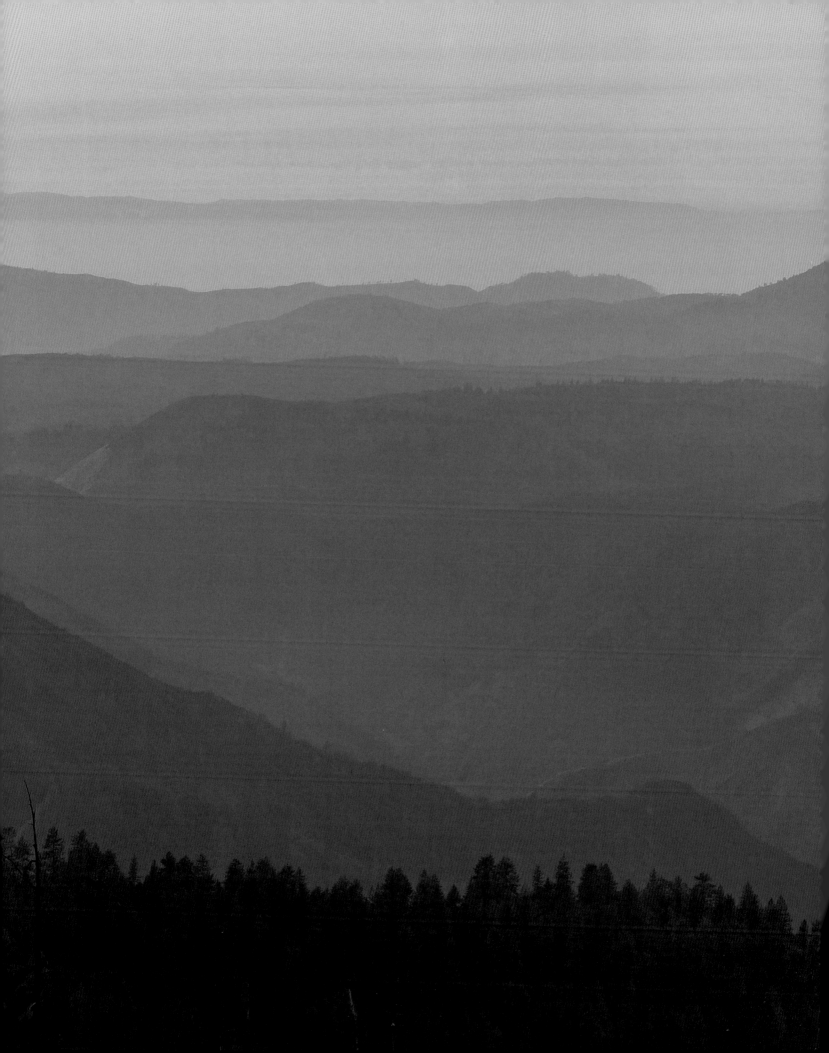

WATERSHEDS & WATERFALLS

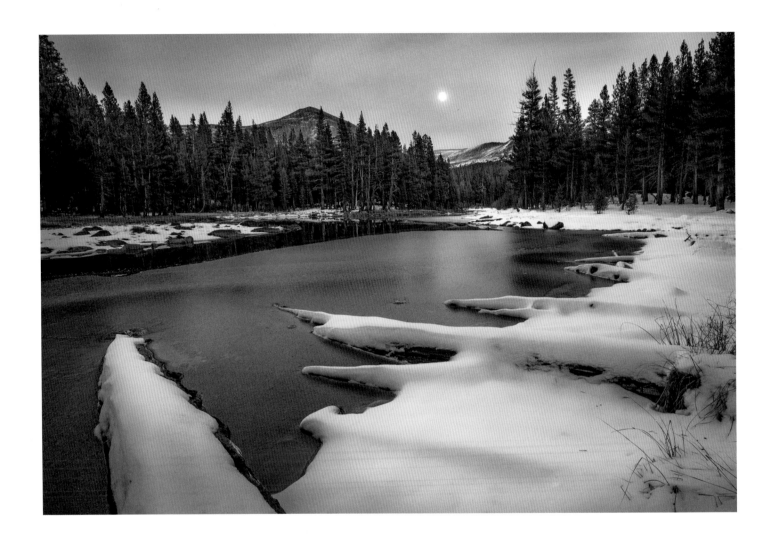

Moonrise on the Pass. This tarn, a shallow little pond, lies between Tuolumne Meadows and Tioga Pass. Here, just above 9,000 feet (2,700 m) in elevation, snowmelt begins as a trickle, then joins the Dana Fork of the Tuolumne River, eventually ending up in Hetch Hetchy Reservoir.

Opposite: **Bridalveil Fall.** The primary source of Bridalveil Fall is Ostrander Lake, 10 miles (16 km) to the south. Unlike Yosemite Falls, Bridalveil flows nearly year-round. Its watershed is north facing and has more meadows and soil in which to store water. In the early afternoon, there is a very short window when light breaches the top of the cliffs, illuminating the outer edges of the fall but not the shadowed cliff behind it. Although this happens year-round, my favorite time to photograph Bridalveil from Northside Drive is in spring when the snowmelt is at its peak.

Next spread: **Storm over Glacier Point.** In a grand landscape, a great sky is always a plus. I'd been keeping an eye on the clouds for much of the day, and a trip to Glacier Point came to mind. I was not disappointed. Seems my photographer friends were thinking the same thing, resulting in a little rendezvous between Washburn and Glacier Points. Nevada and Vernal Falls are the two prominent waterfalls tumbling down the Merced River canyon.

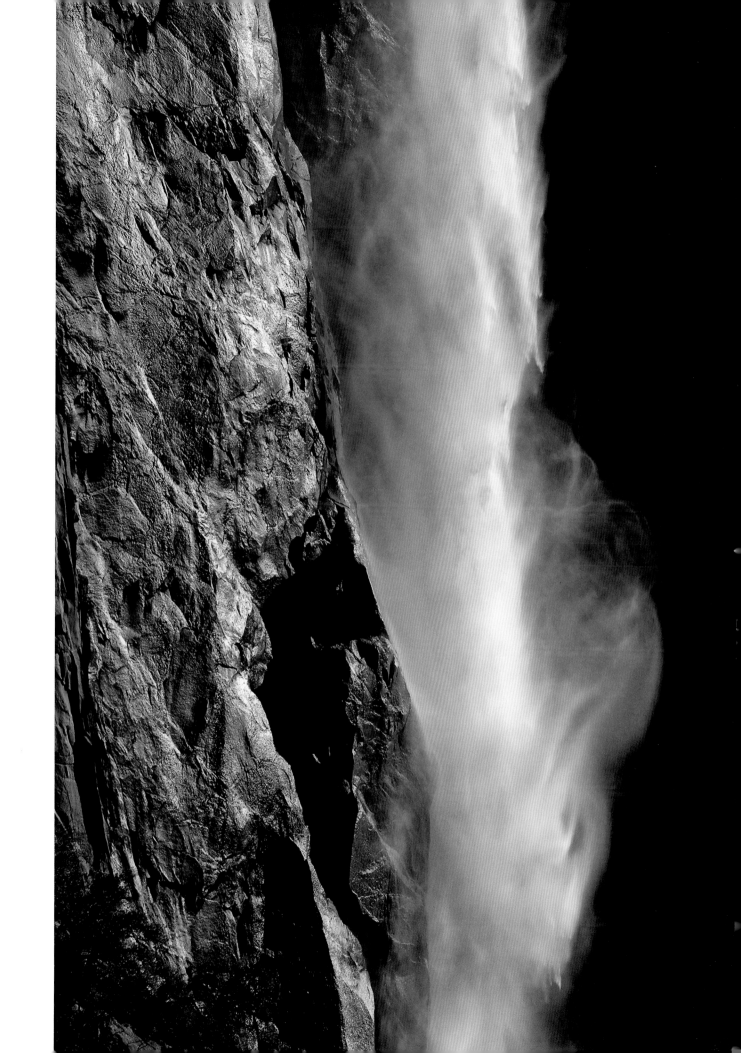

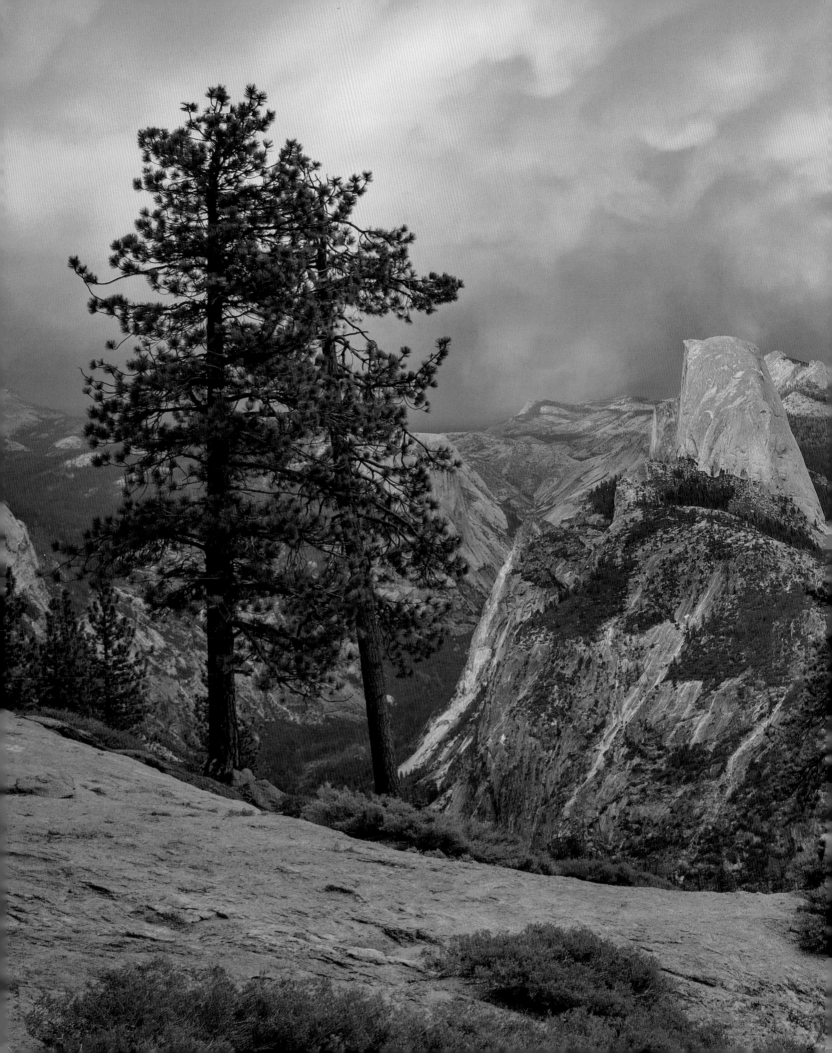

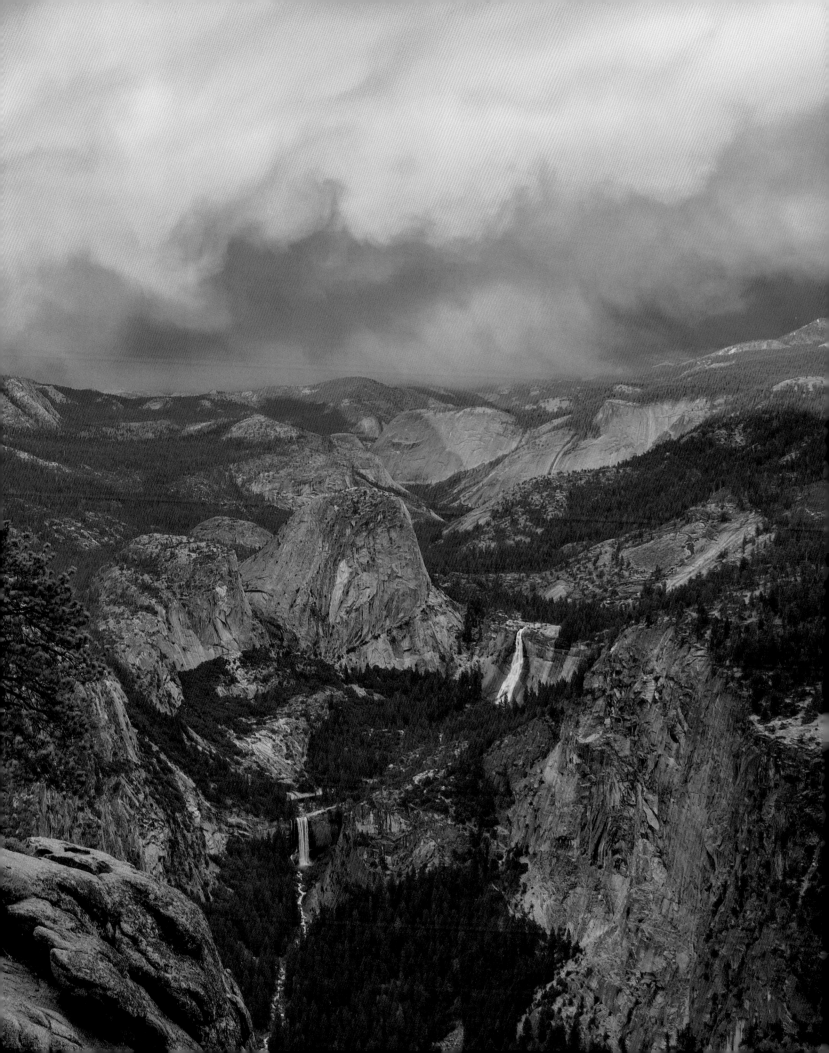

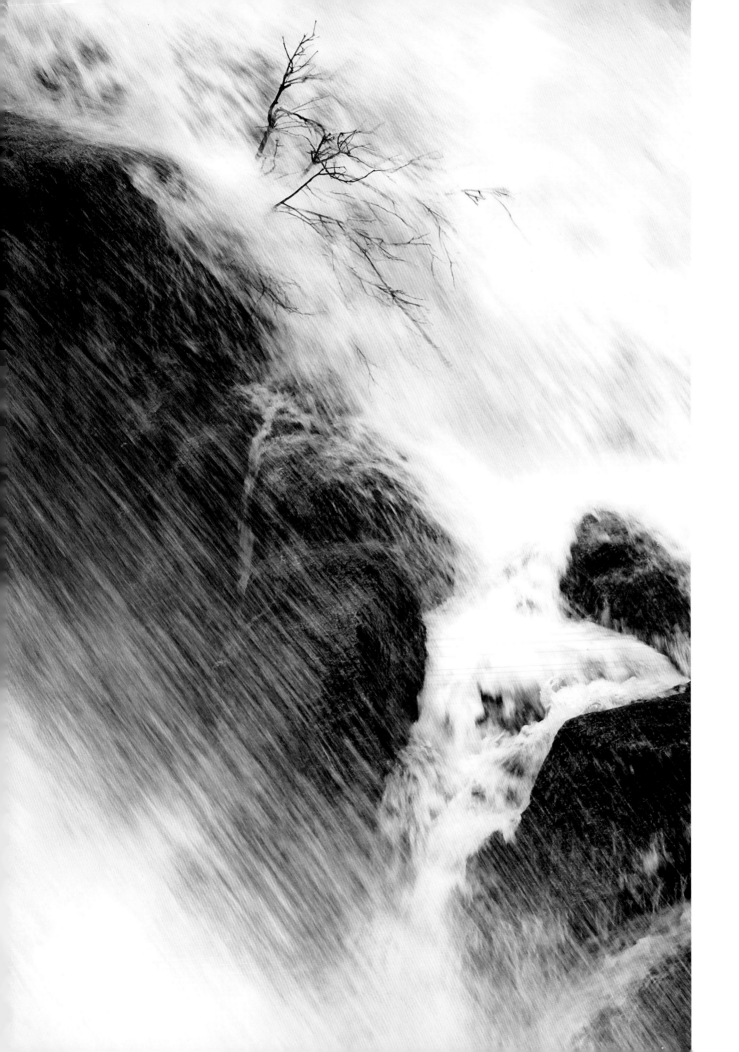

Winter's Sticks and Stones. It's cold in Yosemite Valley near Pohono Bridge. The direct sunlight never sees this area in wintertime, so a fresh snowfall can last undisturbed for quite some time before it melts and becomes tomorrow's Merced River. El Capitan's warm glow can be seen reflecting in the cool hues of the chilly water—a great combination. I can usually find some solitude down at the western end of the Valley, but on this day there were bobcat tracks next to my tripod holes, so I guess I wasn't completely alone.

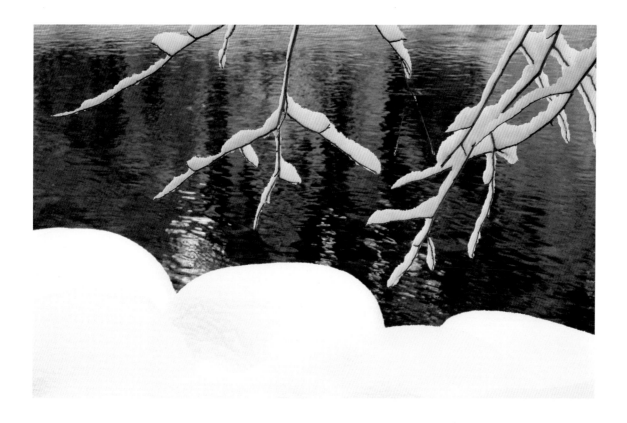

Opposite: **The Power of Spring.** This photograph was taken in my neck of the woods, Wawona. I had never seen Chilnualna Creek quite like this. It was 2008, the snowpack was well above normal, and the daytime temperature had suddenly risen. The cascades were rushing down, singing out of control, and at the mercy of the rocks ahead. The ledge where I usually enjoy sitting was completely under the gushing torrent. I played with various shutter speeds, trying to capture the intensity of the cascade as it plunged toward the South Fork Merced River.

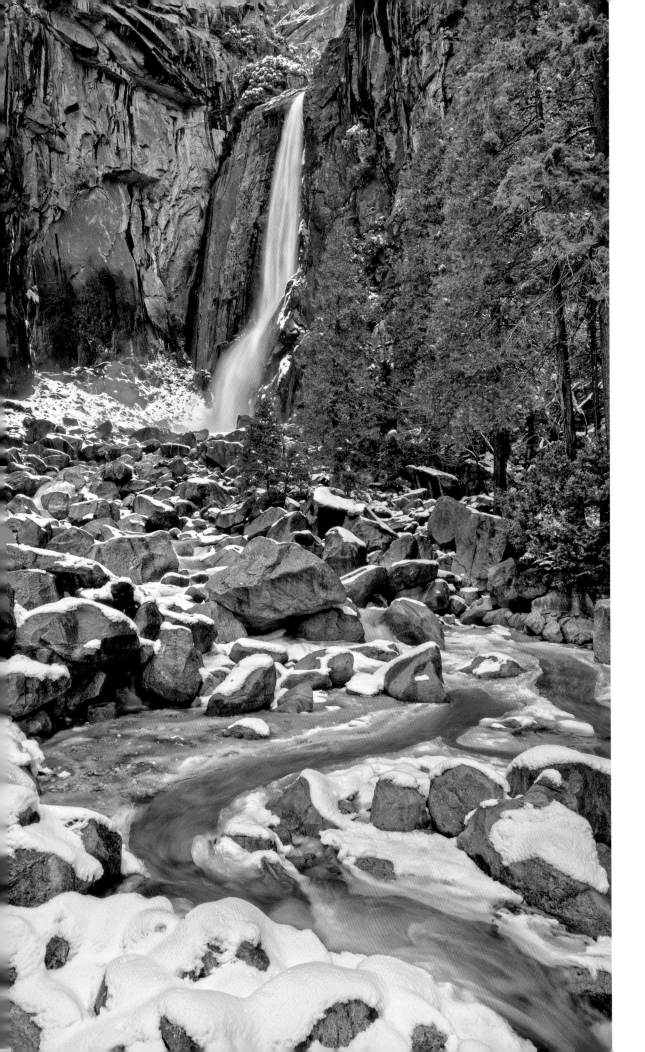

Frazil Ice, Lower Yosemite Fall. A frazil ice event is entirely weather dependent and difficult to predict, but occurs most commonly in spring. The waterfall must have a moderately high flow, and overnight temperatures must be below freezing. Mist from the waterfall freezes before flowing down the creek in the form of slush, rather than water. The color is typically an oily green. I witnessed this phenomenon before I'd ever heard of it. The first thing that came to mind was Slurpee! I highly recommend looking online to see a video of frazil ice in action.

Illilouette Fall. This is one of the lesser known of the five main waterfalls of Yosemite because it's tucked away in the southeastern corner of the Valley. My goal was to get a unique photo of Illilouette Fall and its canyon creek from a less-than-usual angle, which I did. Without a doubt, the perch where I took this shot was the hairiest spot I've ever been. I think I left a few heartbeats up there. I sometimes forget that the perfect shot might not be worth the risk.

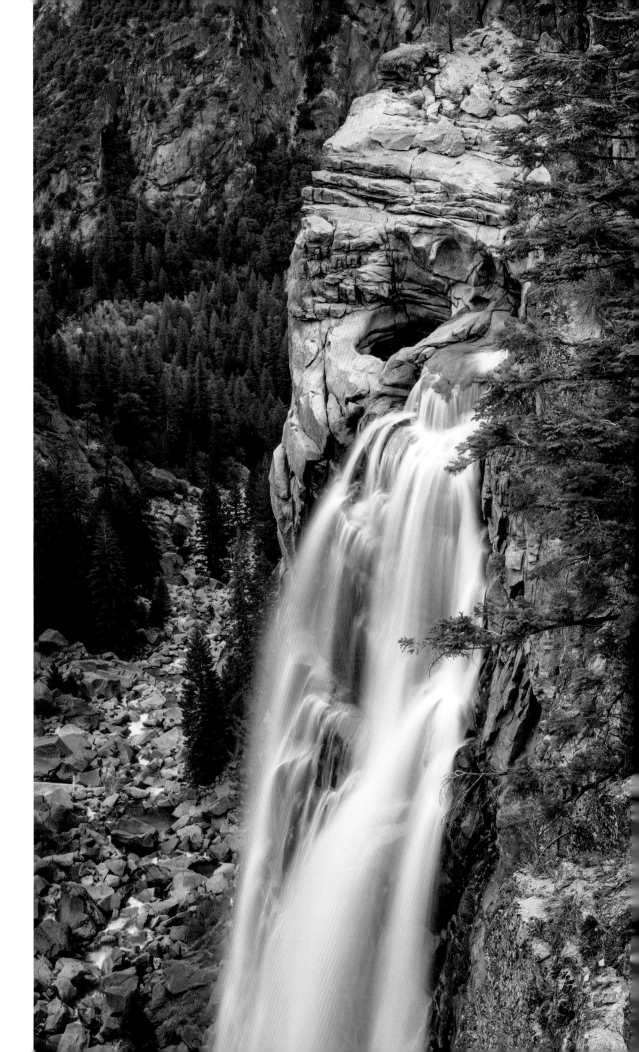

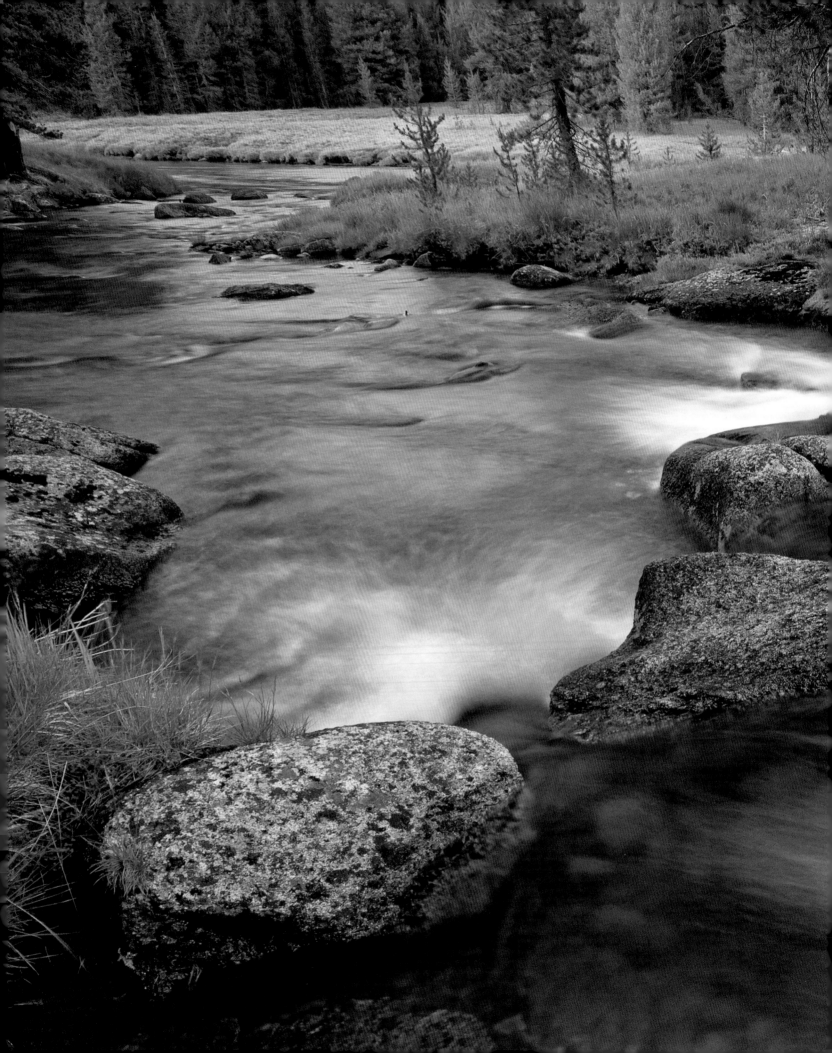

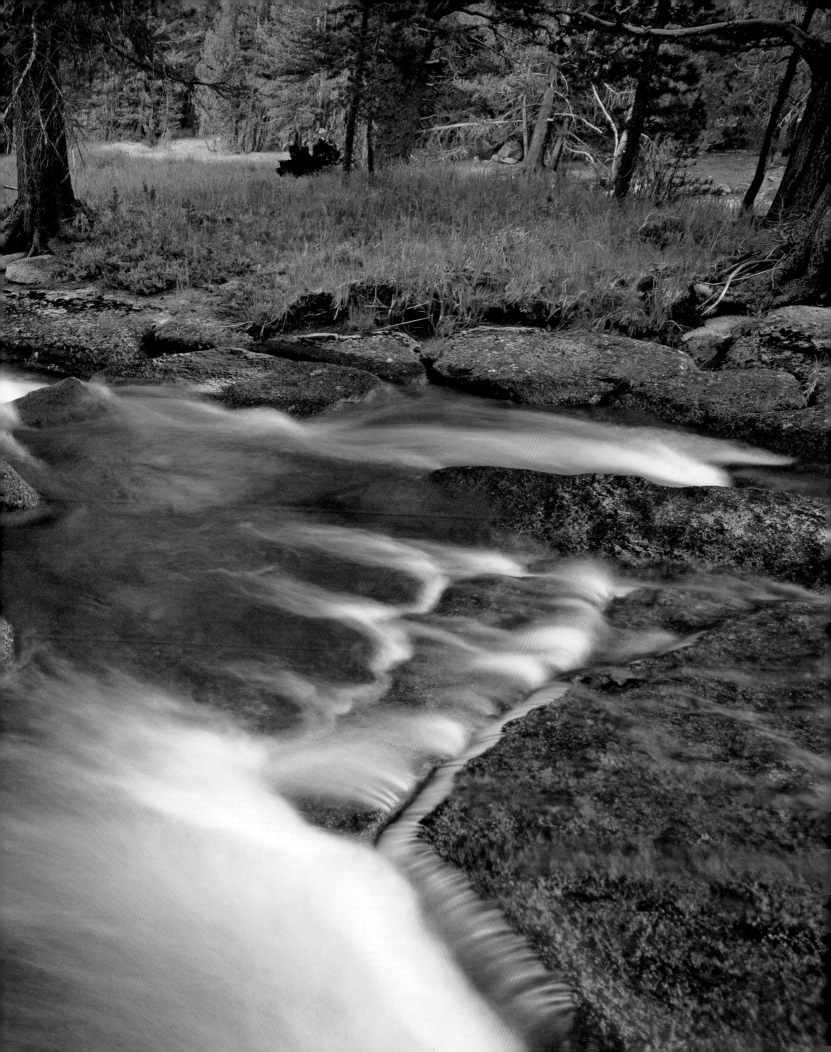

Previous spread: **Lyell Fork of the Tuolumne River.** This is one of the prettiest hikes in the park, and it's so easy to get to. The Pacific Crest Trail, also known as the John Muir Trail in this stretch, parallels the Lyell Fork of the Tuolumne River as it meanders for miles with very little downward gradient. This is a fascinating place to people watch: the young, the old, day hikers and overnighters, and through-hikers. The latter, as a whole, are the most appealing to me (except for the smell that's almost inevitable after their many weeks on the trail). I'm always trying to carry a lighter load, but PCT hikers really have it dialed in. A quick and friendly chat with them always includes the words "pounds," "ounces," and even "grams." Even though they're just a few miles from Tuolumne Meadows Grill and a really good hamburger, they're always willing to stop and talk to me.

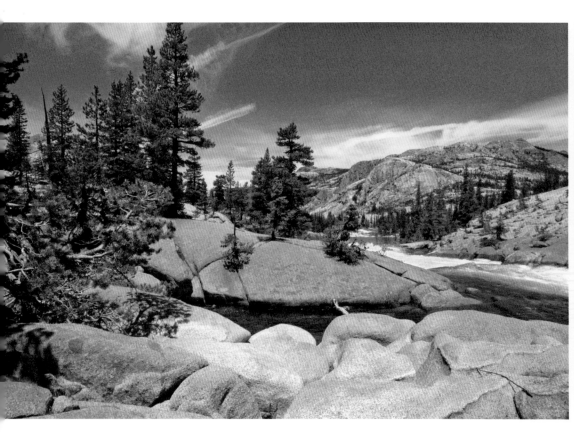
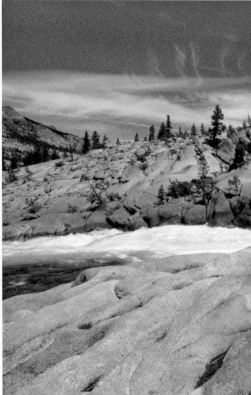

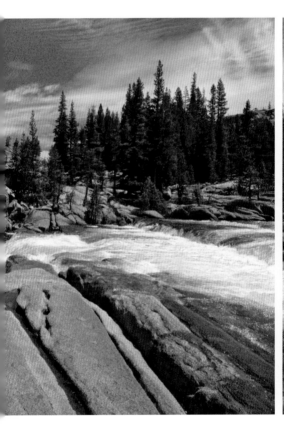

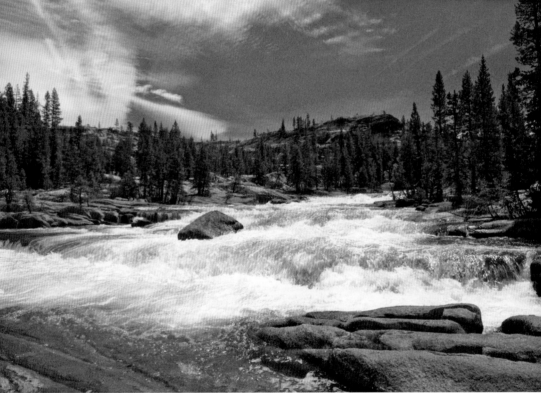

Glen Aulin. The segment of the Tuolumne River Valley just below Tuolumne Meadows is known as Glen Aulin, meaning "beautiful glen." Often when I venture into an area of Yosemite for the first time, I think, "This is most beautiful place on earth." Glen Aulin is no exception. While the hike in is a pleasant downhill coast, the return is an arduous uphill grind—but entirely worth the effort, with views of the Tuolumne River and its cascades stretching out along the entire route.

Hetch Hetchy. There are many peaceful hikes in the Hetch Hetchy area, including the trail to Wapama Falls, which traverses several bridges as it hugs the reservoir's edge. The San Francisco Bay Area gets 85 percent of its water from the pristine Sierra snow-melt stored in Hetch Hetchy Reservoir. The path can be slippery in spring, so I take my time and marvel at the similarities to Yosemite Valley.

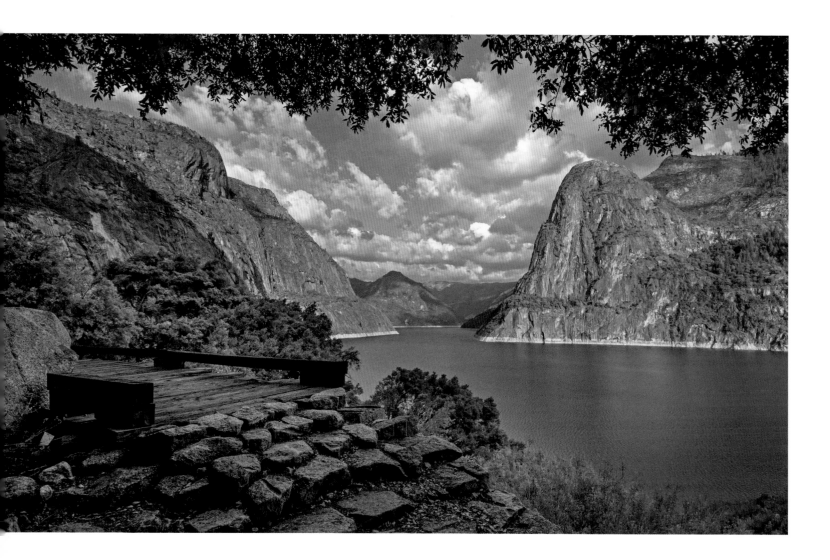

Opposite: **Yosemite Falls Morning.** As the early morning light illuminates the vibrant foliage it also strikes the outer spray of Upper Yosemite Fall, giving off an ethereal glow. Yosemite Creek, Tenaya Creek, and many other smaller tributaries have filled the Merced River to the brim. The surface appears calm but the underlying current is moving much faster. Just remember, still waters run deep! Stay safe.

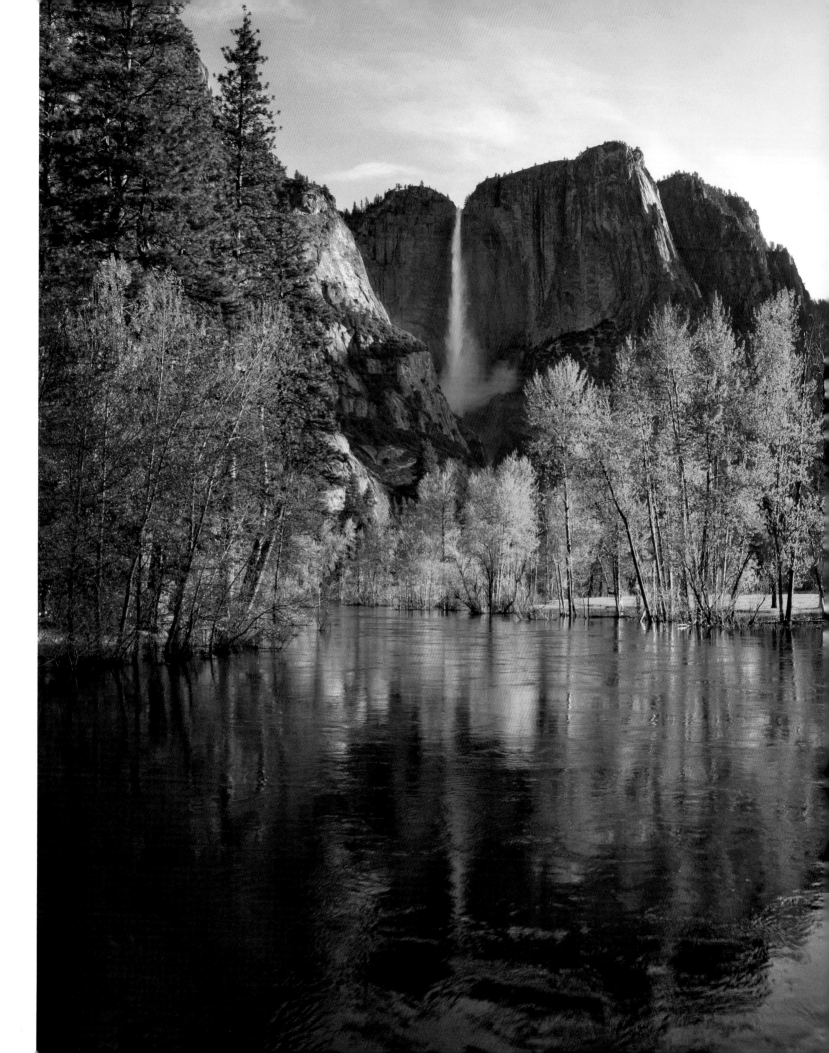

OUR YOSEMITE: A SENSE OF PLACE

WHEN DOES A PLACE become special? How does our relationship with a region begin and grow? When does Yosemite become *our* Yosemite?

In 2013 the Rim Fire swept through parts of Yosemite—more than a quarter million acres burned, about four hundred square miles within and outside the park. As the smoke drifted over our farm, I wondered, "What's my connection with Yosemite?" Like countless others, I had visited this place many times and was moved by the splendor of Yosemite Valley, the dramatic granite walls and dense forests.

I am fortunate to live in a geography shared with Yosemite. The watershed for the San Joaquin Valley begins in the mountains that claim the park. I breathe the same air that feeds the vegetative growth of Yosemite's understory. The peaches, nectarines, and grapes that flourish on our organic farm share the soils that have eroded and washed down over centuries from the Sierra Nevada. But how close does something need to be for us to claim it as "our own"?

Many of us live in a world seemingly disconnected with nature. The information age allows us increased virtual contact but limited physical connection. The casual visitor to Yosemite may well ignore the rich history of American Indians who lived on that land and, instead, they may erroneously believe that John Muir discovered this beauty and preserved it for the privileged. Some observers have criticized the National Park system as being elitist, that it saves such wondrous natural geographies only for those who can afford the journey.

I see a new awareness transpiring. Just as is happening with food and farming, people are seeking a personal connection to places and the story behind those places. Ironically, new technologies can help us bond with nature. For example, the satellite photography of the smoke from the Rim Fire provided me with an image of "my neighbor" to the north, creating a heightened awareness of my relationship with Yosemite.

Many people will share a growing identity with specific geographies: this may simply require a visit to Yosemite and other marvels found in nature. These locales are sacred, not as memorials to a past but as part of an evolving nature around us all. They are irreplaceable because they are impermanent. We become a placed people when meaning and significance is found: we start to care. We all have a stake in the destinies of these sacred geographies.

When we actively seek a connection and bond with a place, when we claim ownership to a place, we are no longer alone in nature but rather part of the natural world that envelops us. When we bind with places, empathy flourishes and thrives—as do we. We do not live in isolation; we share a common domain. A fire can thus trigger a sense of simultaneous unity and fragility.

To use the phrase "our Yosemite" means accepting responsibility and finding refuge in nature. And then we can feel the warmth.

—Mas

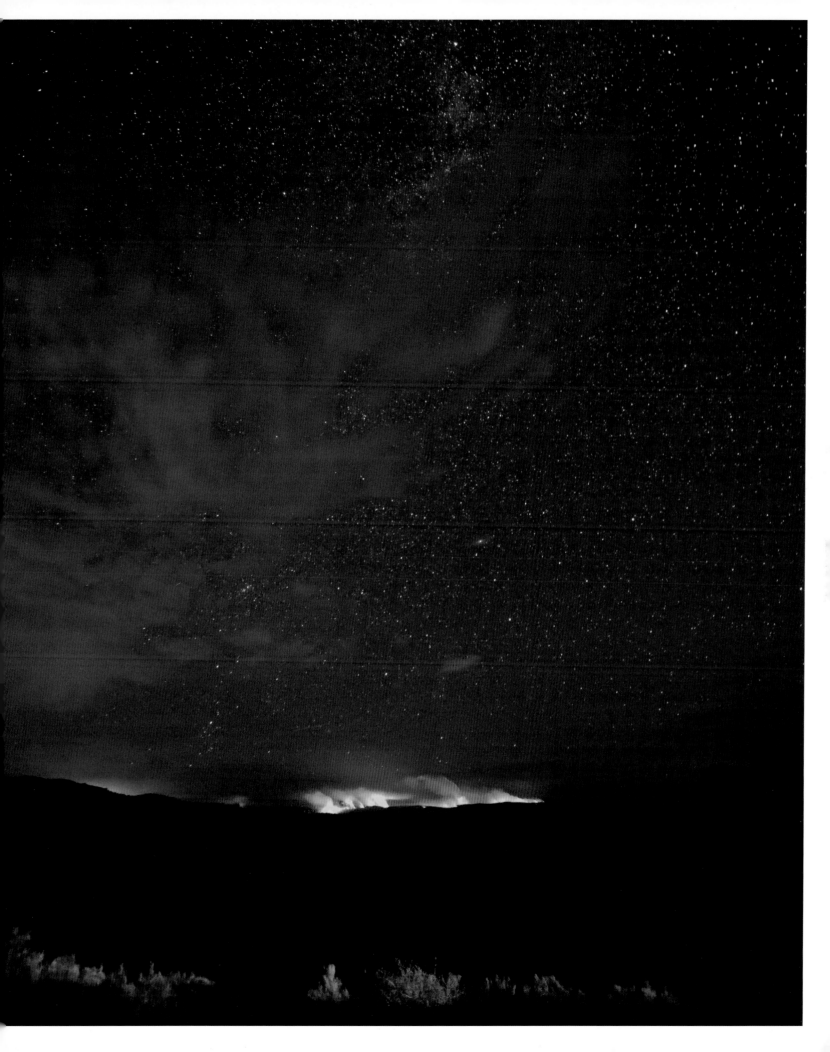

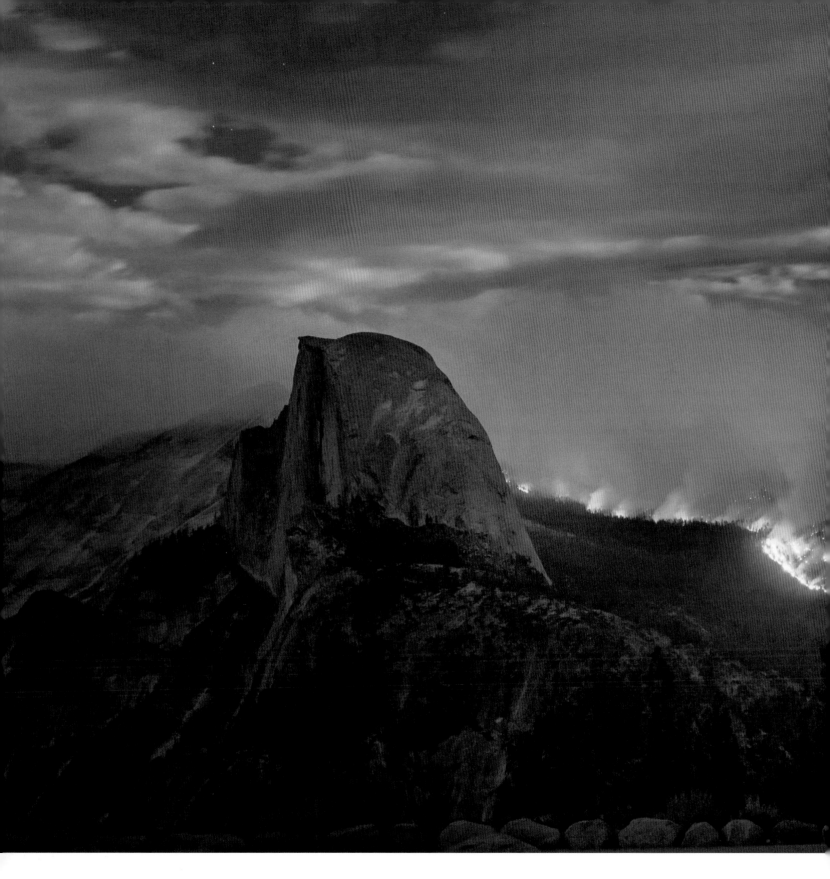

Previous page: **Rim Fire and Milky Way.** Standing in the darkness alongside Highway 49, staring at a blazing inferno framed by the Milky Way, I was in awe of the great forces before me. It was a battle pitting five thousand firefighters against a mountain of flames. Our neighbor galaxy Andromeda appears directly above the fire. I got a sense that the universe was sending a message: "It's okay; fire is good for you."

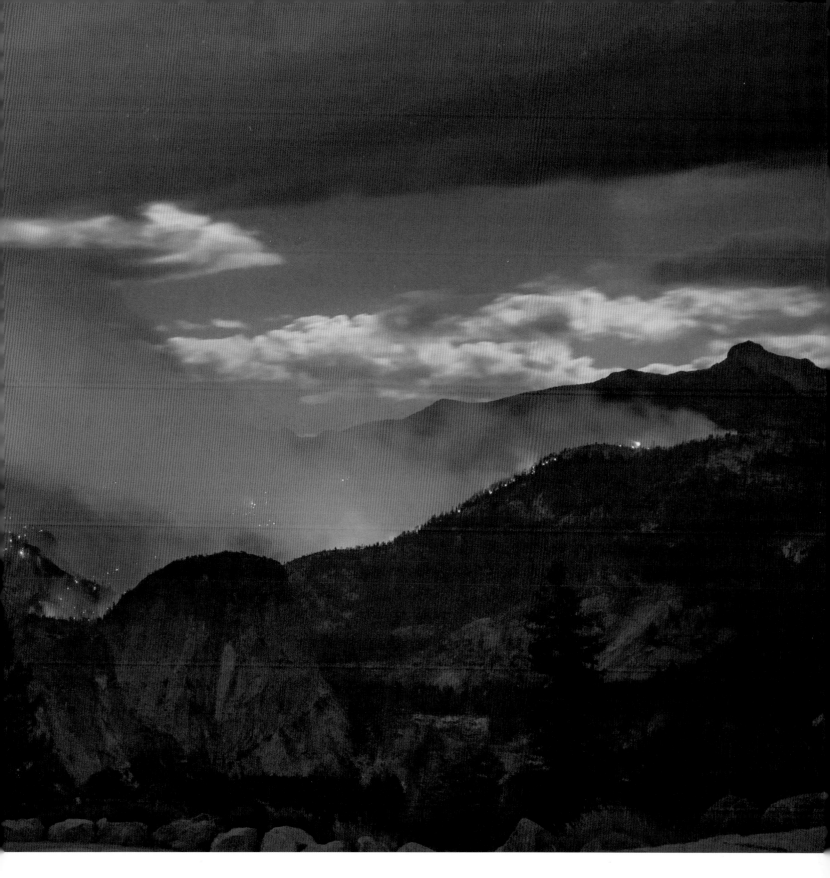

Meadow Fire. It was September 7, 2014, and hurricane Norbert, off the coast of Baja was pushing clouds over the Sierra Nevada. That, combined with a nearly full moon, had me excited to do some late afternoon photography. I checked the Yosemite Conservancy website to see what the sky was like over the Valley. Holy moly! Smoke behind Half Dome. I was at Glacier Point in forty-five minutes.

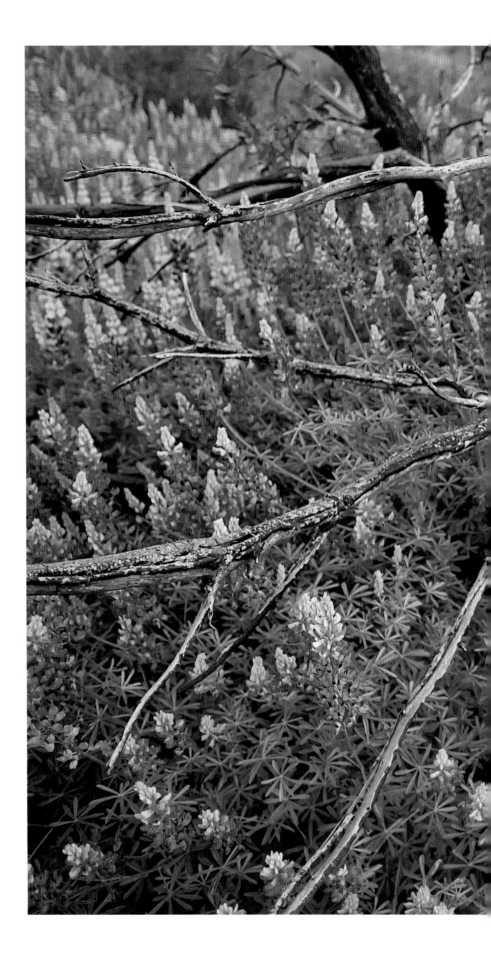

Out of the Ashes: Lupine and Manzanita. These are the skeletal remains of a former forest. As humans, with our short life spans, we tend to see fire as the ultimate destruction. But for the forest and nature more broadly, fire is an essential part of the ecology. Here, the lush growth of lupines is surging forth just one year after the Foresta Fire. Wildflowers begin to grow abundantly bringing the bees and small insects. Small rodents will feast on the insects and new plant life. Coyotes will come to seek out the rodents. The cycle has begun again.

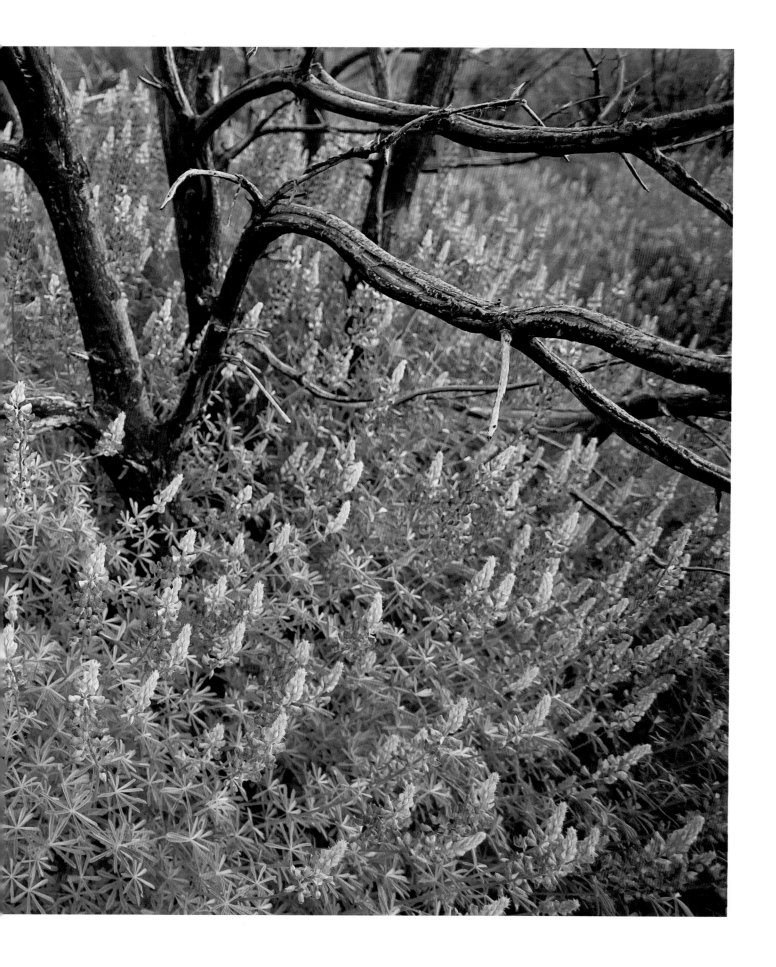

THE HIGH COUNTRY

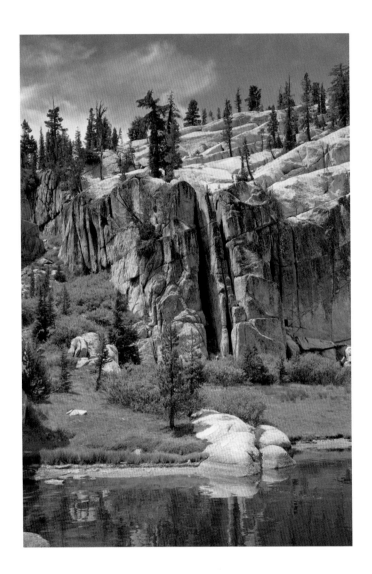

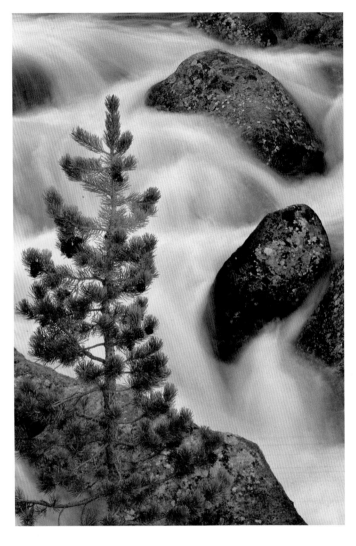

Upper Cathedral Lake Detail. Surrounded by meadow and forest, this end of the lake is abruptly cut off by an impassable wall of solid granite. Those vertical fractures in the rock are from the stresses delivered to the crust during the uneven uplift of the Sierra Nevada within the past five to ten million years. Even the slightest crack can trap enough water and nutrients so that trees and other plant life can eke out an existence.

Cascades and Lichen. Up near the top of Tioga Pass, Tioga Road parallels the Dana Fork of the Tuolumne River for miles; sometimes they are just a few yards apart. These waters tumble over lichen-covered boulders, creating hundreds of little waterfalls along the way to the Tuolumne River. I can spend hours in this area and never be at a loss for a subject.

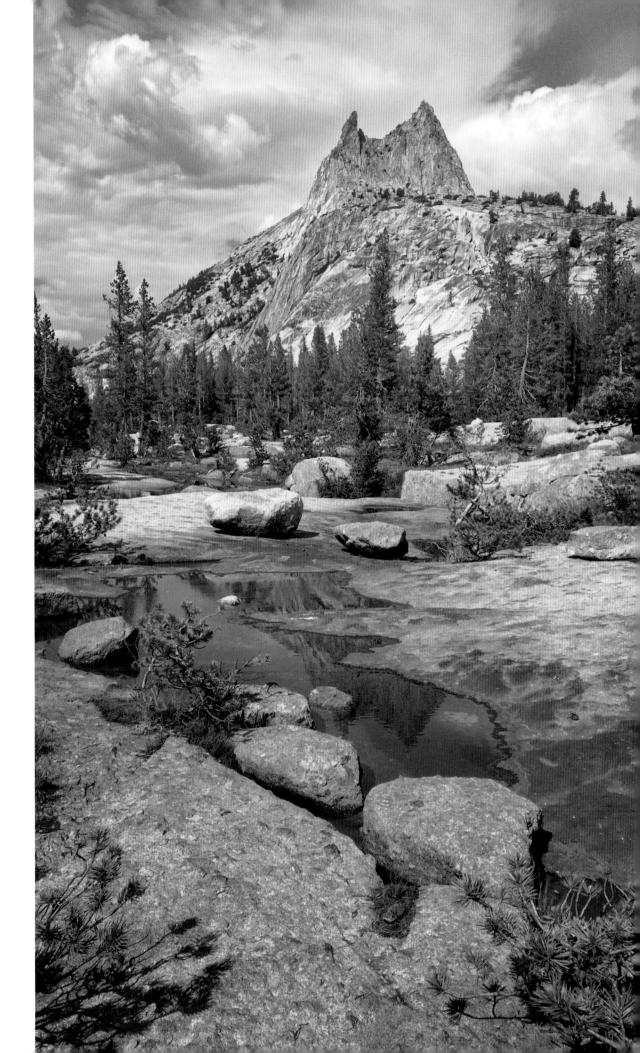

Cathedral Peak. I was attracted to how the rich red of the weathered rock contrasted with the vibrant blue of the sky. The deep green foliage and the gray rock of Cathedral Peak completed my artist's palette. Although the short growing season in the high country makes for smaller plants, it also imbues them with determination and tenacity.

Next spread: **Tuolumne Meadows and Approaching Storm.** After the long winter, photographers, like others who visit the park, eagerly await the day Tioga Road reopens. The mountains greet visitors with stunning scenery, breathtaking vistas, sparkling water, and clouds bigger than the mountains themselves. More often than not, tranquil summer afternoons are suddenly interrupted by the crack of thunder and flash of lightning from storms scudding by overhead.

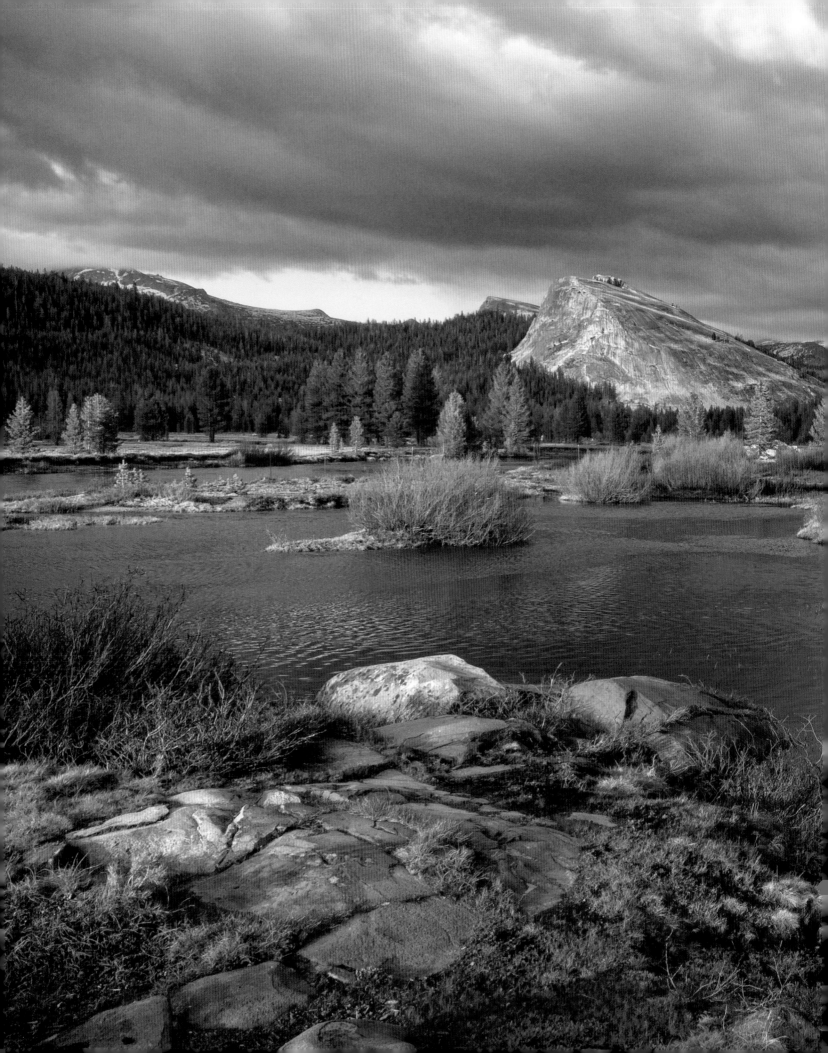

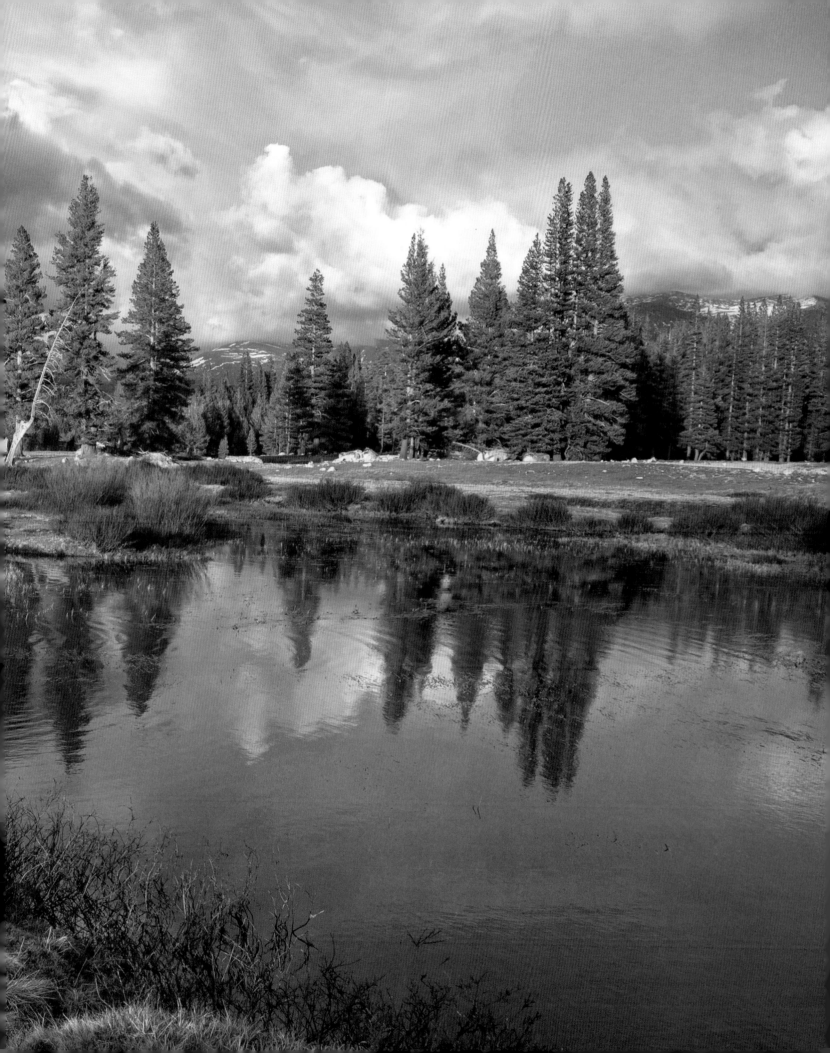

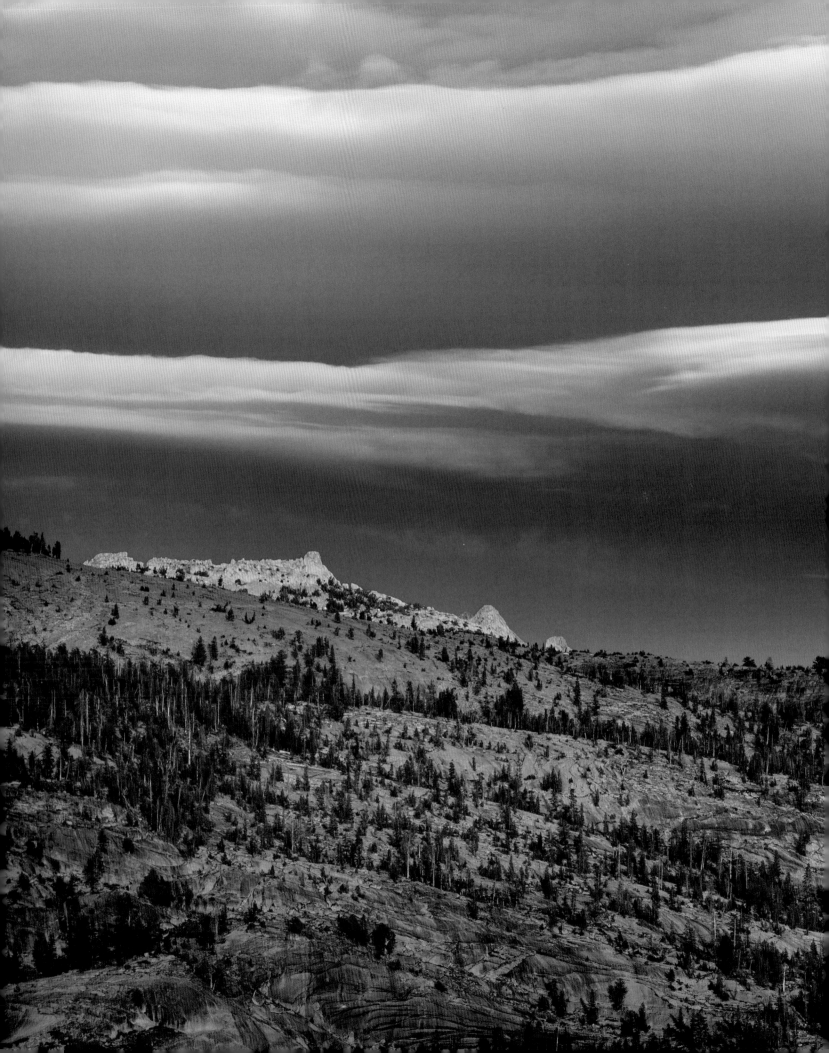

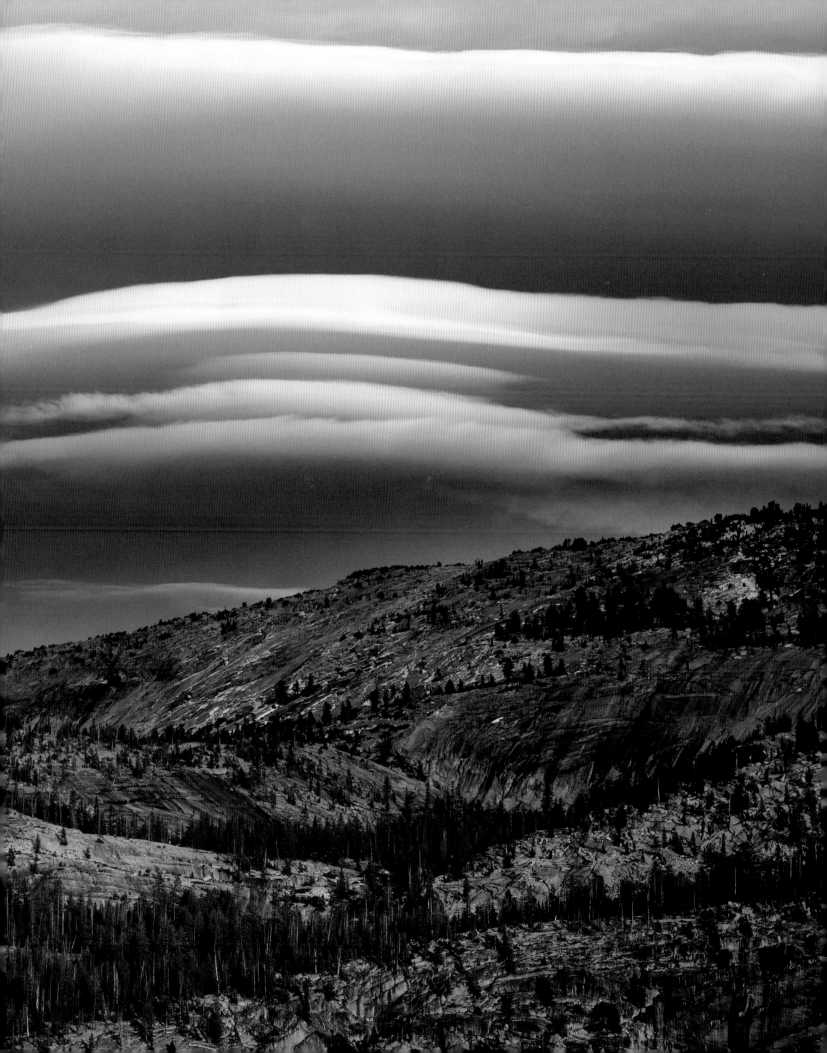

Previous spread: **Sierra Wave.** I was driving over to Lembert Dome to photograph glacial polish at sunset when the Sierra Wave (a name given to regional lenticular clouds created by rising winds) formed high above. Right in front of me, the land and the sky conspired to echo each other.

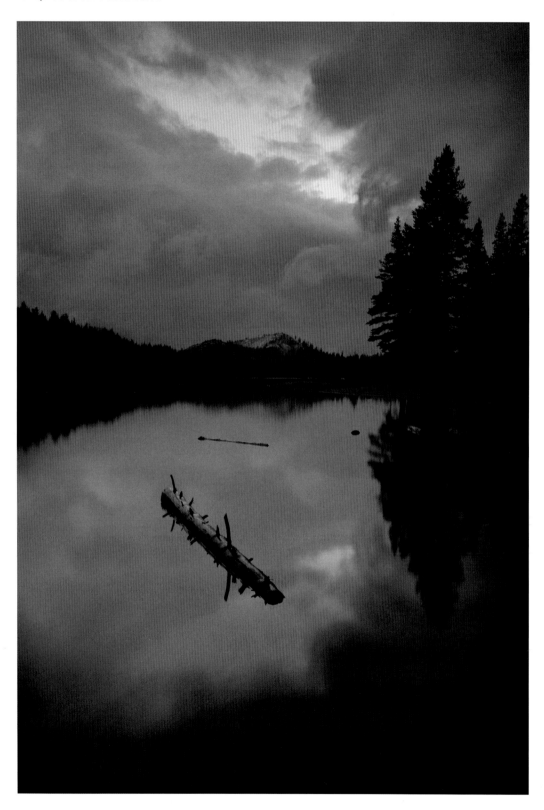

Tenaya Lake Illusion. Racing home in order to beat an incoming storm, I was struck by an odd sight as I passed Tenaya Lake. The sun had already set, and the lavender sky was reflected in the glassy water. But there was something else: a log that was stuck in the shallows but appeared to be floating against a backdrop of sky. A long six-second exposure helped create the illusion you see here. Just hours later, the storm dropped enough snow to close Tioga Road for the winter. Whew! Close one. I almost got stuck on the east side of the mountains.

Tenaya Lake. The ice on Tenaya Lake at sunset expands with a groan, terrifying the unsuspecting visitor—in this case me! On this particular afternoon, my buddy and I were the last people out on its frozen surface. Due to the delay of any snow in the mountains in the winter of 2011–2012, the lake was accessible, allowing us to explore an otherwise unreachable wonder and to marvel as it cracked, bubbled, and heaved.

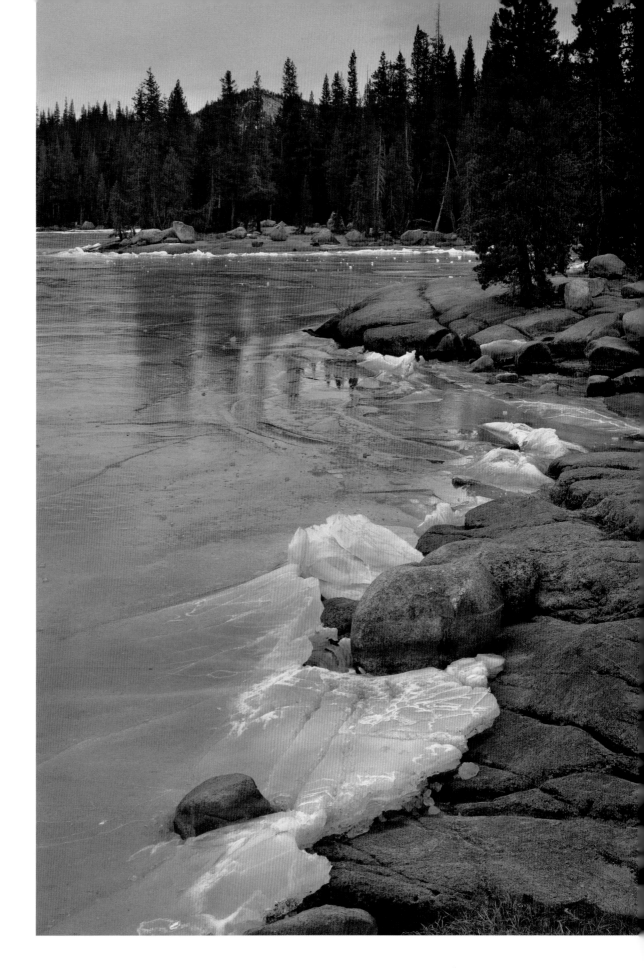

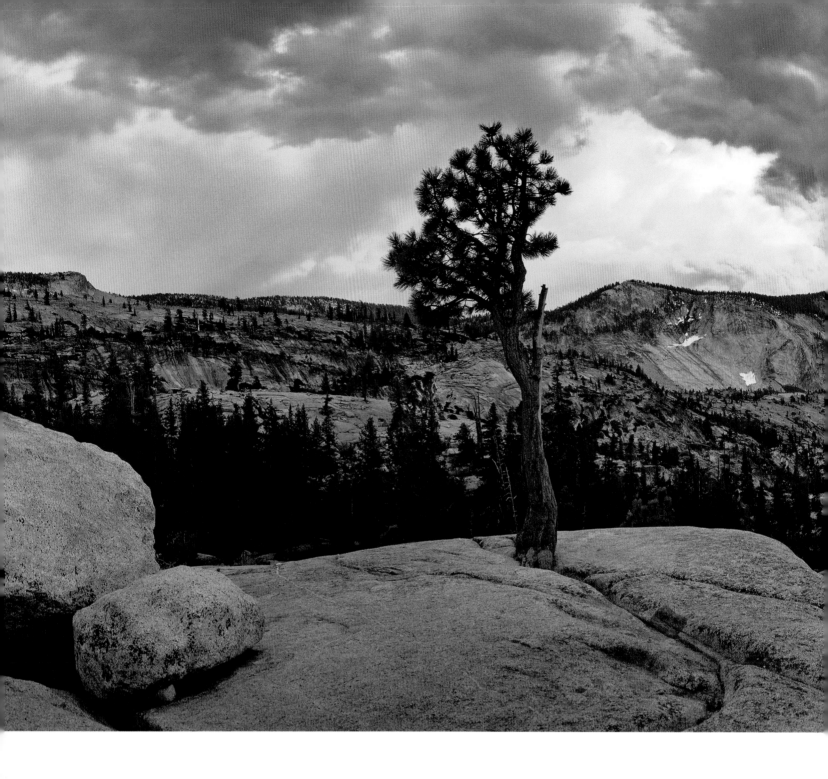

Olmsted Point Panorama. East on Highway 120, an hour and a half from the Valley floor, I find myself at Olmsted Point, the most extraordinary overlook on Tioga Road. I never skip an opportunity to stop and take in the view. Hovering thunderclouds are a common phenomenon in Yosemite's late afternoon summer skies. You can see how Clouds Rest, the peak in the distance, gets its name. On this day, a slow-burning lightning fire up in the high country added smoke to the air, contributing to the color and drama in the photograph.

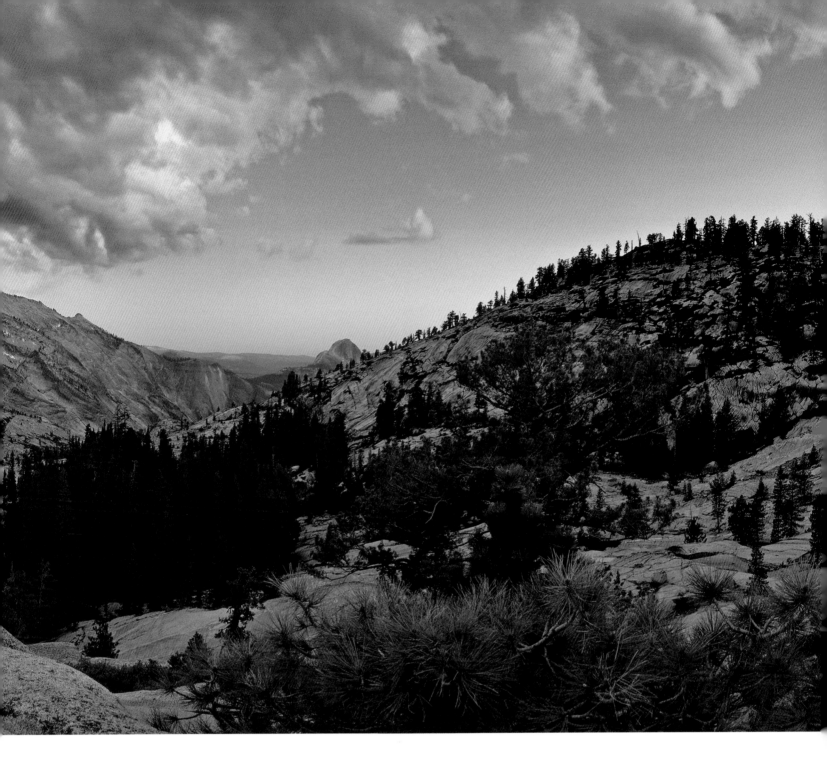

LIGHT MAGIC

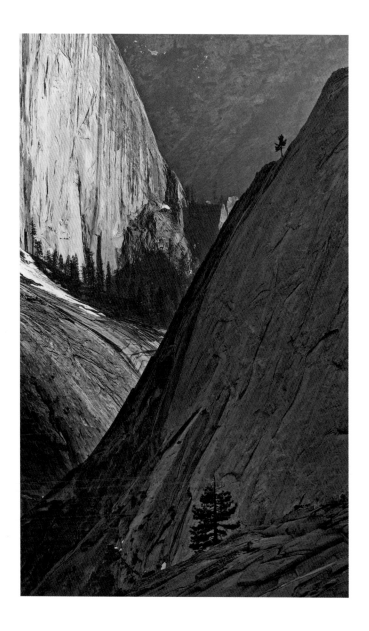

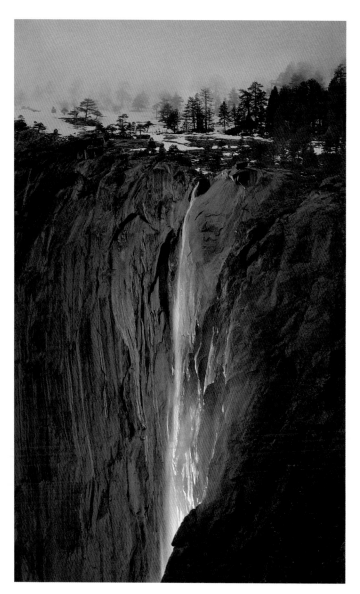

Tenaya Canyon Afternoon. I tell young photographers, "It's all about the light." Composition, timing, subject matter are all important. But the quality of light is often the factor that will lift an average photograph into something more captivating. Here, the late afternoon light ricochets up Tenaya Canyon, first illuminating the face of Half Dome. The light then silhouettes a single pine tree before bouncing off Yosemite's massive walls to fill in the shadowed granite.

Horsetail Fall. Horsetail Fall, on the eastern edge of El Capitan, is seasonal, running only for only a few months in winter and early spring as snow melts atop the rock. This photograph shows a rare event that can happen in the latter part of February. If the weather is clear on those special days, the setting sun strikes the fall, lighting it up so that it appears to be on fire. It's possible to spend many evenings waiting for this to happen and never witness it, but when it does happen, it's pure magic.

Lunar Rainbows and Big Dipper. When the bright light of the full moon shines on the heavy mist of Lower Yosemite Fall during spring runoff, it's possible to witness a lunar rainbow, also called a moonbow. Happily, the Big Dipper also makes an appearance directly above the waterfall. In May and June, hundreds of photographers and onlookers gather to witness this amazing phenomenon. This is my first "signature" landscape shot; it was taken in 2005.

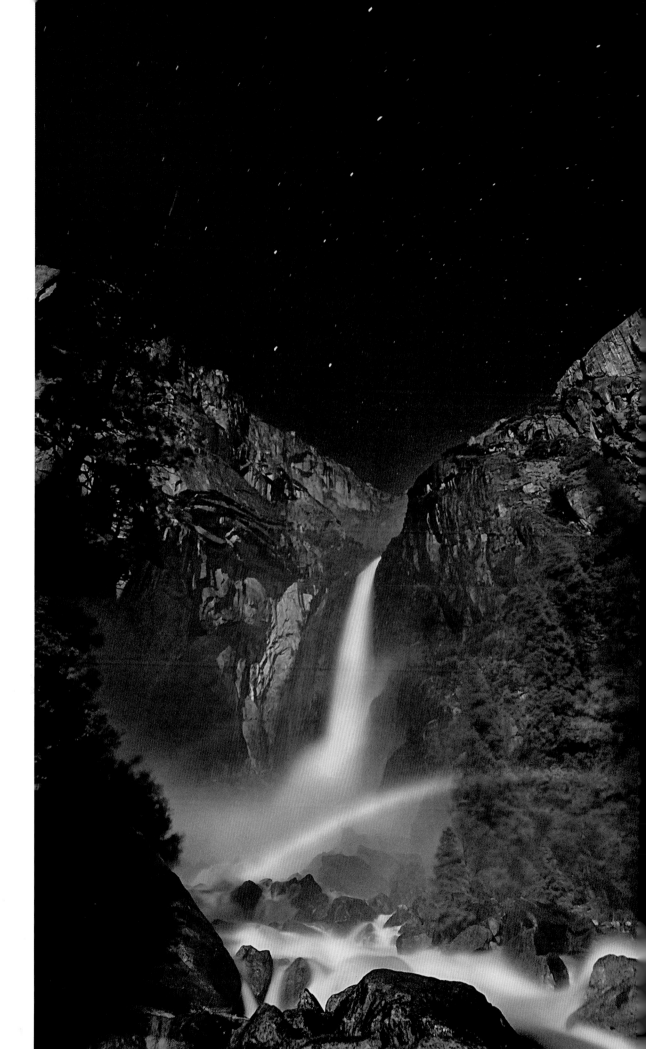

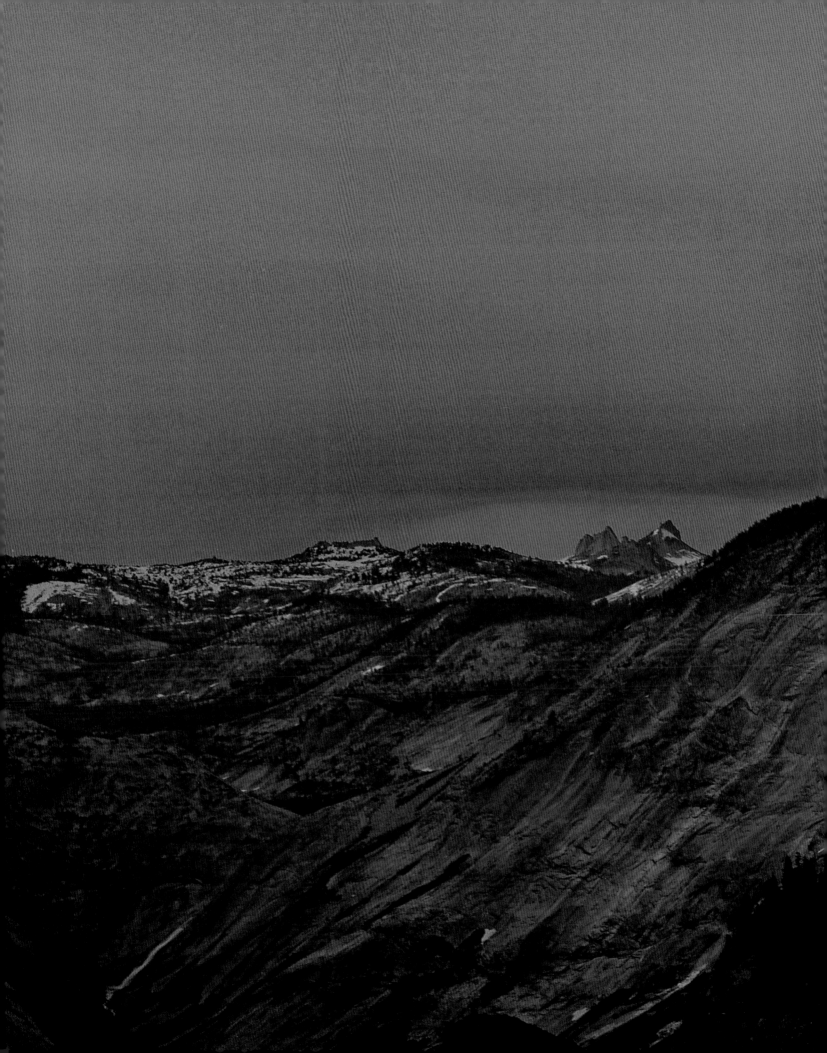

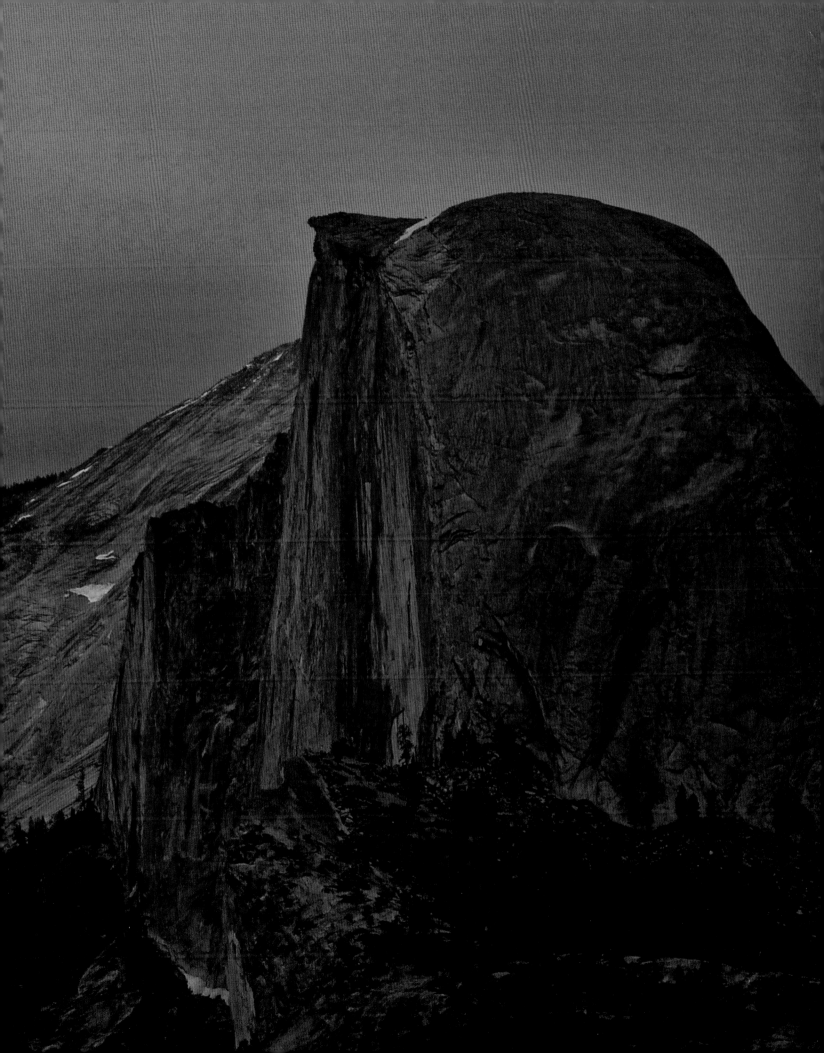

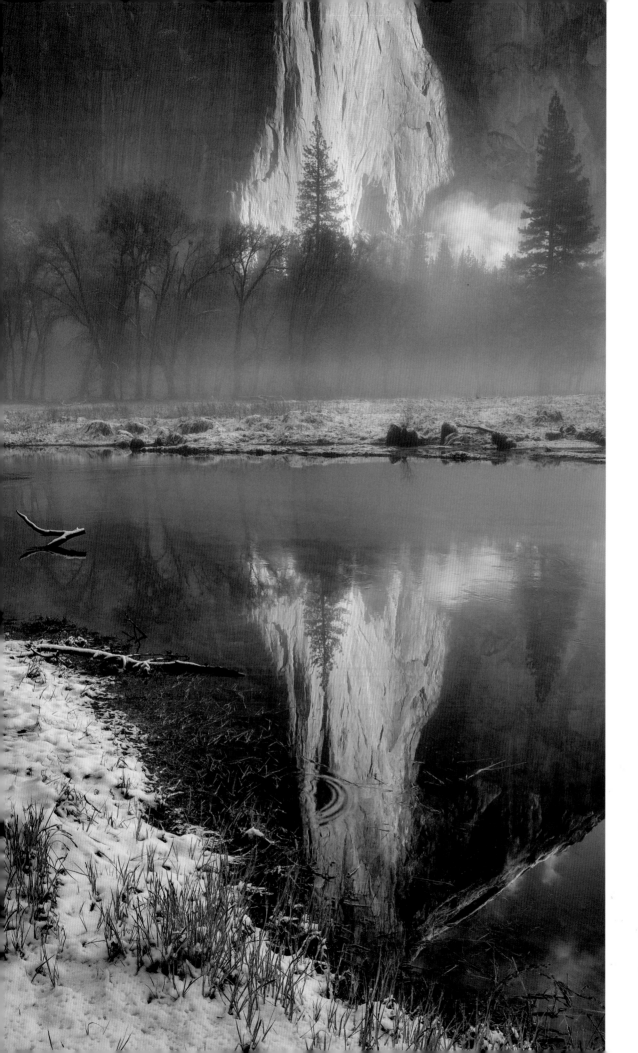

Previous spread: **Alpenglow from North of Washburn Point.** Photographers consider the first and last hour of light each day to be golden hours—times of magic light. The vistas from Glacier Point Road provide spectacular views of the crest of the Sierra Nevada. Here, the most brilliant color is opposite the setting sun and is caused by light reflected off of ice and water particles low in the atmosphere. In the mountains this spectacle is called alpenglow. On this day, the whole world was colored a rosy red; even my clothes turned this color. This sunset goes on my all-time top-ten list.

Dawn's Early Light. Known as the Dawn Wall, the east side of El Capitan captures the early morning light. Although reflections can be seen at any time of year, the typically still water of fall and winter provides a near-perfect mirror image. The melting snow on a branch above me offered the occasional water ringlet. I waited for one of those moments. . . . Oops, breaking the mirror.

Shadowplay with Bigleaf Maple. The bigleaf maple has the broadest leaf of any tree in Yosemite, some measuring twelve inches or greater. A little breeze and the foliage begins to dance. To make the best of the midday sun, I played with the shadows on the granite canvas. It was fun to photograph but even more fun to watch.

Next spread: **Glacial Polish on Lembert Dome.** The illumination of the glacial polish contrasts with the silhouette of the Cathedral Range, and the textures of the granite are almost tangible. When I look at this image, I can just about feel both the roughness and the smoothness of the rock without the benefit of fingers. To get the shot I scrambled up Lembert Dome, in Tuolumne Meadows, as far as I could comfortably go. I had to use two long tripod legs and one shorty because it was so steep.

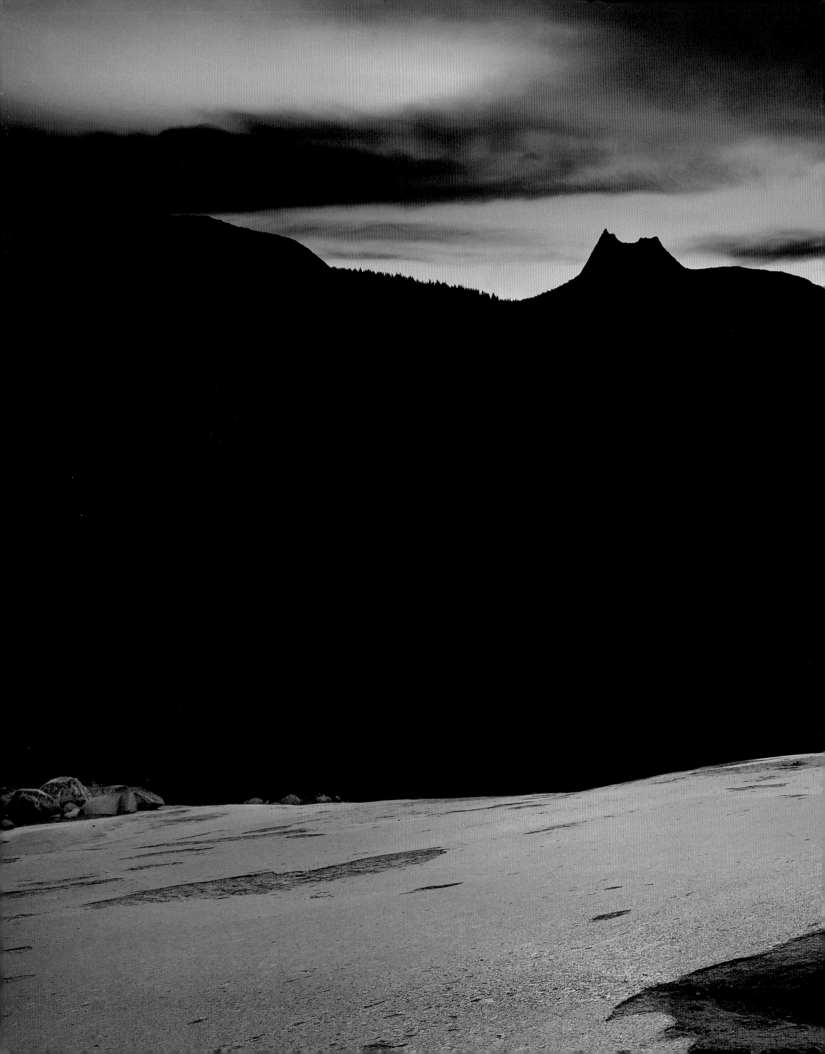

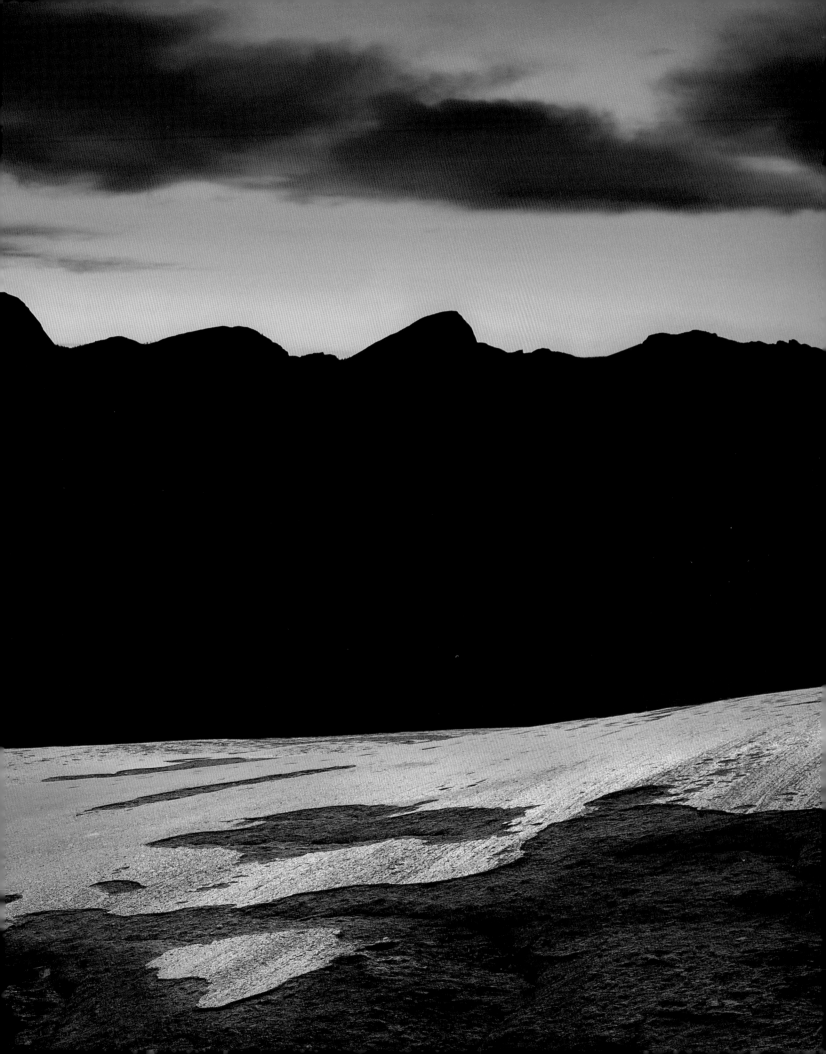

YOSEMITE THROUGH THE SENSES

I'M AT MY BEST on the farm when all my senses are employed. The scent of a peach helps me determine when it's ripe. The feel of a pruning shear guides me as I snip and slice to sculpt a tree. I listen to the irrigation valves in the darkness as I check water before retiring for the night. I taste each peach variety to compare the changes from year to year and decipher vintage of a great harvest. All good farmers see their land through the lens of time and generations—a type of native competency that accompanies my work daily.

Likewise, as astute visitors step into Yosemite National Park, we engage in a world of sensory experiences.

—Mas

Poppies in the Breeze. Poppies require sunlight for the flower to open, making them a great subject to photograph in the middle of the day. The slight breeze was not cooperating for a still portrait, so I chose instead to emphasize the flowers' movement with a slower shutter. What I find particularly interesting is the contrast of ancient stone and the ephemeral poppies, which bloom for only a few weeks. Some of the oldest rocks in the Yosemite area are found in the Merced River canyon west of the park boundary. This one looked as if it had been around awhile—maybe more than a hundred million years.

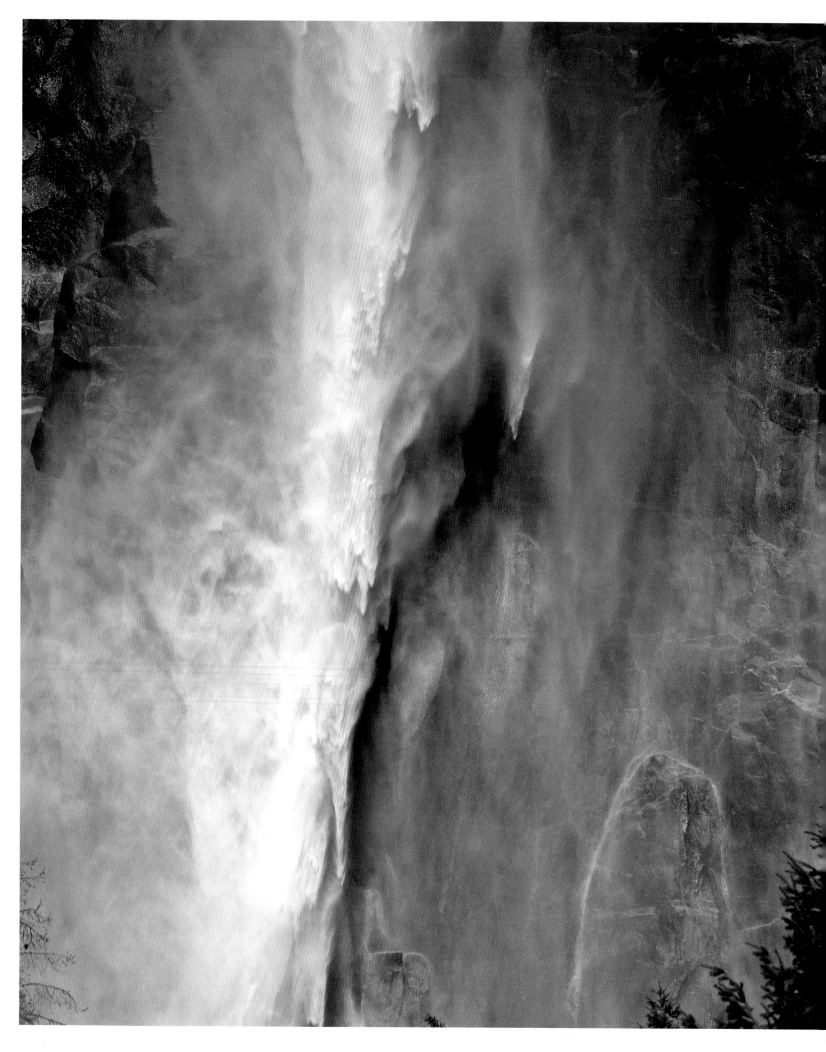

THE NATURE WE SEE

We are a visual people: we see first. The splendor of the natural world strikes our visual perception around each bend and curve of Yosemite. For many of us, this is how we experience art, through the colors and shapes of nature: the shimmer of a flowing stream; the sharp edges of a cracked granite boulder; the misty gray of clouds hovering over a horizon; the crisp clarity of snow-capped mountains reflecting in a pool; the sparkle of fresh green leaves or the red hue of day's end.

I'm always struck by the scope and expanse of Yosemite's landscape. Standing at the base of a granite outcropping or near a waterfall, I suddenly sense the immense size and range of the natural world. Ironically, the breadth and beauty of the vast environment makes me feel small, awed, and humbled. Seeing helps me feel grateful. It can take time for the rhythms of work and machines and the business of life to fade away. I pause to breathe in the sight, to step into a frame of nature.

Many have secured a memory of Yosemite in a simple photograph. Visitors have taken countless snapshots—from the early photographers whose images of Yosemite introduced us to this land to famous artists like Ansel Adams, who captured the visual grandeur of this place. There are millions of simple snapshots in photo albums, or tucked away in boxes and closets, or on computers and smartphones, images of family vacations or portraits as we posed with Yosemite over our shoulders.

These images became the reality for many of us, as we carried a little of Yosemite back home with us and were able to share it with others. Years later, we may rediscover a forgotten photograph and stop to remember when and where it was taken. We try to identify the people in the photos and quickly slip into remembrances and stories, further implanting the images of a trip into our seen memories.

Today's phone cameras allow even more photographs to be taken and easily shared. We can instantly introduce Yosemite to our networks of friends and family, exposing new visual interpretations of our personal journey into a natural wonder, all captured in a selfie posted on social media. We literally see ourselves in Yosemite.

—Mas

Afternoon Rainbow in Bridalveil Fall. Rainbow! I still get excited every time I see a rainbow, even though you can find one every sunny afternoon at Bridalveil Fall. If you zero in on the pointed tips of the spray, you'll see why John Muir called these plunging water features "comets."

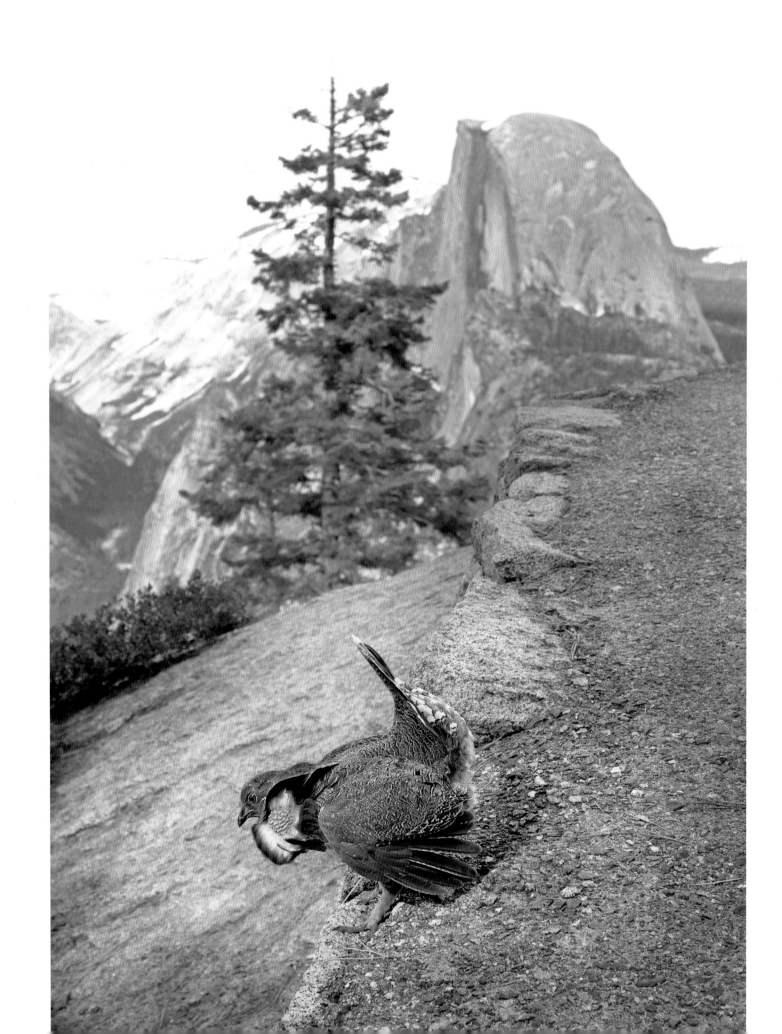

Opposite: **Sooty Grouse.** One spring my neighbor and I rode bicycles up to Glacier Point before the road was open for the summer season. There, we were greeted by an amorous grouse. We were both flattered, of course. And then we saw the female and realized we had interrupted some heavy flirting. Oops! Sorry, excuse us . . .

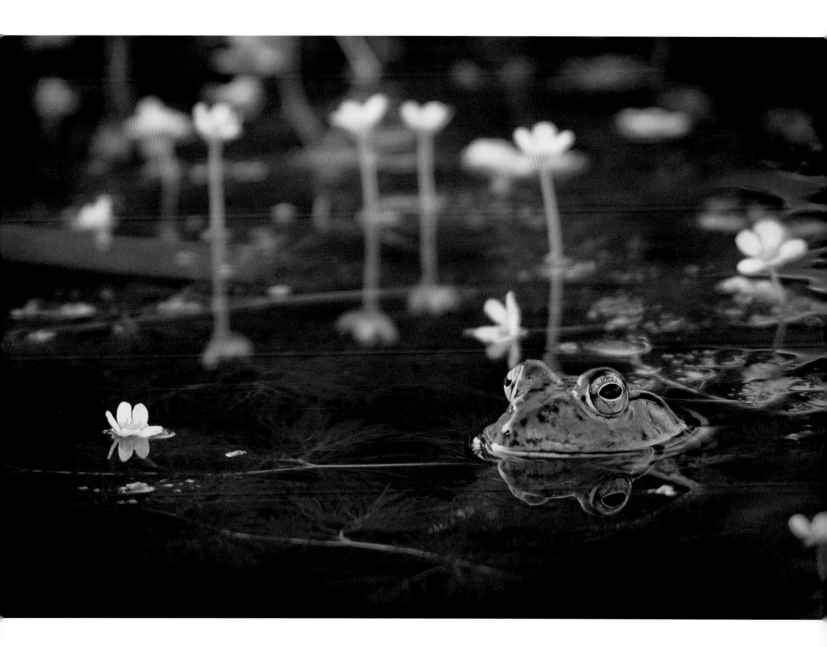

Bullfrog in the Lily Pond. I pass this small pond almost every day, traveling between my home and my studio. A sure sign of spring is the emergence of water buttercups and a pool full of frogs. This little fellow was hanging out among the flowers hoping that they'd attract an insect or two. Instead, he attracted a 200 mm lens. Inside the park, the National Park Service has implemented a program to eradicate bullfrogs, as these invasive predators are responsible for the decline of many species of smaller native animals, from amphibians to snakes and small mammals and even birds.

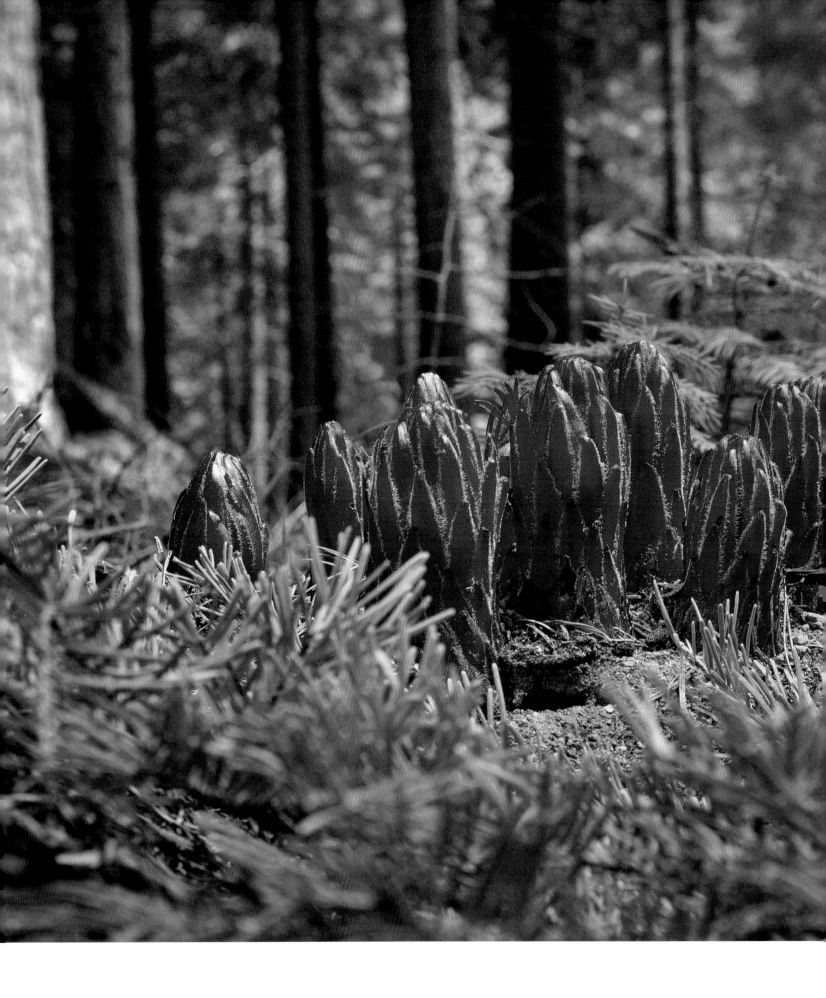

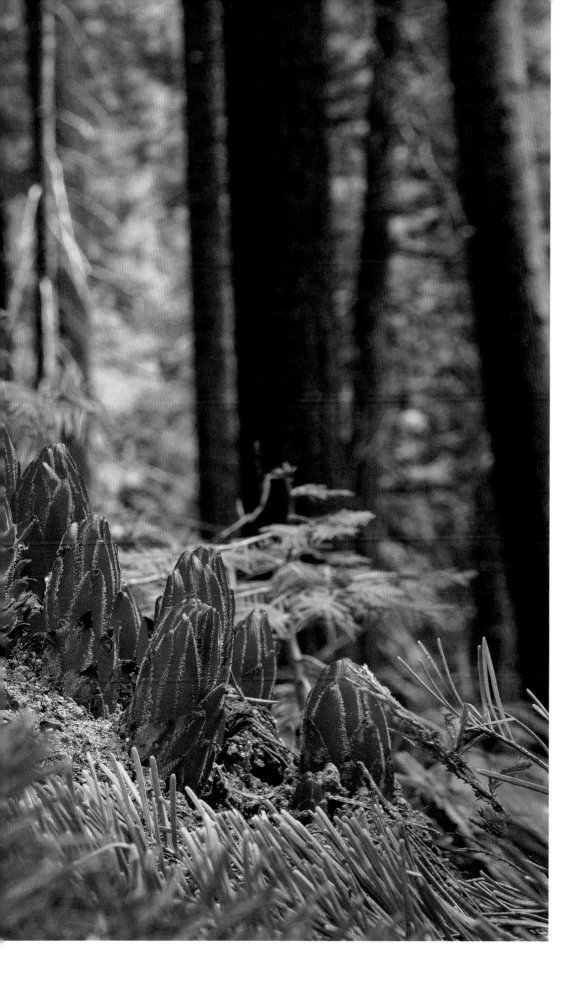

Snow Plants. One of the first plants to emerge from the melting snow in spring, snow plant is winter's gift to the coniferous forest, providing a splash of festive red against the background of evergreen boughs. It's rare to find more than two or three in one spot. As for this jackpot, a hotel employee called and told me that one of my students had left me a hand-drawn treasure map that would lead me to something she discovered the day after our photography workshop. I was excited! After following the dotted line past various oak trees, downed logs, and large boulders, all indicated on the map, I arrived at the location of the big "X," where my very wide eyes were rewarded with the bountiful gift of thirty-four snow plants.

THE NATURE WE FEEL

The joy of Yosemite is felt, not just by our emotions but also by our hands, our feet, our fingers, our skin. I can't help but want to reach out and touch the rocks and dirt and plants. When we touch nature, we are touched.

A thrill comes when I'm surprised in this astonishing geography. A coarse rock seems to be softened by the sun when I can feel the warmth. The fluid movement of a brook or stream carries the shocking cold of freshly melted snow: I can feel winter in the late spring. As a farmer, I thought I knew greens, but wandering in a Yosemite meadow, stroking the grasses and plants, I feel a different shade and hue. These are mountain plants; they seem fresher and free, perhaps because no human hand planted them.

I feel the expanse of the National Park—a place designated as special and protected. This is not just a natural wonder but a landscape for people to visit and feel. A pristine land we can touch, a place where we can expand our being. Here we can feel the delicate balance of nature and humans as both struggle to find rapport and compatibility. We reach for a harmonious symmetry.

Allowing my imagination to soar, I extend my arm and hand as if stroking the sky. Can I feel a cloud? What does the red setting "sunscape" feel like? Does a dark cloud, shaded brown by the late afternoon light, have a different texture? In this place we can be free to caress our fancy.

We are privileged to feel this wildness, yet I recognize that not everyone can feel this sacred place. I worry about the future: how can one miss something never felt? The invitation remains open: a visit to feel the power of Yosemite to touch people and make a lasting difference in their lives for generations.

—Mas

Oak Texture. The textures of oak trees are often so vivid that you can almost feel them with your eyes—though feeling them with your hands can be a lot of fun. Scars make for great stories, and this tree looked like it had a lot to say. So I stayed a while to hear its tale and take photographs.

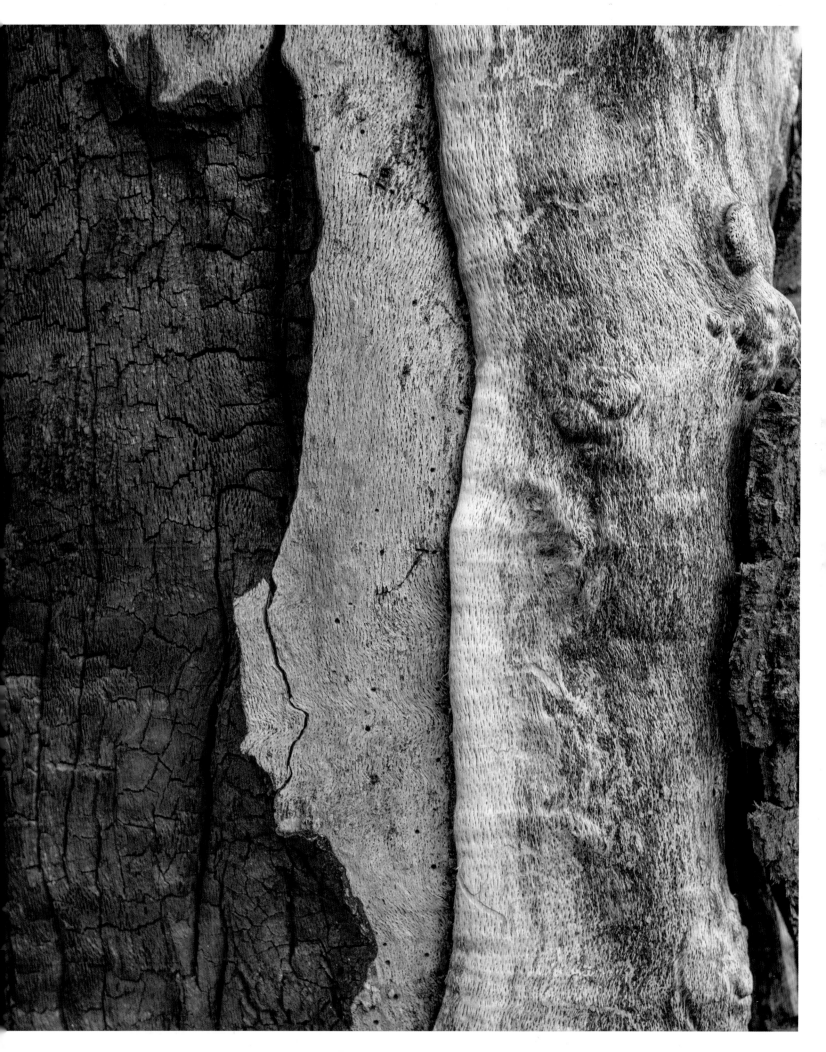

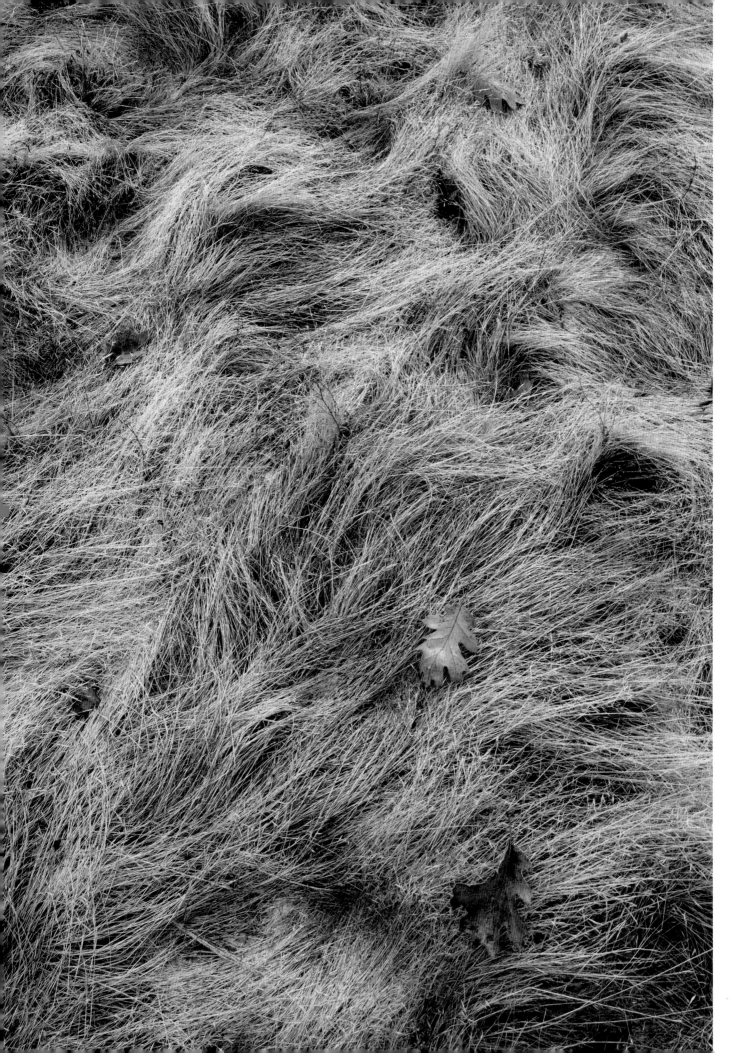

Opposite: **Grass and Oak Leaves.** It hadn't snowed yet, but we'd had some frosty mornings, and the textured grasses were getting ready to lie down for the winter. This photo reminds me of my hair after a few days in the high country, minus the leaves (well, maybe one or two . . .).

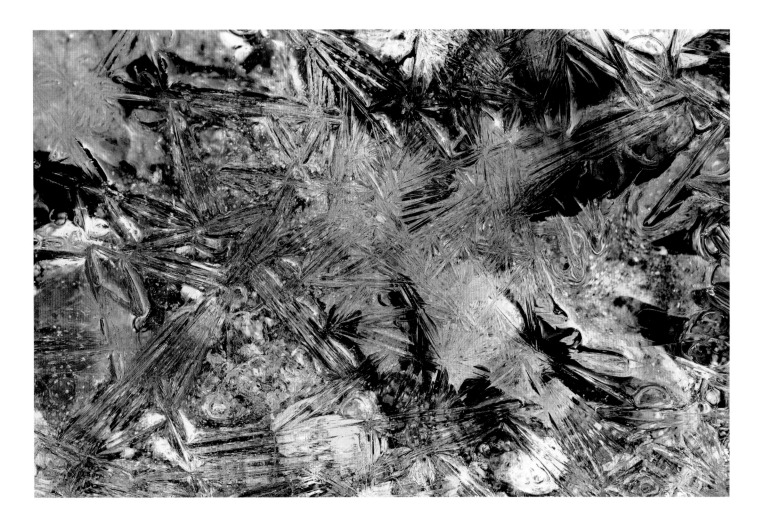

Winter's Chill. This photograph was taken on New Year's Day as I was walking with friends along the South Fork Merced River. The location is only about three hundred steps from my house, in a quiet shady spot dotted with large oaks. Warm days and cold nights had created a lovely combination of two seasons, preserving autumn leaves under winter's chilly glass.

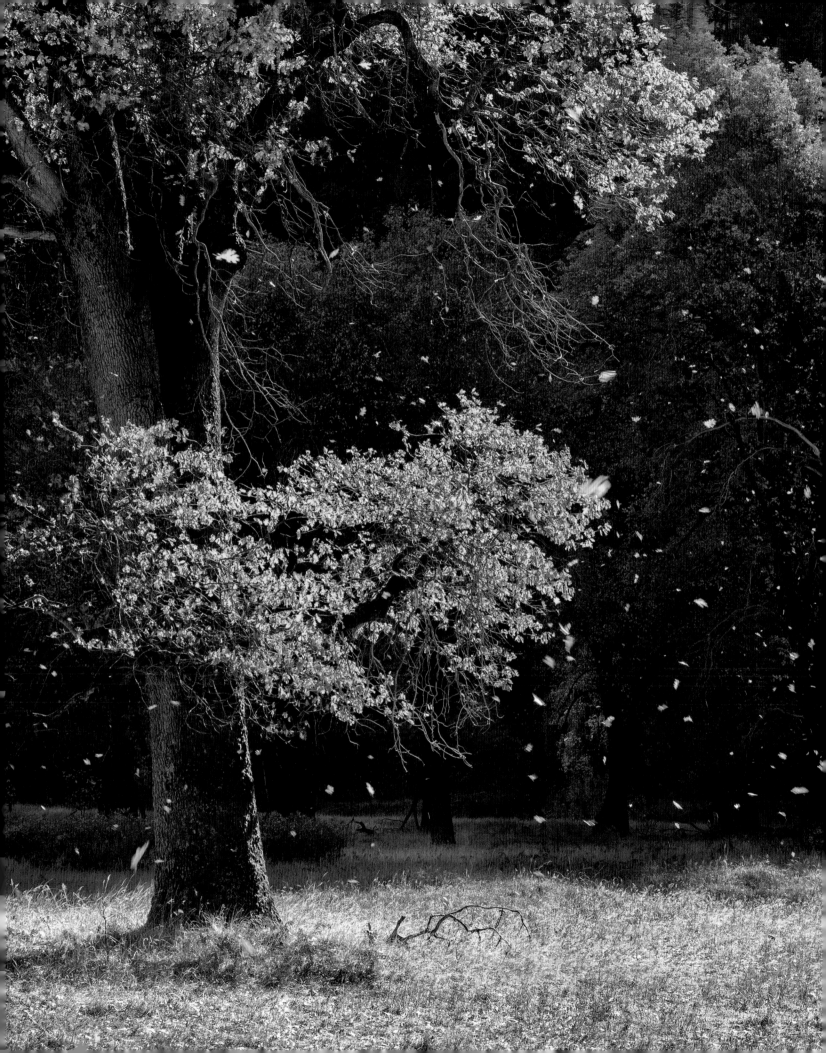

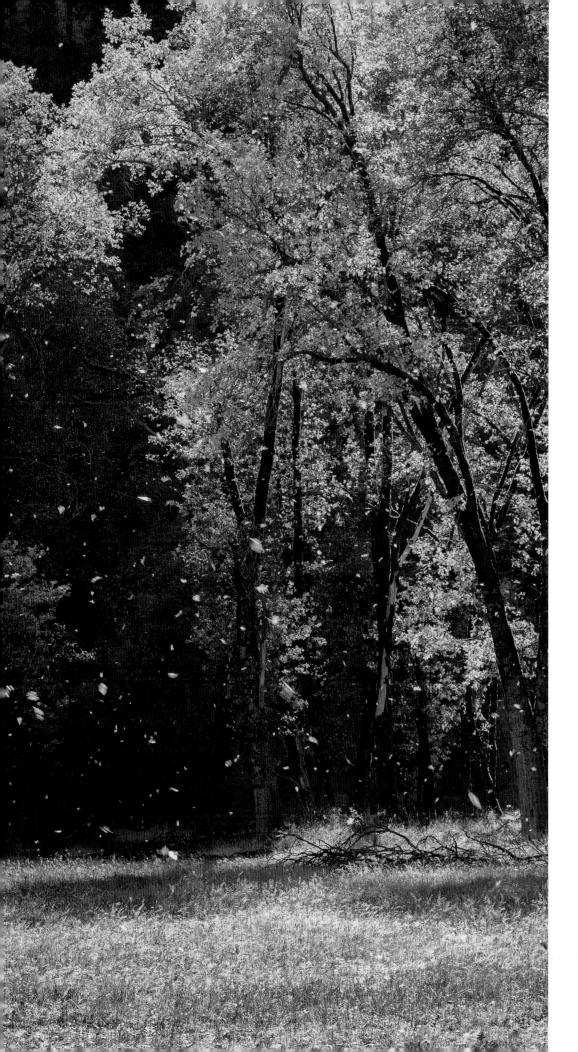

Fall Is in the Air. Every year there is that one day when I know autumn is on its way out and winter is just around the corner. The sound of the wind arrives a split-second before the wind itself, and before I know it, the chattering leaves are migrating across the Valley floor, fluttering, skittering, and tumbling in this blustery event.

THE NATURE WE SMELL

Smell is one of the most powerful senses. Fragrance affects how we taste and our perception of what we see and feel. Aromas evoke strong sensations that trigger a rush of emotions and memories. The whiff of an old girlfriend's perfume, the odor of oil and machinery, the spice of a home-cooked meal—all powerful ways we connect with places. What is the scent of Yosemite? How do we put into words the perfume of "nature"? Or can Yosemite be defined by difference? This is not the odor of the city. We may not notice the missing pungency of car exhaust. Instead, initially we detect nothing: the absence allows us to explore.

Nature creates its own bouquet. Sometimes it's by season: the perfume of spring wildflowers such as fragrant azaleas or lupines or the fresh aura of splashing water from a waterfall. Other times it's by weather: the smell of rain in the air after a quick rainstorm. This is all part of the landscape of nature.

Fragrance often requires a close relationship to objects. The spice of juniper differs from the bay laurel. The ponderosa pine, as it ages, changes from a black to yellow bark color and a vanilla or butterscotch scent becomes distinctive. Some claim that the Jeffery pine, a close cousin to the ponderosa, harbors the smell of baking cookies when closely sniffed. A sweetness accompanies such trails.

I have heard of the rare Yosemite bog orchid, hidden and mysterious. This delicate and small flower with shallow roots has an unmistakable quality for the discerning nose: it's been said that it emits a robust musk aroma like strong cheese or sweaty human feet, a fragrance I'm sure we'd remember from a Yosemite visit. Even rocks carry a scent, released especially after a rain. I recall times when, exhausted during a hike in Yosemite, I lay prone on a large boulder, my cheek pressed against the surface. I breathed in the smell of stone mixed with lichens and moss blended with fatigue.

Finally, of course, there are aromas that trigger a memory of Yosemite. The lazy incense of smoke from a campfire makes me think of camping trips to Tuolumne Meadows and the annual literary festival. On another visit the bouquet of pine transports me back to the High Sierra Camps; the distinct pungency of body odor prompts a grin and a flashback of spending hours on a trail. Distinct and memorable.

Fragrance adds to our relationship with a place, creating a powerful conscious and unconscious bond. The pleasant trace of the familiar. Comforting. Unifying. Complete.

—Mas

Drop Circles on Mirror Lake. Mysterious aliens have arrived from the sky. During an extended dry spell, oils and resins from plants accumulate on cedar boughs, grasses, and even granite. When the rain arrives, all of those surfaces give off a sweet scent that wafts from the forest floor. It's nature's aromatherapy at its best.

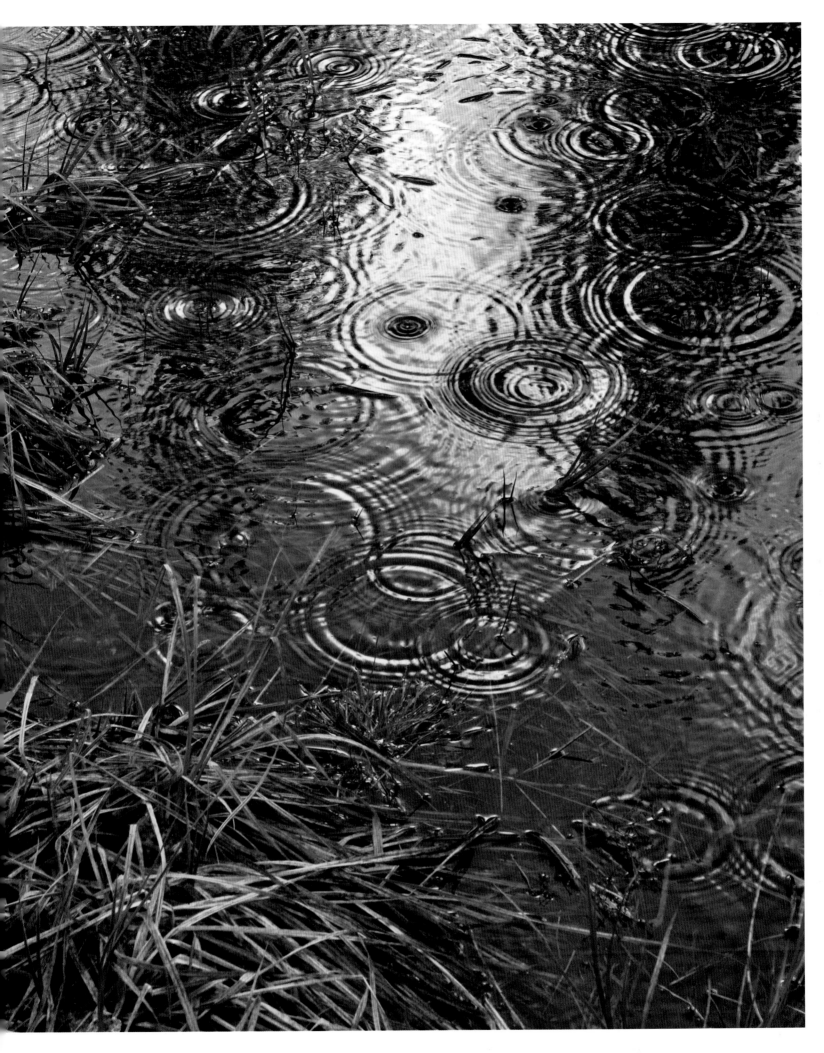

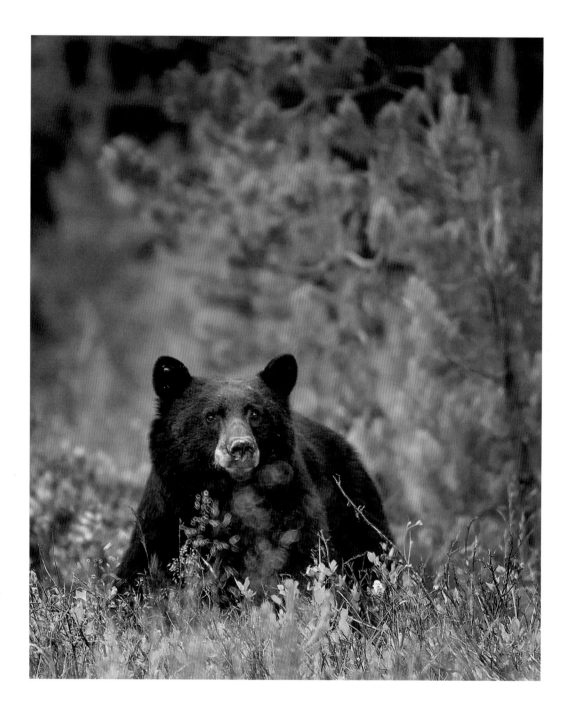

Black Bear. I'm a bear magnet. It's pretty exciting to see a bear, especially from a respectful distance in daylight, as in this photo. But if you see one when it's inches from your head while you're in your tent . . . well, then it's beyond exciting. I once forgot to remove some trail mix from my camera bag before retiring for the night, and mama bear sent baby bear in to get the loot. I awoke to a loud sniff at my ear—and then woke half the camp with my scream. I'm not sure who was more frightened at that point, me or the baby bear, but a lesson was learned: double-check all pockets. Anything with a scent must go in the bear-proof boxes—for our sake and for theirs. I don't know if this bear is the one that was in my tent, but I can tell you, at two inches away and face to face, bears all look the same to me. Yikes!

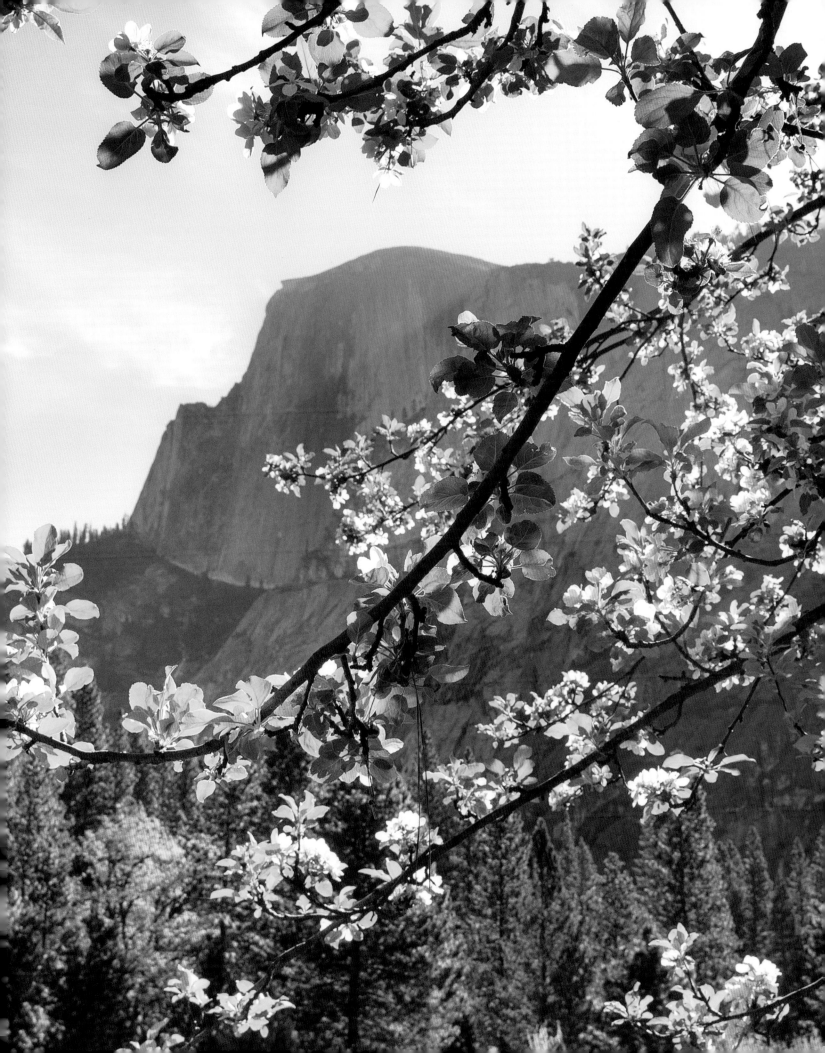

THE NATURE WE TASTE

What does Yosemite taste like?

We can imagine wildlife savoring the flavors of Yosemite: the fresh fish of a river or plants and wild fruits from native vegetation. Picture insect life feeding on the flora (and each other!). If we extend our sense of taste further, the fungi and bacteria too feed on this land and region. Historically, American Indians have utilized plants as a food source and for medicinal remedies. The bay laurel cured aches and pains. The original Yosemite diet may have included berries, pine nuts, bulbs, and special snacks of insects and pupae. The staple go-to food was the acorn.

We carry pure memories of taste. Recall a legendary meal while visiting Yosemite. It may have been as elaborate as a special event at The Ahwahnee or a simpler meal at a lodge or café. Regular food is transformed into something special following a weeklong backpacking trip. A casual meal around a campfire blends with the taste of friendship and vacation and exploration.

As a farmer and a participant in the culinary arts, I know that a sense of place cannot be separated from my world of flavors. I search for the tastes of landscape; I have an appetite for lush greens or the zest of snow. My palate savors the browns of a horizon and delights in the sparkle of a waterfall. I appreciate the darker greens of older vegetation, a building block of growing plants.

Yosemite feeds my imagination. My mind is allowed to wander. Creativity soars. Inspiration nourished. I taste a freedom of the soul.

—Mas

Morning Sun and Oak. Amidst a variety of other trees, black oaks rule El Capitan Meadow. The American Indians who lived in Yosemite preferred acorns from this oak, which were a major component of their diet. When I think of photographing trees in the Valley, this area always comes to mind. The autumn sun remains low in the sky, providing luminous backlighting that, in this case, is enhanced by the rising mist.

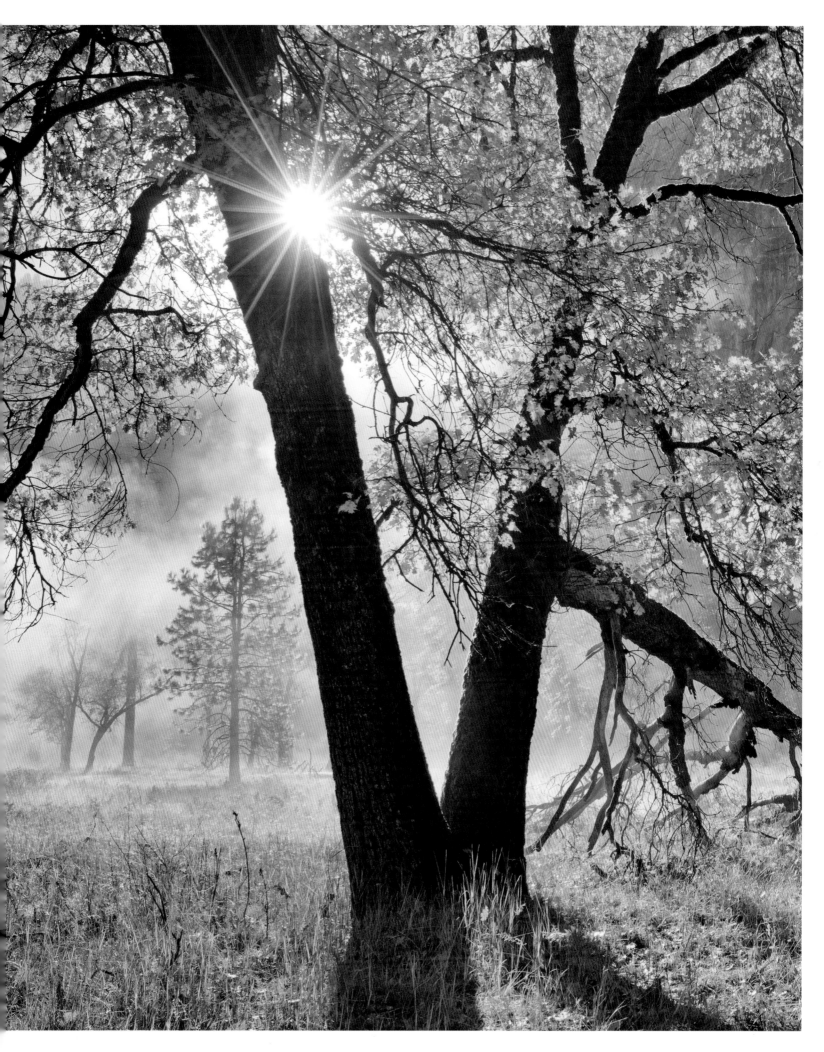

Coyote Hunting. The coyote's coat blends with the tall grasses of summer. In winter, coyotes are easier to spot as as they stalk the voles eking out an existence beneath the snow. This one is very sincere as he dives into the snow, committing to the pounce with both paws and jaws. I've never seen one miss!

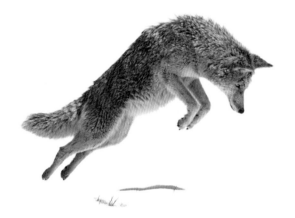

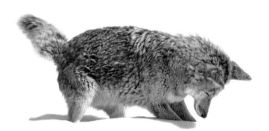

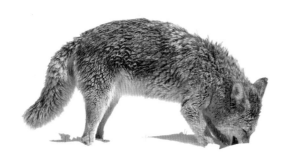

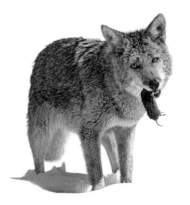

Next spread: **Breakfast at Tuolumne.** In summer, mule deer gather in Tuolumne Meadows. The males tend to graze in the open meadows near the river, while the females and their fawns cautiously keep to the edges of the forest.

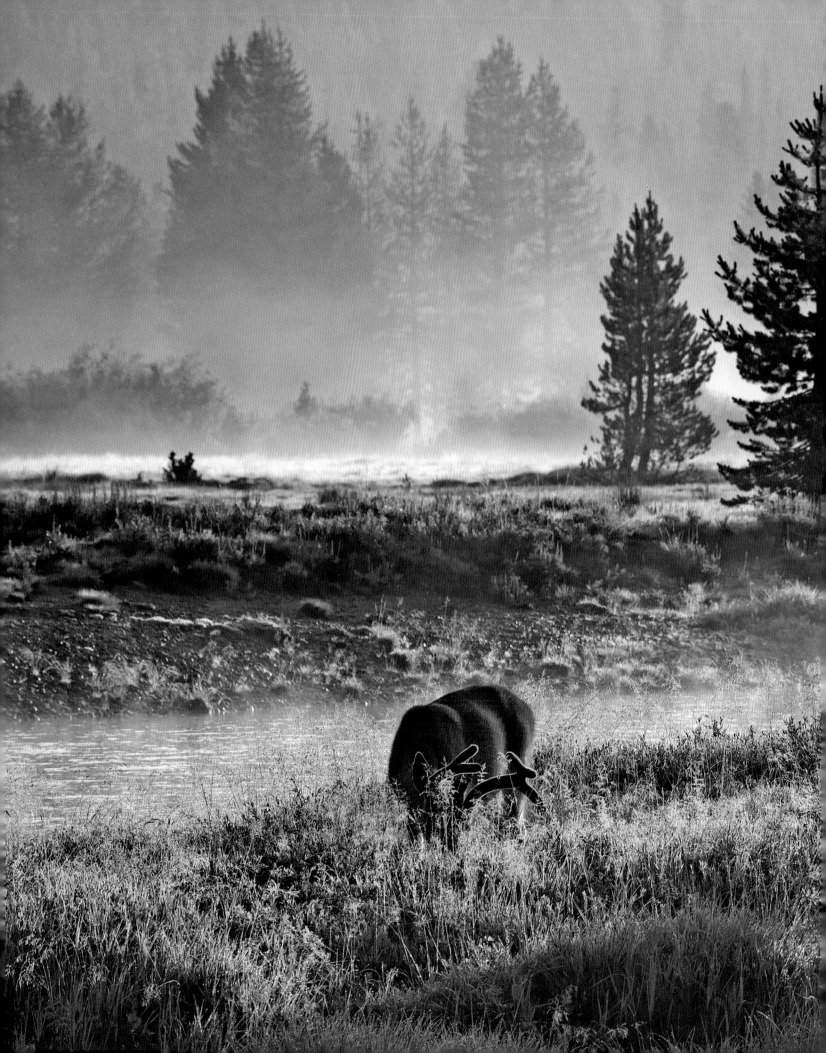

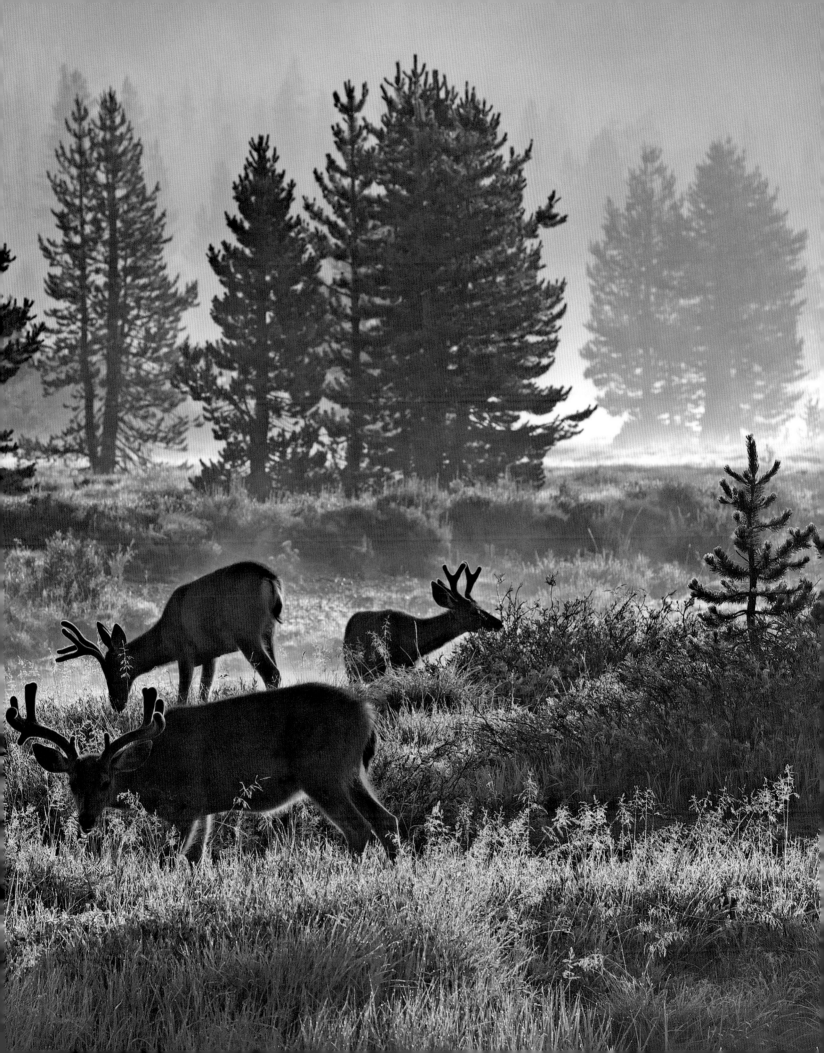

THE NATURE WE HEAR

When I journey to Yosemite, at first I hear nothing. It takes a while for my ears to adjust, away from the noise of machines. Gradually, the sound of all things electronic fades away. I'm left with human voices surrounding me, and in most cases they too gradually become quiet. Finally, I hear silence.

And only then do I begin to listen.

Initially, there doesn't seem to be much to hear. A distant bird. A possible voice. Later, the sounds begin to intensify around me, starting with the buzz of insect life. Mix in the sound of my boots crunching along a trail and the scuffing and scraping of my body as it moves through the landscape. If I'm fortunate, I can hear myself breathing and I'm enveloped by place. Then the soundscape is complete. That's when I notice the roar of a breeze through pine needles. Something unnoticed a few moments before now commands attention. Where did the gust suddenly come from? Or was it always there and I wasn't paying attention?

I love the wind. Something we can't see but feel and hear. Something that can sway huge trees or kick up in a burst of dust as we listen to its power. Wind can transport clouds and catapult a cold front of darkness marching overhead in the sky. I can only imagine the sound of such forces of nature. Wind announces its presence the most with sound. The same wind will disclose different characteristics in specific locales—a pine forest, an open meadow, a pass between mountains.

Only with sound am I allowed to see and truly feel wind. It proclaims itself as a song of nature, the music of a place, an anthem of Yosemite.

—Mas

Western Tanager. When you're surrounded by the looming cliffs and thundering waterfalls of Yosemite, it can be easy to overlook the small creatures. Walking through a wooded area near El Capitan Meadow, I heard this bird before I saw it. But thanks to its flaming orange-red head, it didn't take me long to spot this western tanager.

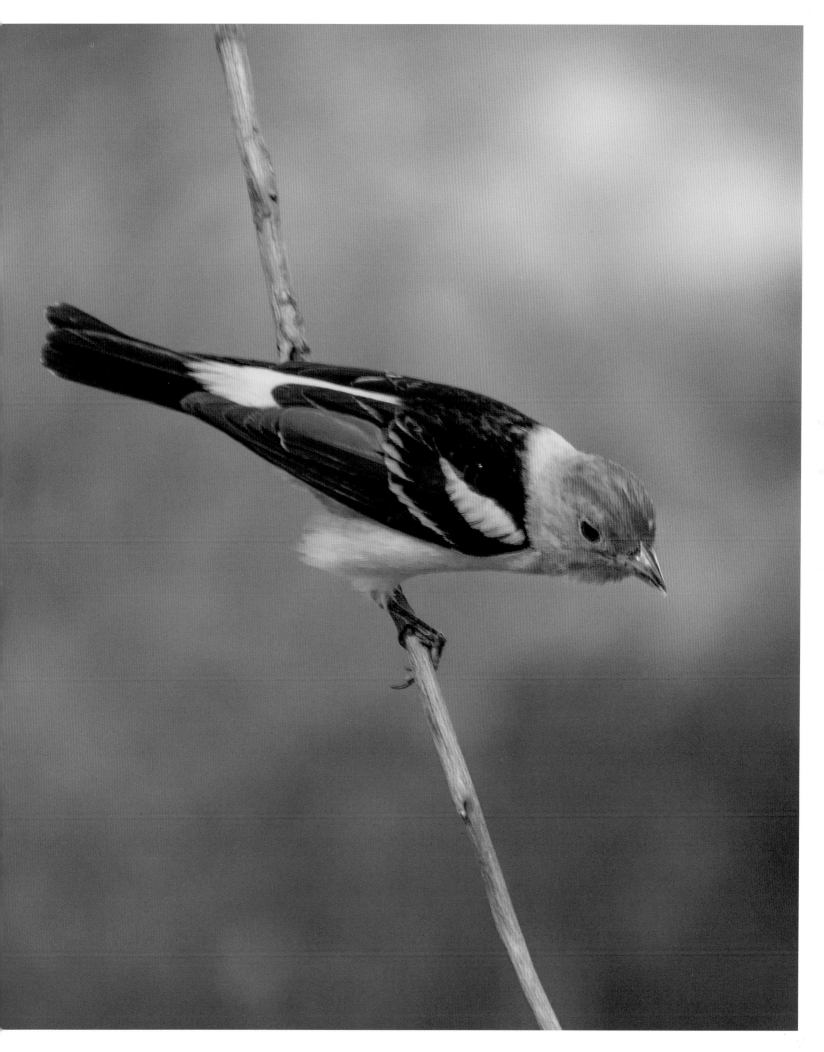

Fern Spring. Sometimes referred to as Yosemite's smallest waterfall, Fern Spring has a vertical drop of 1 foot (30 cm). People in the Valley filled their water containers from this natural spring for hundreds if not thousands of years. It's a great place to take a break and listen to its burbling song—the sweetest babble in all of Yosemite.

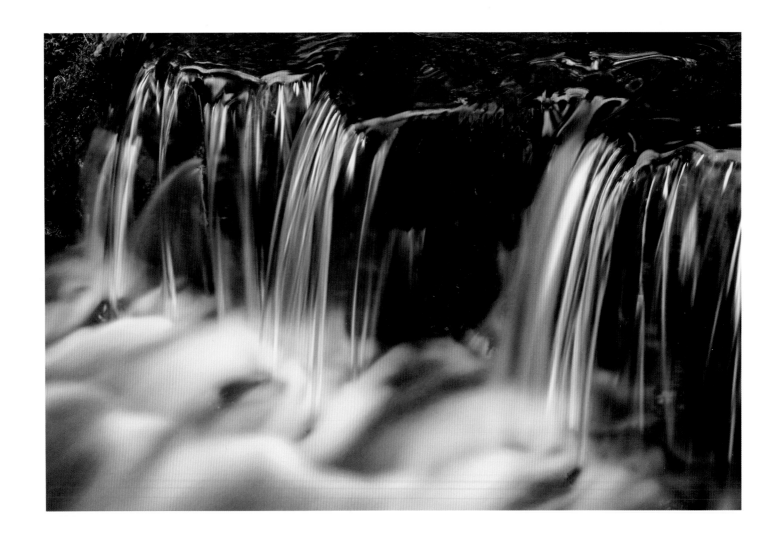

Opposite: **Upper Yosemite Fall from Fern Ledge.** Inspired by John Muir, I wanted to get a closer look at Upper Yosemite Fall, and some climbing friends volunteered to guide me to Fern Ledge, a spot high on the side of the fall. That hike is not for the faint of heart. It involves a little climbing and a lot of guts. At this close distance, the sound of the fall is thunderous, and in spring, it can be heard throughout the eastern end of the Valley.

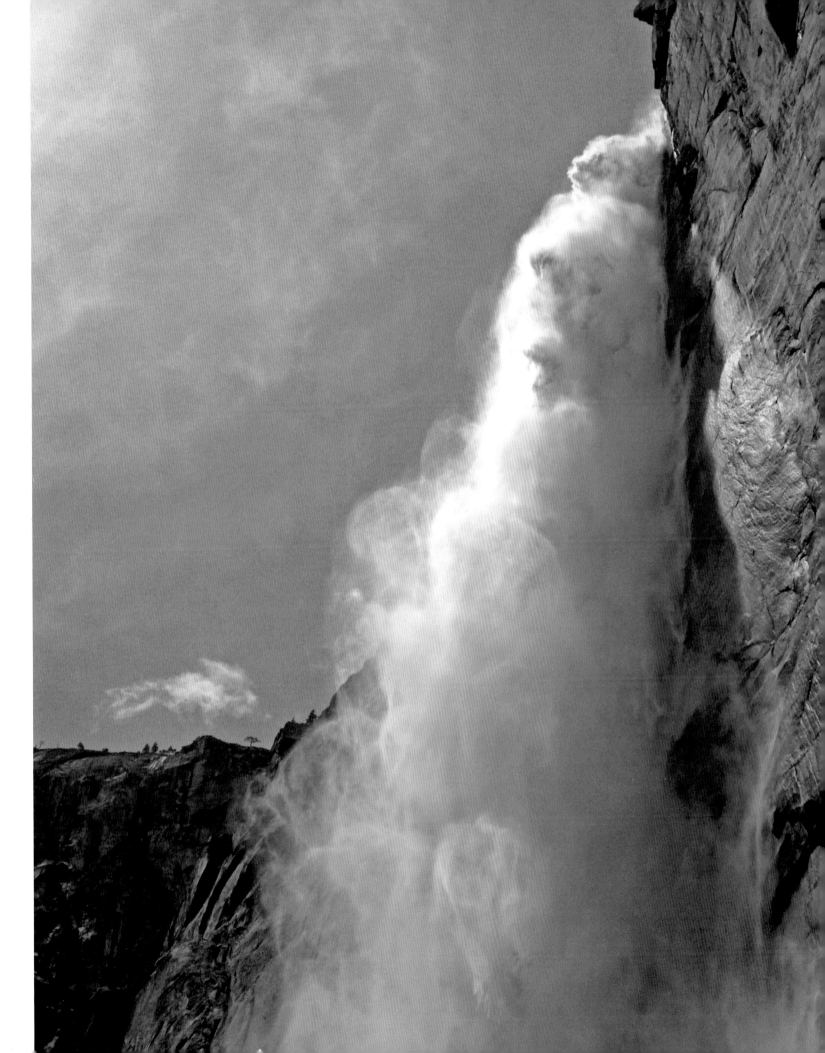

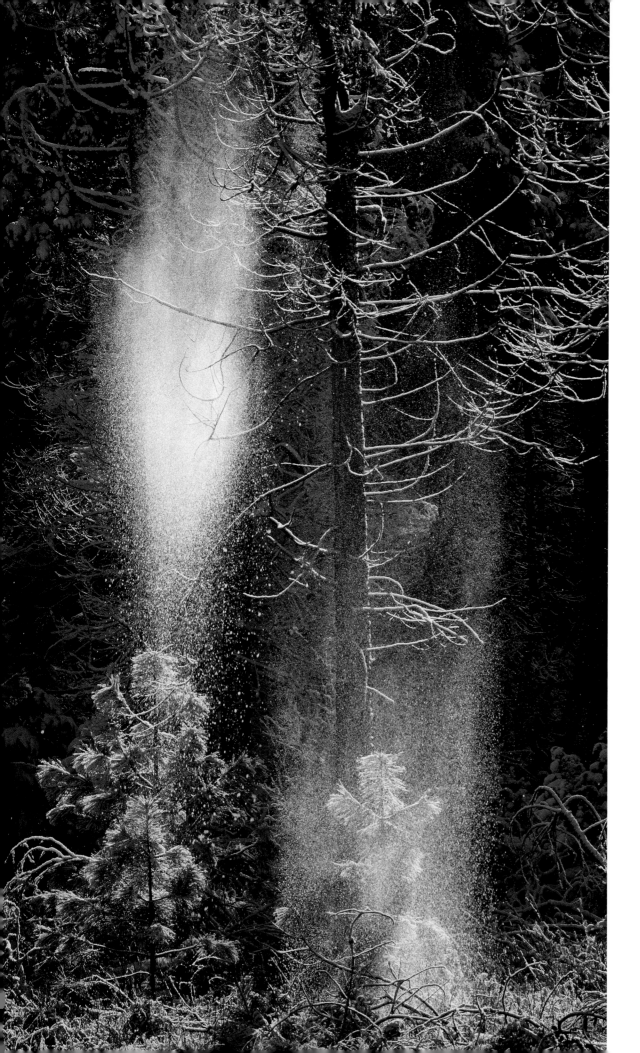

Breaking Quiet. Yosemite Valley is silent after an overnight snowfall—until the first sunlight hits the trees. First in whispers and then in song, the snow drops off the boughs, avalanching all the way down to the forest floor and fading into whispers again.

Mule Deer and Newborn Fawn. This doe and her newborn fawn passed through my yard to get to Deadhorse Creek. I was quiet, but she heard me anyway. Her big ears twitched. As I looked at her and she at me, we shared a moment as neighbors.

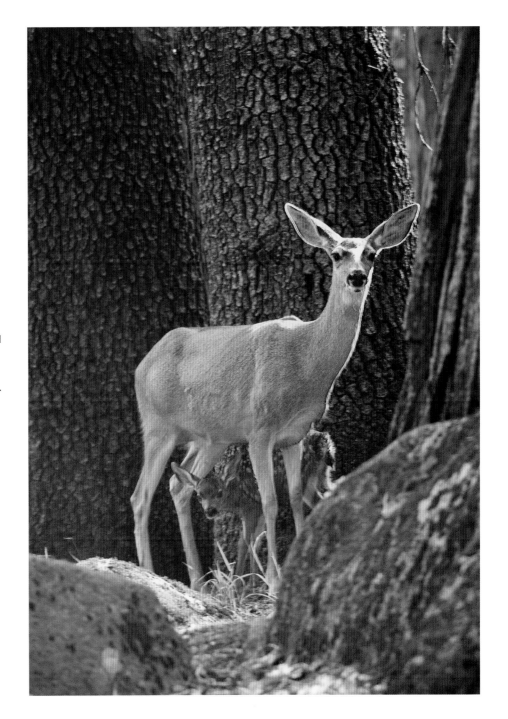

YOSEMITE THROUGH THE SEASONS

WINTER

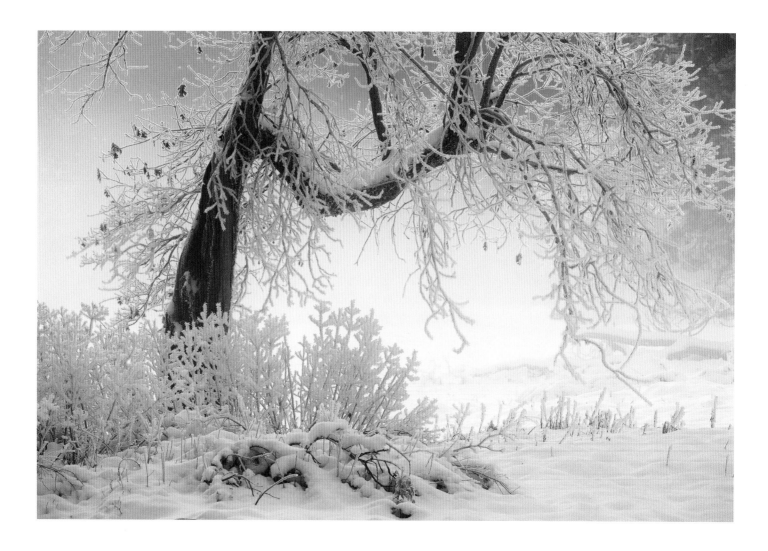

Hoarfrost. When temperatures have been below freezing for a while and conditions are right, hoarfrost—ice crystals that look like snow—develop on branches, grass, and leaves. These are fleeting moments of beauty. Hoarfrost may only last a few hours in the morning, and less if the sun hits it earlier. In the brief instant when the sun tickles these crystals, it creates an unbelievable light show. It feels like being inside a snow globe.

Opposite: **Grizzly Giant.** In winter the park exhales, and I strap on my snowshoes to blaze a trail through the newly fallen snow to my favorite big tree in the Mariposa Grove of Giant Sequoias, the Grizzly Giant. The girth of the horizontal branch on the left exceeds that of most tree trunks, and the tree's circumference at the base is nearly 100 feet (30 m). The tree is estimated to be 1,800 years old, plus or minus a few centuries.

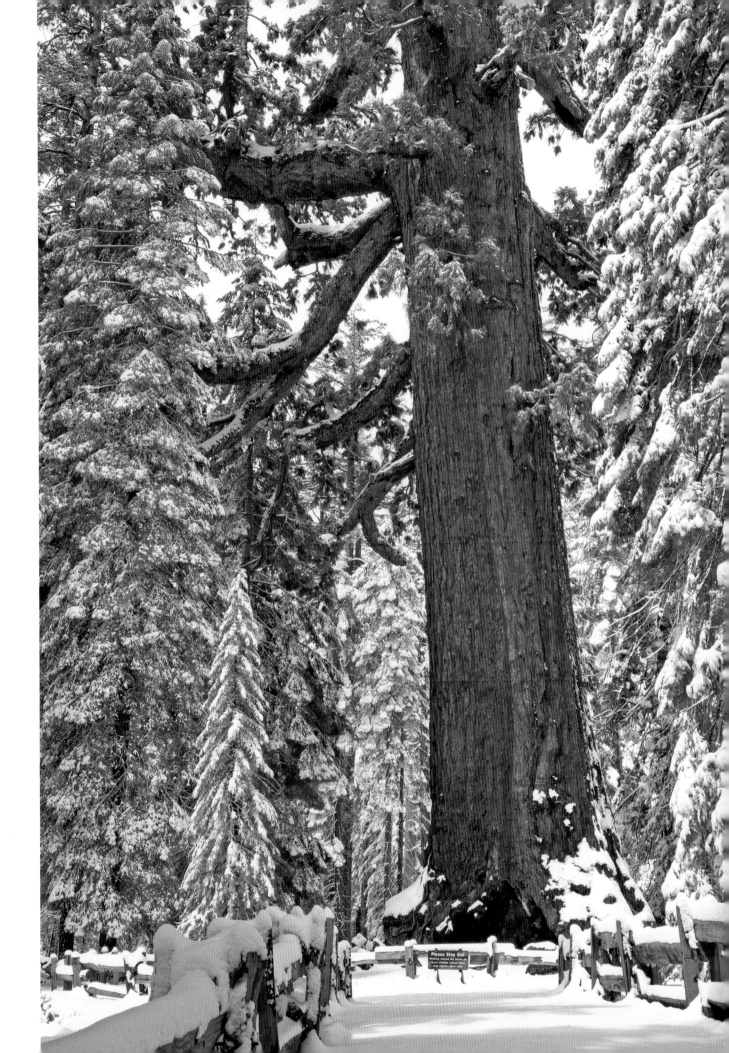

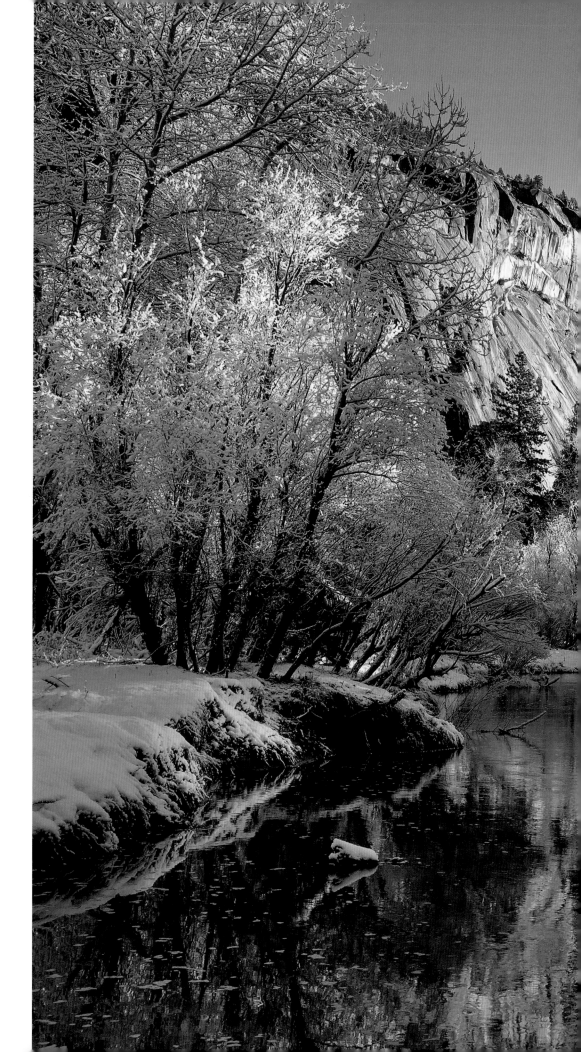

Half Dome in Winter. On the winter solstice, the sunrise is at its farthest point south. From this vantage point, the sun emerges to the right of Half Dome, illuminating the frosty cottonwood trees along the edge of the Merced River. The sun doesn't warm the face of Half Dome until afternoon.

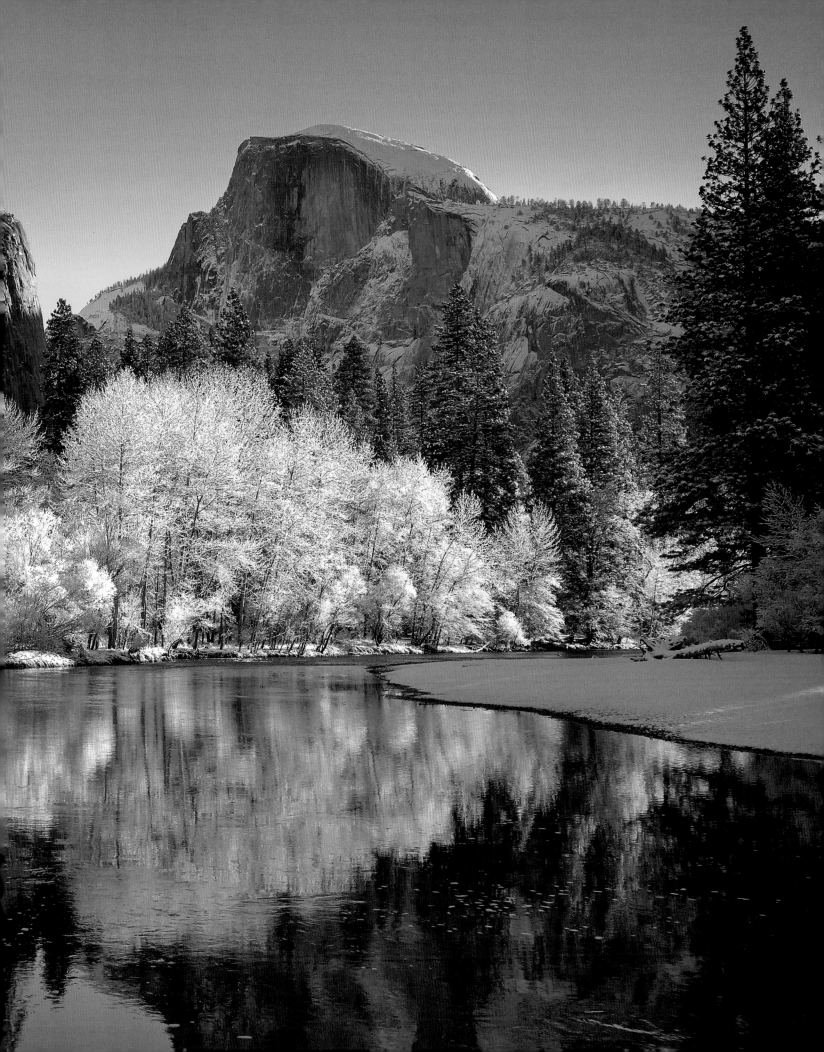

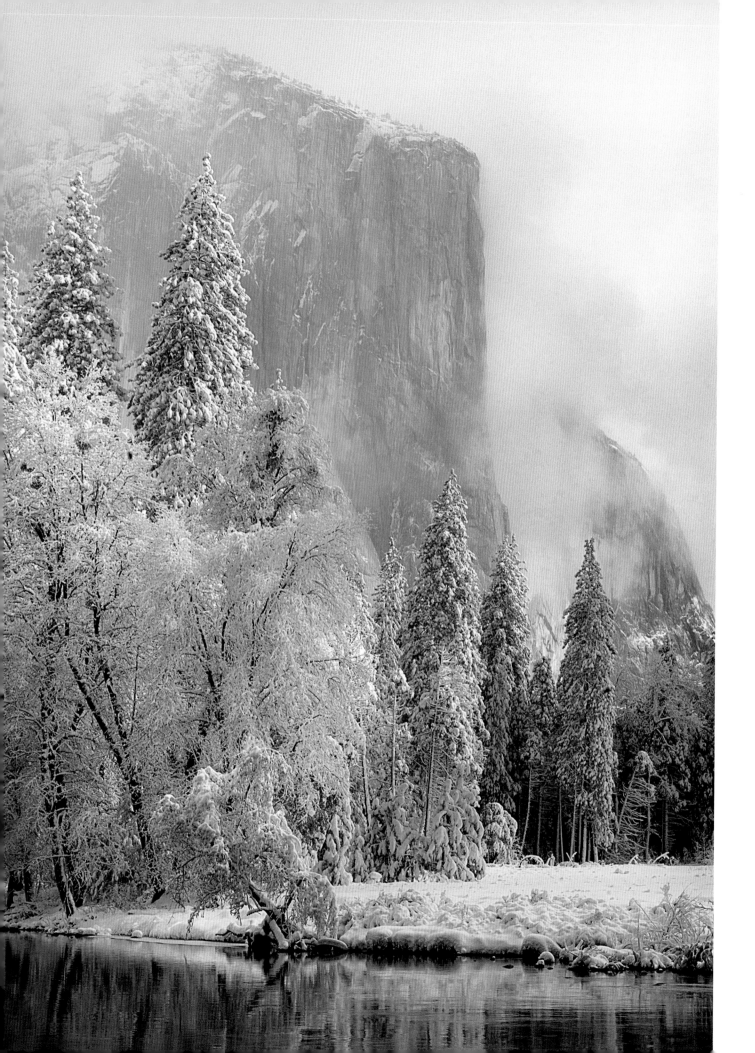

Ducks in a . . . Snow. My favorite pond always has something new to offer, whether herons, ducks, frogs, waterlilies, or reflections. This time my eye was drawn to the diagonal lines through the partially frozen surface. To my amazement, ducks had created numerous trails through the snow-dusted ice. And then there they were! Finally, I have my ducks in a row.

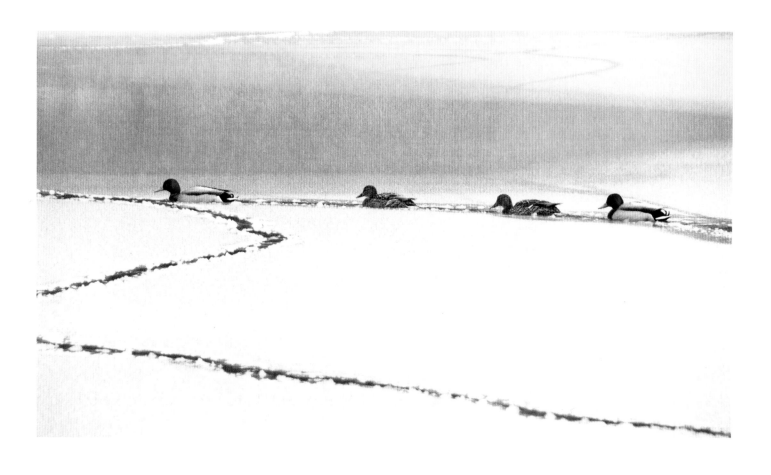

Opposite: **El Cap Awakens.** Early morning. A fresh snow. I arrived at my favorite spot along the Merced River, Valley View, just in time to capture El Capitan's golden glow.

Window with a View. It was a bitterly cold morning in the Valley when I jumped into my car for an early outing. I noticed the ice crystals that had formed on my windshield. Hoping the frost would last, I stuck my head out the window and drove toward Half Dome. The resulting photograph includes Royal Arches, North Dome, Washington Column, and Half Dome. That's 1/125 of a second that will be forever frozen in time.

Opposite: **Upper Yosemite Fall, Winter.** Another beautiful winter day in Ahwahnee Meadow. Color of the day? White!

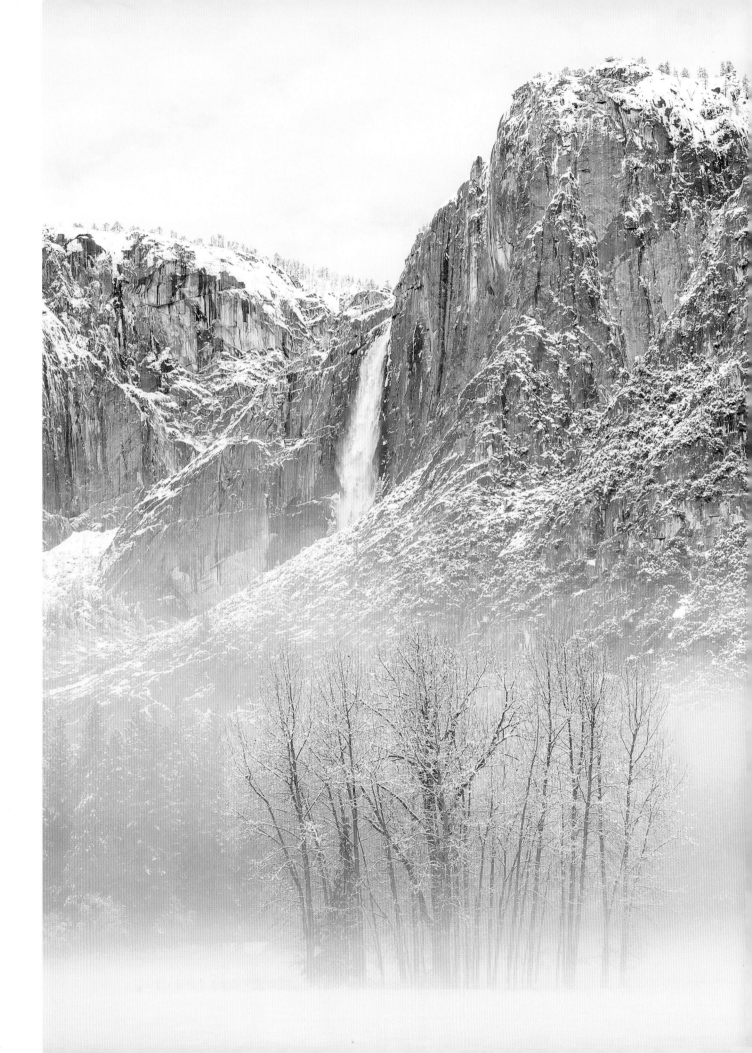

SPRING

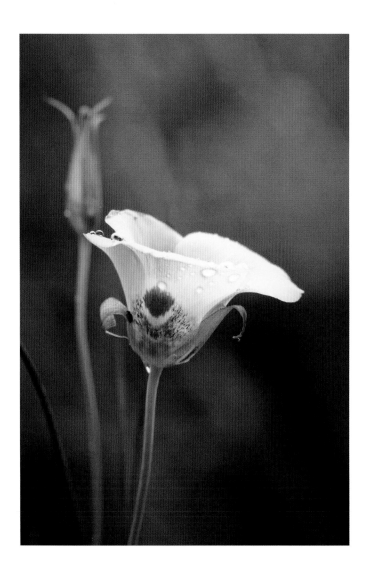

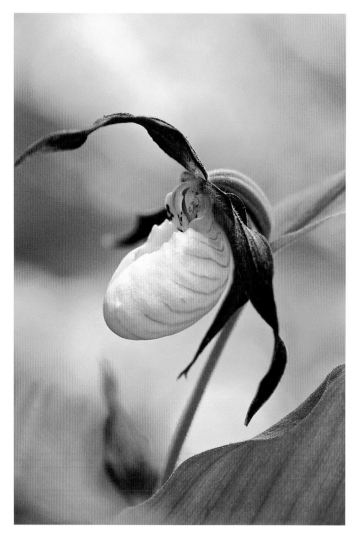

Mariposa Lily. Spring has sprung! Time to get out the macro lens and roll around on the ground. The wildflowers are everywhere. I like to see them eye to eye, especially the mariposa lily. Mariposa is a Spanish word meaning "butterfly," and the flower was given this name because of the butterfly design on its petals.

Lady's-Slipper Orchid. One of Mother Nature's wildest inventions, the rare lady's-slipper orchid blooms in the Sierra Nevada in June. Sometimes I take their portrait, and sometimes I just go to look at them.

Opposite: **Color on Highway 140.** Enter the park via Highway 140 in early springtime and, if there's been enough rain, you'll see a fabulous display of color in the Merced River canyon. California poppies cover the hillside, and redbud graces the foreground.

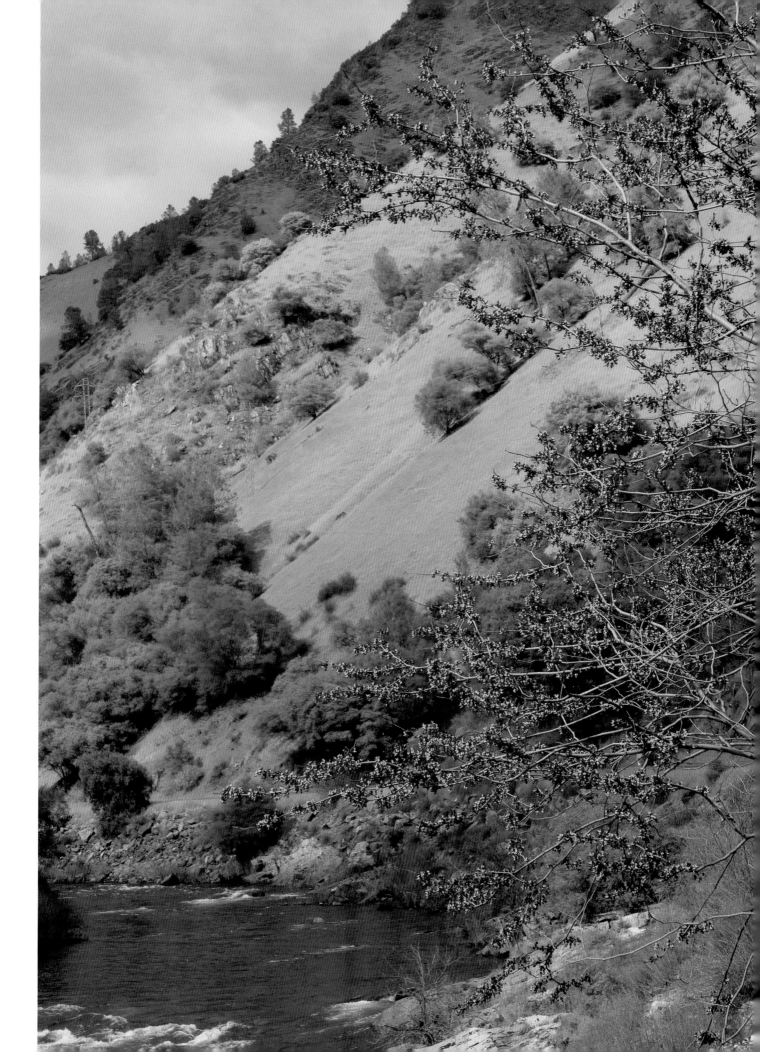

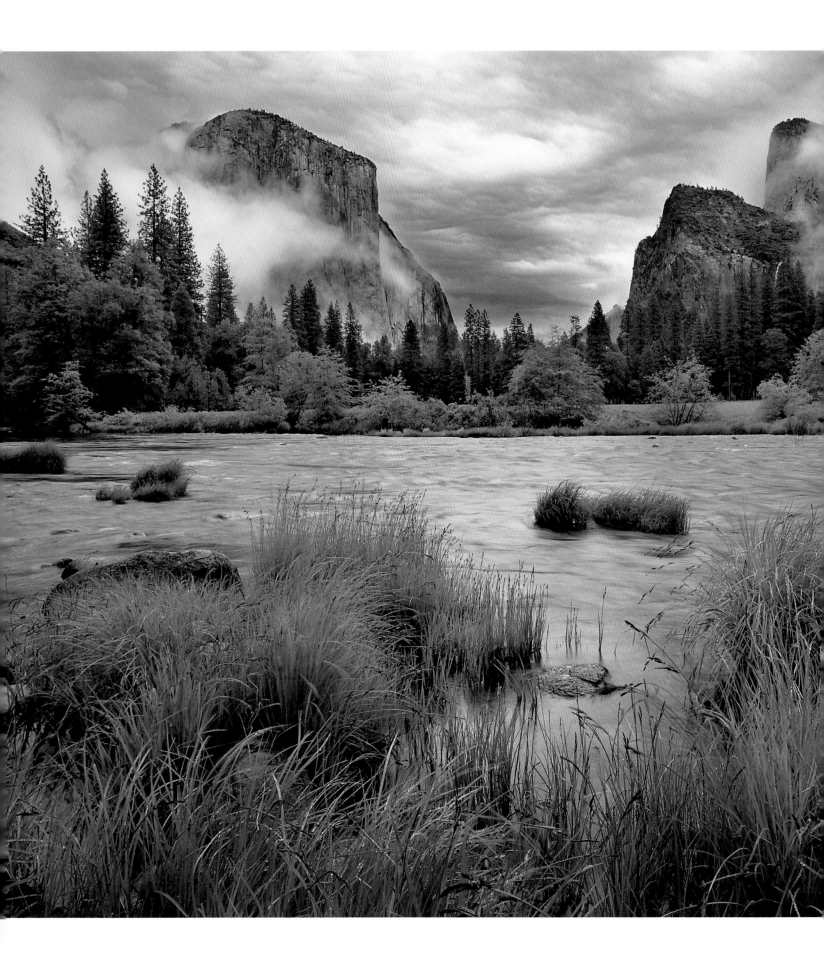

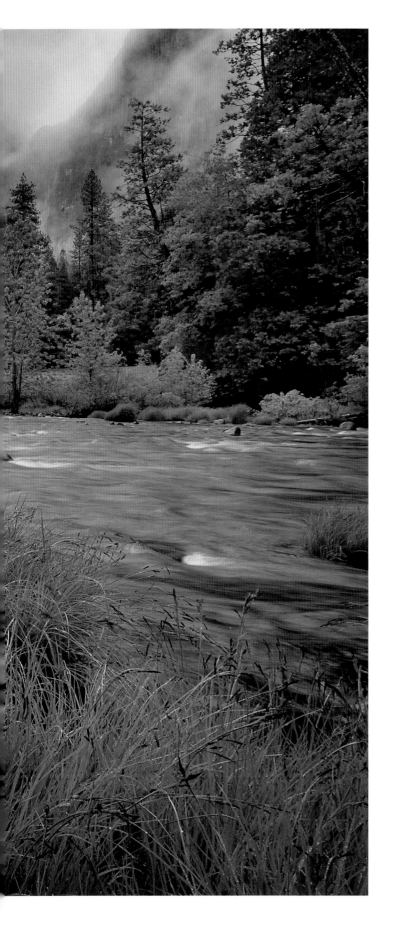

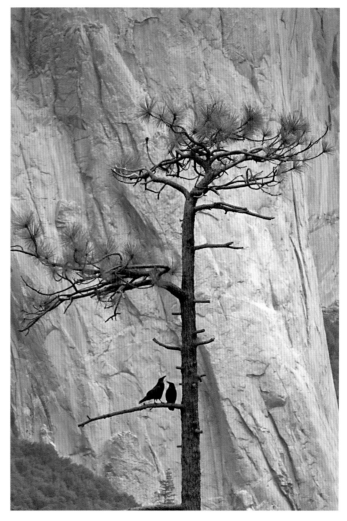

Ravens. Ravens mate for life, so they are often seen in pairs around the Valley. From Tunnel View I noticed these ravens in a tree, but with their jet black feathers against the dark pines, they all but disappeared. I needed to move a few hundred yards to my right and use my long lens to isolate them against the lighter background—the impressive granite face of El Capitan.

Left: **Valley View.** It doesn't get much better than a clearing storm on a spring afternoon. This is that Valley View spot that is so well loved, the Gates of the Valley. El Capitan stands on the left and Cathedral Rocks protects the right of what might be called the "entrance" to this seven-mile Valley.

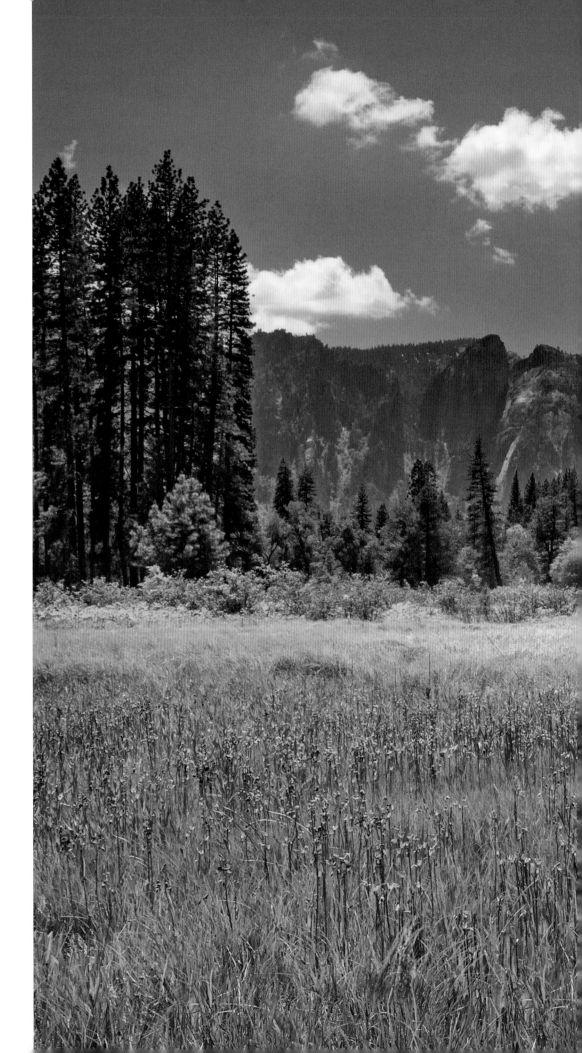

Valley Meadow. A person can't help but notice little purple flowers in sea of green grasses. Shooting stars are one of the first flowers to bloom in soggy meadows. This photo also illustrates how different Cathedral Rocks, in the middle of the photograph, can look, depending on your vantage point. If they look unrecognizable here, that's because most people are used to seeing them from the other side, towering above Bridalveil Fall.

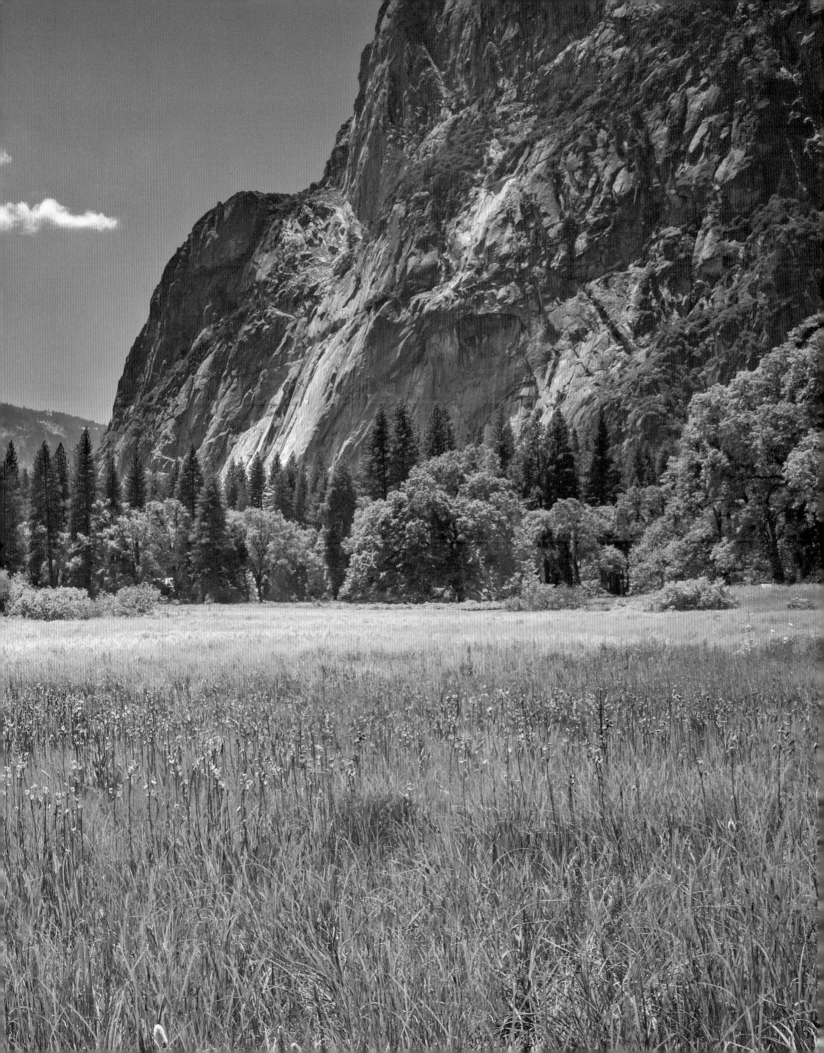

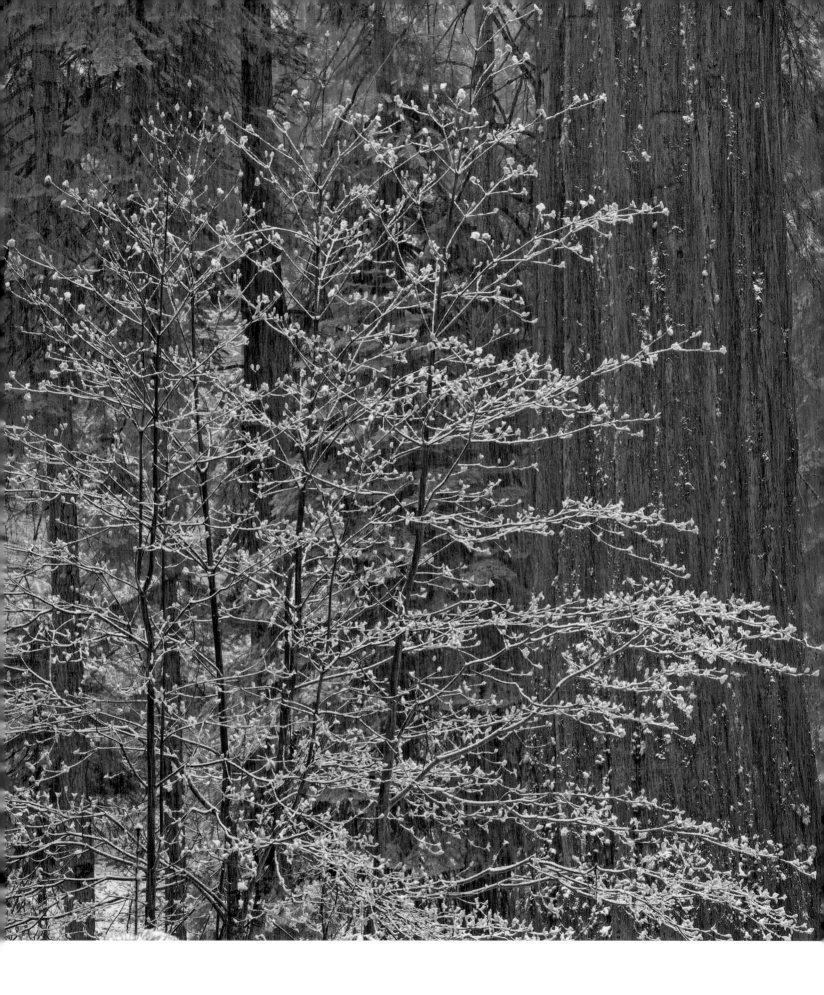

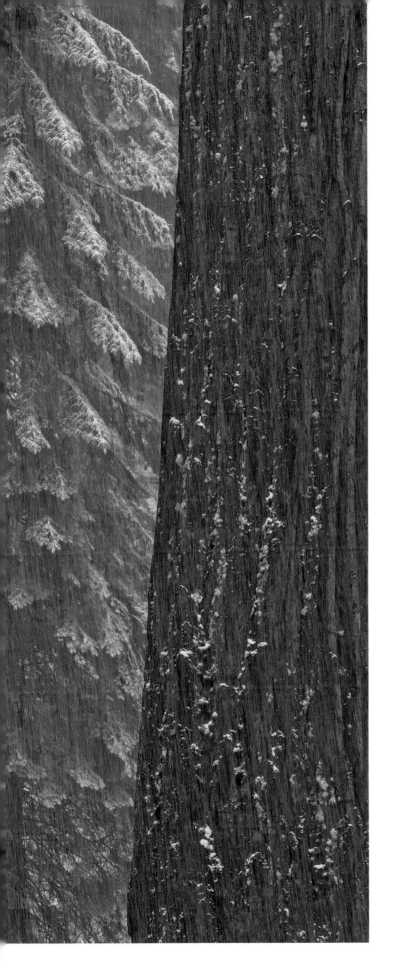

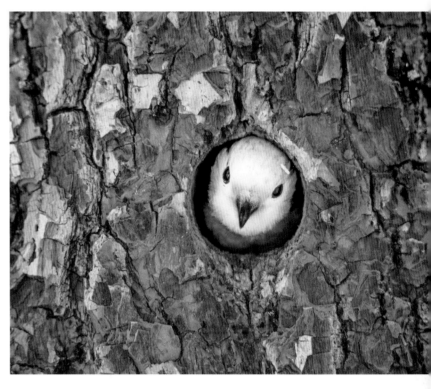

White-Headed Woodpecker. I watched this little woodpecker for a few hours from behind a long lens so I wouldn't interrupt his busy schedule. He was spring-cleaning, for sure, carrying old bedding out of his house and coming back a few minutes later with new materials, time and time again. Every six or seven trips he returned with food, which made me think there were babies in the nest.

Left: **Spring Storm, Mariposa Grove.** Generally growing at elevations of 4,000 to 5,000 feet (1,200 to 1,500 m), mountain dogwoods are occasionally found as high as 7,000 feet (2,100 m), as they are here in the Mariposa Grove, hiding out in the shadows of white firs and giant sequoias.

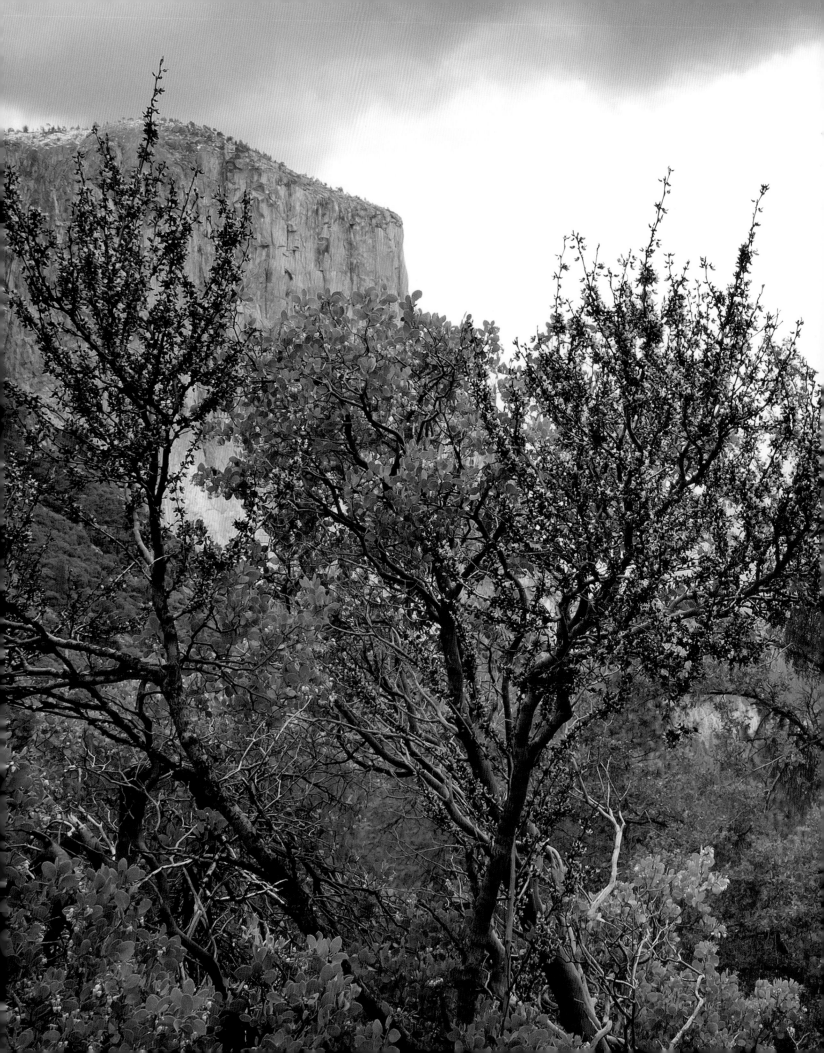

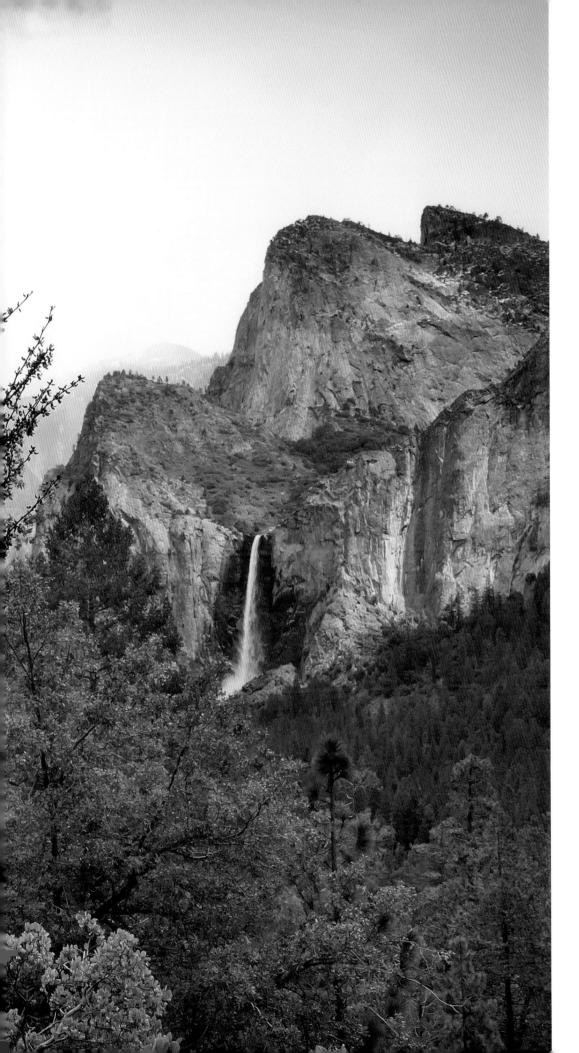

Redbud at Tunnel View.
I never expected to see a redbud tree all the way up at Tunnel View as they're usually found at much lower elevations, but there it was. I wasn't thinking snow either, but in the distance, at the east end of the Valley, it was snowing. Happy spring!

101

SUMMER

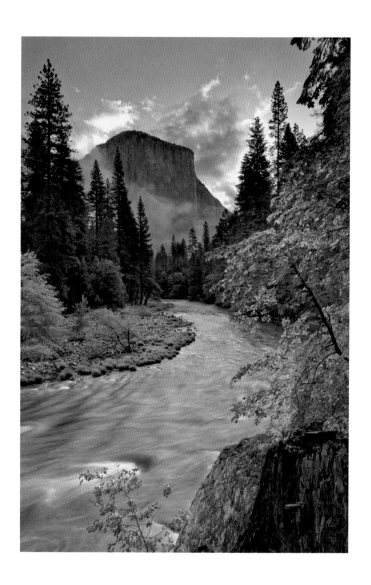

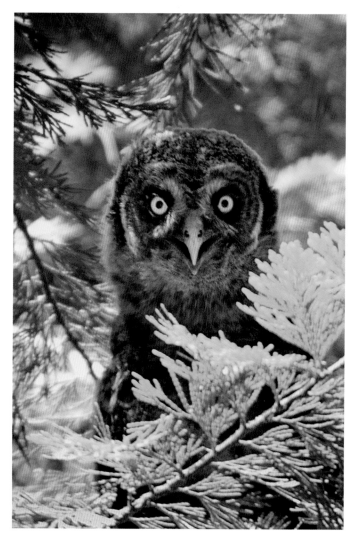

Merced River and El Capitan. It was almost sunrise. I'd been up all night photographing under the moonlight, and now it was time to get into position and wait for daybreak at the west end of the Valley. One of my favorite quiet spots along the Merced River offered the perfect location.

Great Gray Owlet. Of all the North American owls, the great gray is the largest. Yosemite is home to two-thirds of California's population and this young owlet had just fledged. I missed its flight from the nest but heard its excited squeak and looked up to find it.

Opposite: **Mule Deer in Tuolumne Meadows.** Tuolumne Meadows is one of the largest subalpine meadows in the Sierra Nevada. After eyeing the mule deer in this photo, I walked all the way around the meadow to get the Cathedral Range in the background. My patience was rewarded when the doe turned and smiled at me. Click!

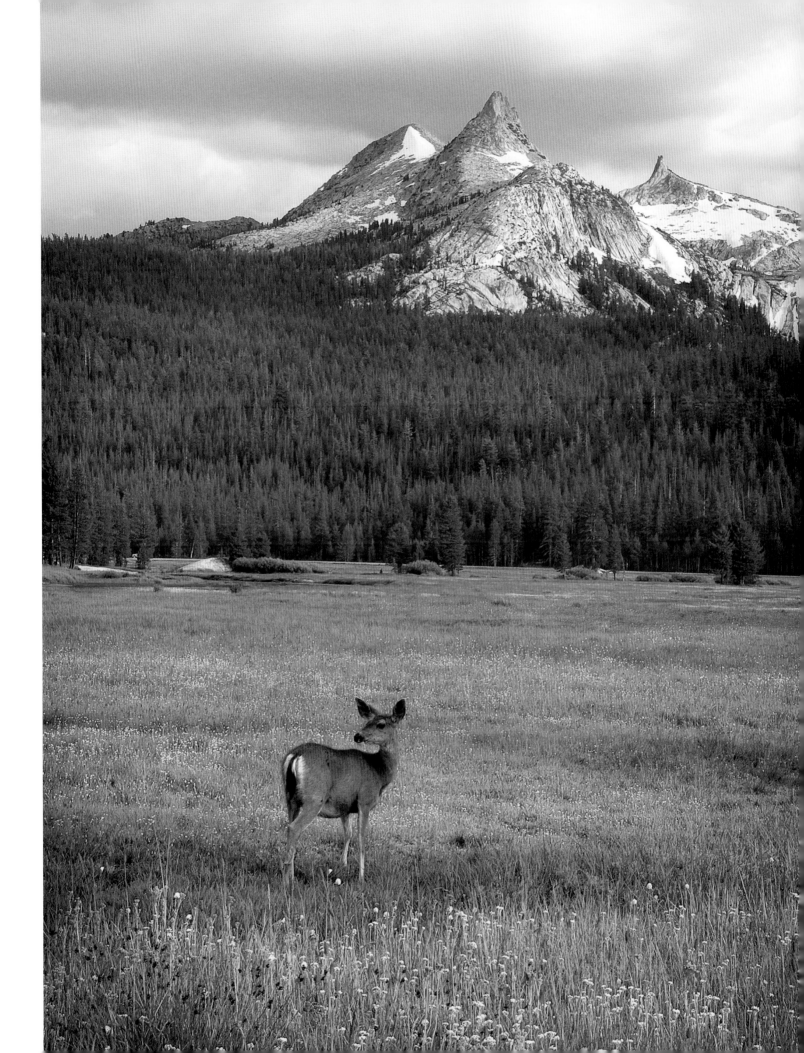

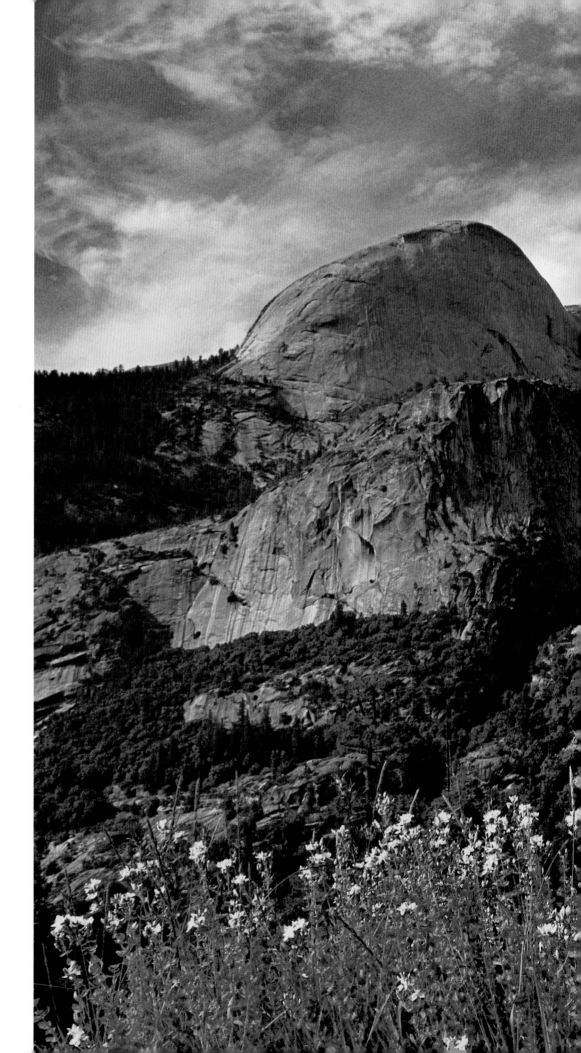

A View of Nevada Fall.
This scene may suggest
springtime, but wildflowers at
this elevation show their true
colors in midsummer. The
photograph was taken in July
from the John Muir Trail, as
I was returning from my first
summit of Half Dome. For a
faster and more direct route
back to the Valley, I could
have taken the granite "giant
staircase": the switchbacks
to the left of Nevada Fall and
just beneath the shoulder
of Liberty Cap. My knees
said, "No!"

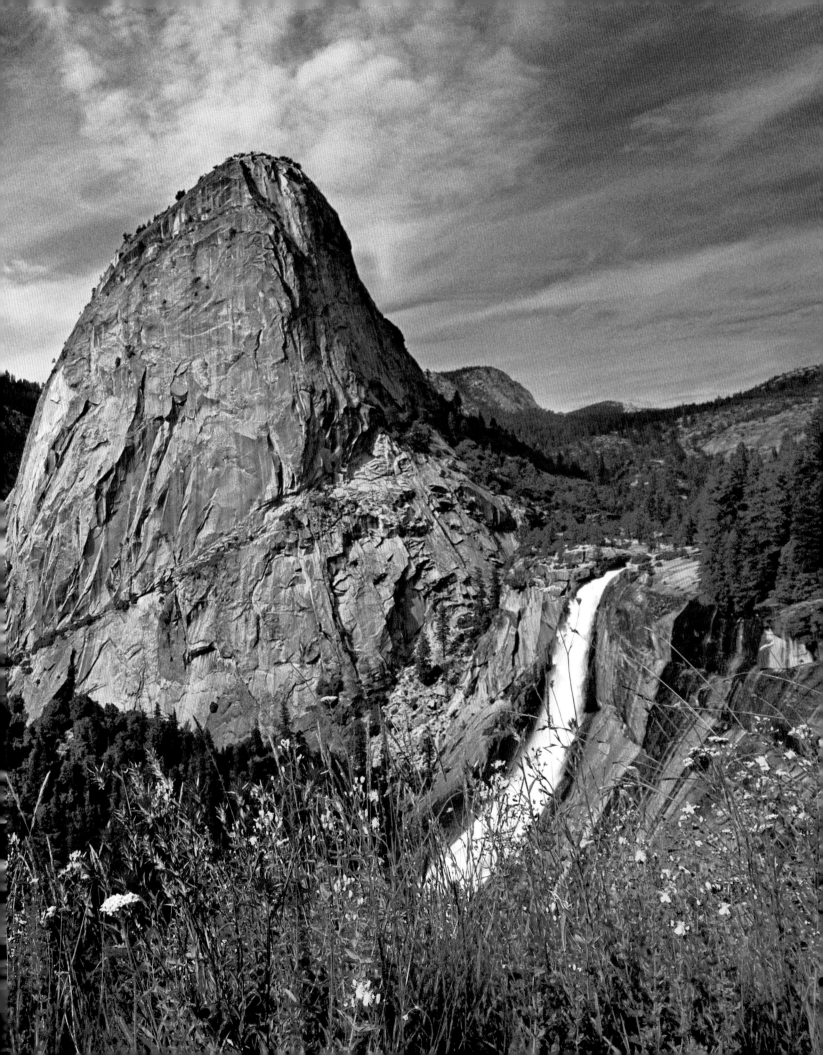

Corn Lily. Interesting designs and patterns are everywhere in nature. I especially love those in corn lilies before they bloom, when the leaves are just beginning to open up. They can be found on the edges of meadows at higher elevations, usually in mid-July.

Opposite: **Twenty Minutes in the Life of a Ladybug.** While exploring the corn lily plant, I noticed a little itty-bitty red spot on the greenery, which turned out to be My Fair Ladybug. I followed her in, around, on, over, above, between, and behind the leaves for almost half an hour, all the while hearing a marching tune in my head. Da-dum da-dum da-dum-dum . . .

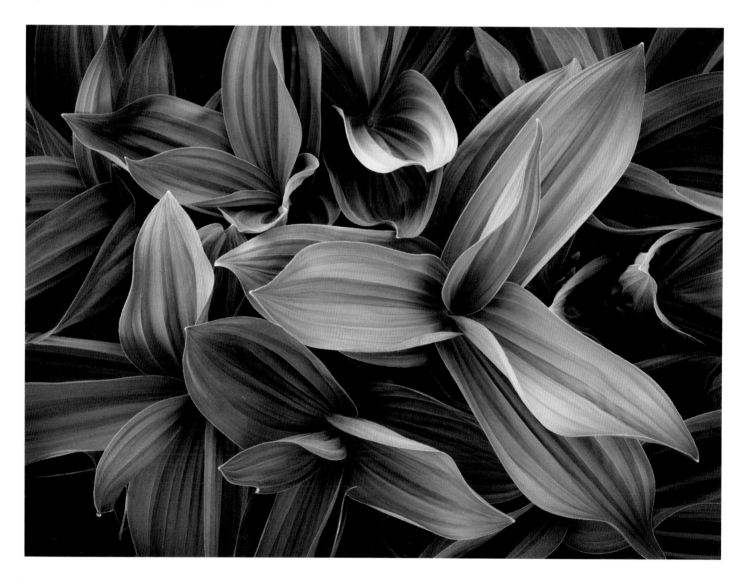

Next spread: **Summer Storm and Rainbows.** I was at the right place at the right time. One of the oldest Yosemite photographs in my archive, this shot was taken on one of my early visits to the park. A passing storm brought with it one of the brightest rainbows I have ever seen. A second rainbow is trying to emerge on the left side. When a second rainbow appears, its colors mirror those of the first. And, obviously, your chances of finding a pot of gold have doubled.

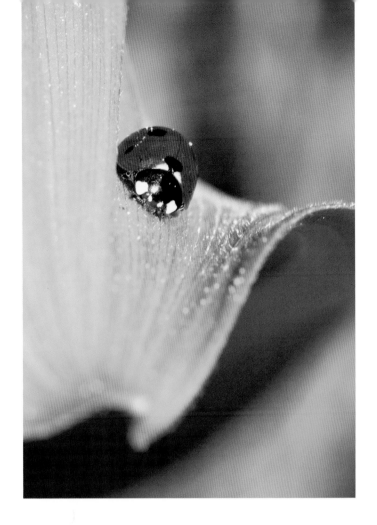
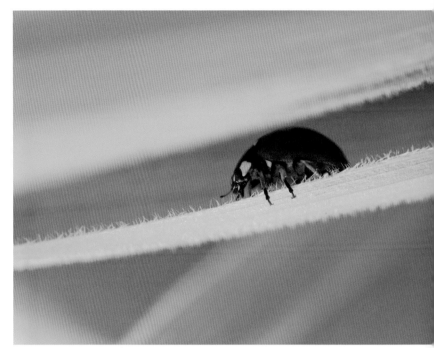
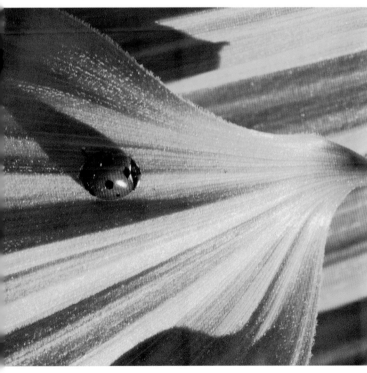
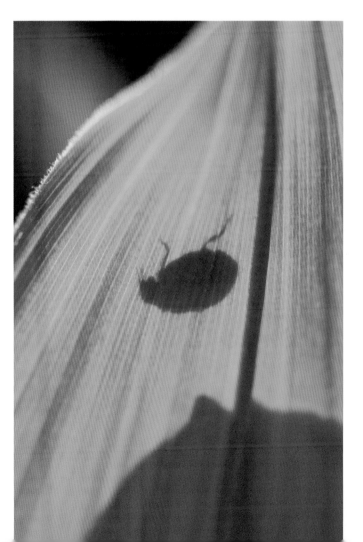

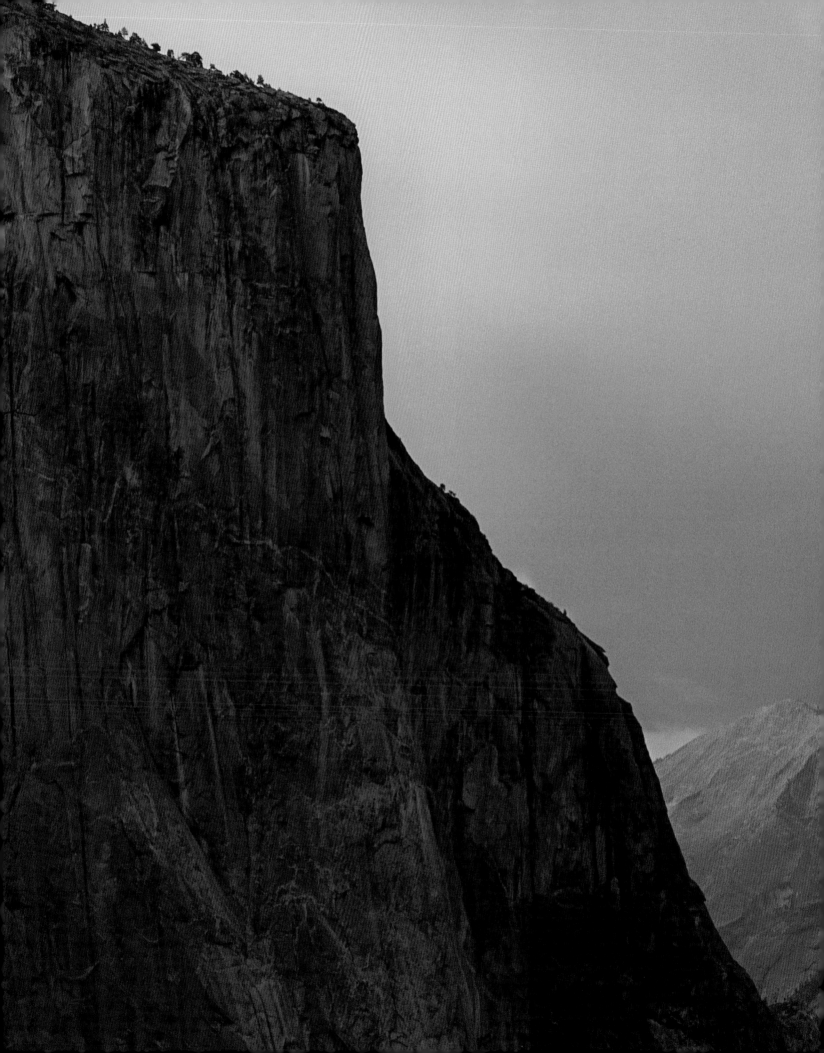

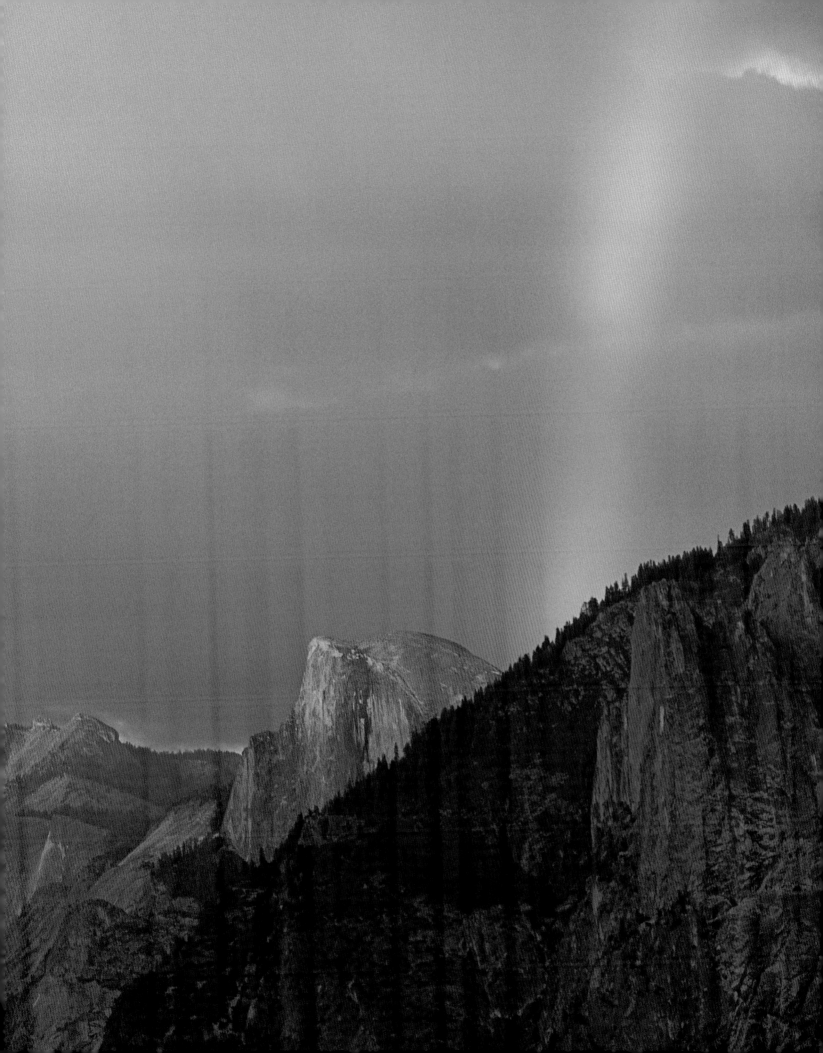

AUTUMN

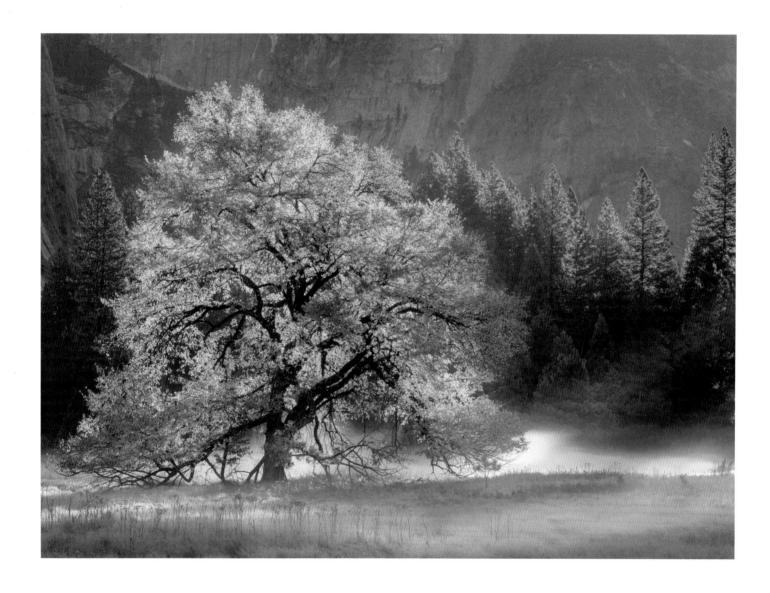

Mystic Meadow. James Mason Hutchings, an innkeeper in Yosemite in the 1860s and 1870s, planted a row of elm trees in Cook's Meadow, but now only one remains. It is by far the most photographed tree in Yosemite Valley.

Opposite: **American Dipper.** I was photographing fall colors near Pohono Bridge when I was surprised by this little dipper hopping into the frame. One of Yosemite's year-round dwellers, the American dipper is always in motion. The bird bobs up and down and plunges below the surface of the water for a meal of insect larvae and small fishes—sometimes to a depth of 2 feet (60 cm) and for as long as thirty seconds. A swimming songbird—now that's a rarity!

Next spread: **Wawona Covered Bridge.** There are twelve covered bridges in California. Only one of those is in a national park. If I'd lived here in the 1930s, I could have driven through it, as it was on the main road from Wawona to Yosemite Valley. Instead, I ride my bike through it to get to the post office.

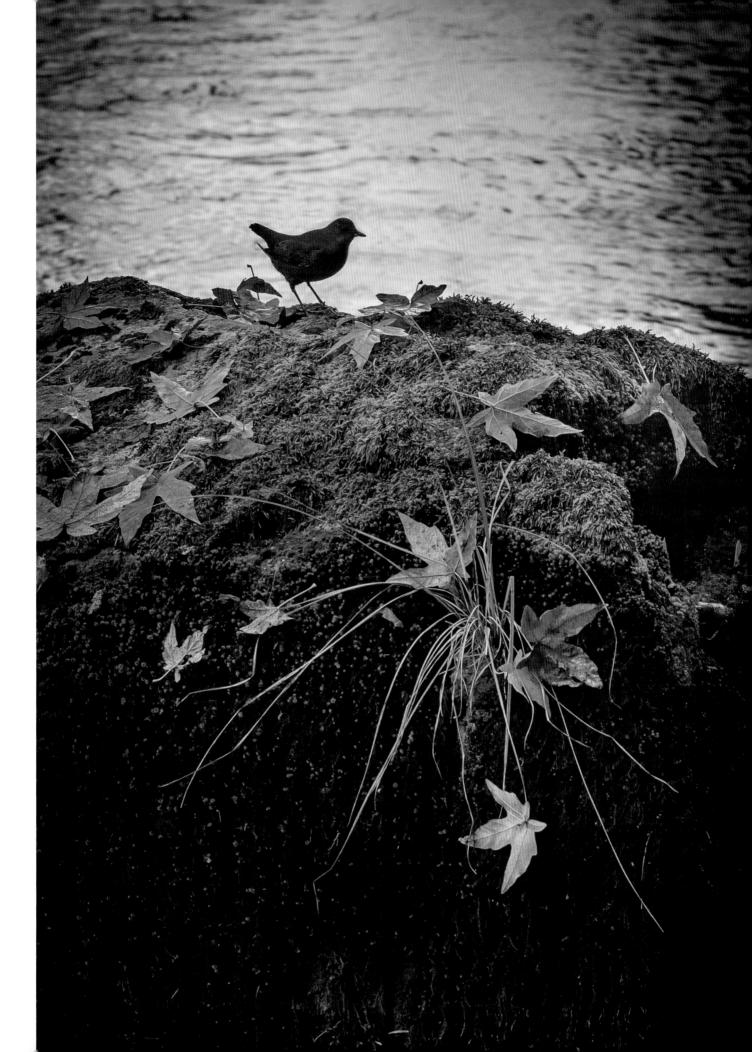

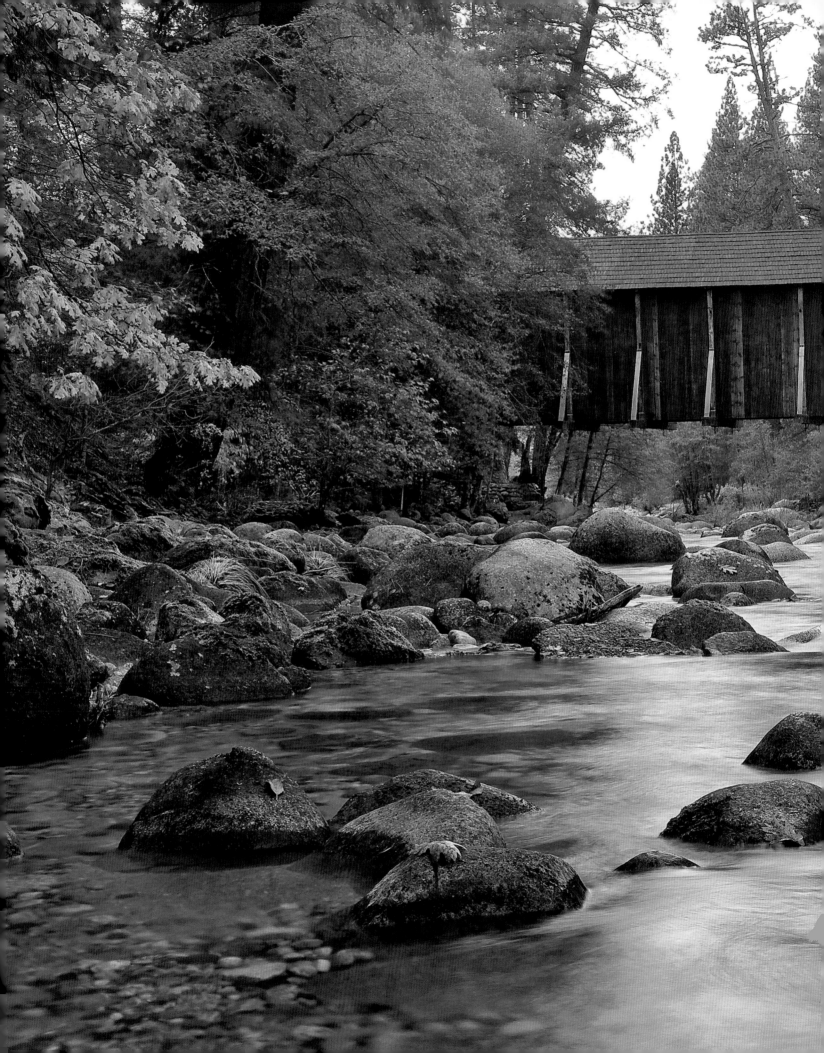

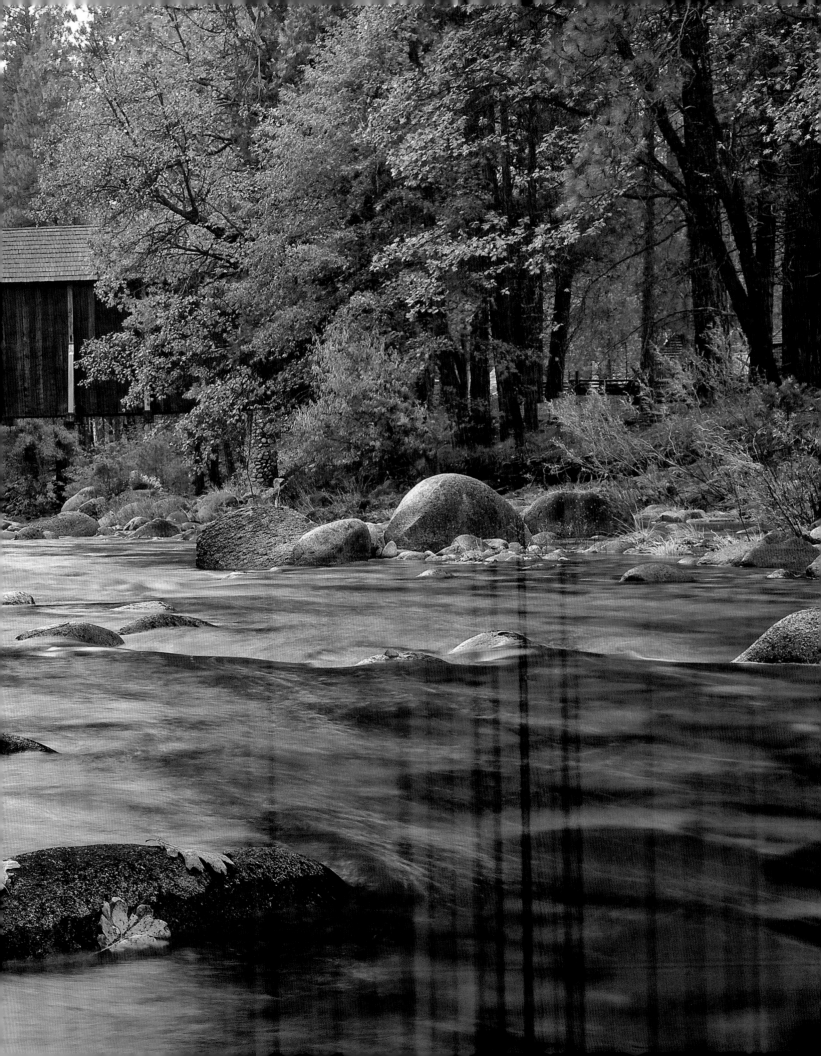

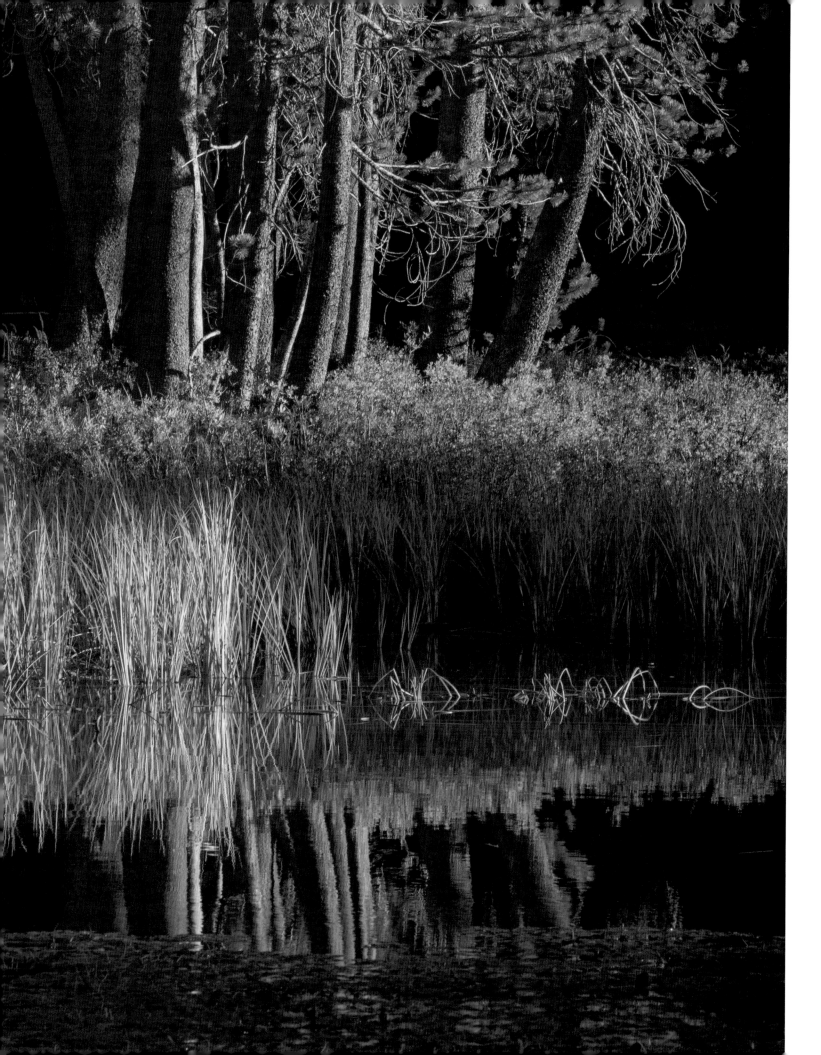

Opposite: **Western Azalea, Siesta Lake.** Siesta Lake, serene as its name implies, draws me to its tranquil shores on every trip to the high country. On this day, the bright fall foliage of the western azalea peeking over the still-green grass has quietly lifted my spirits.

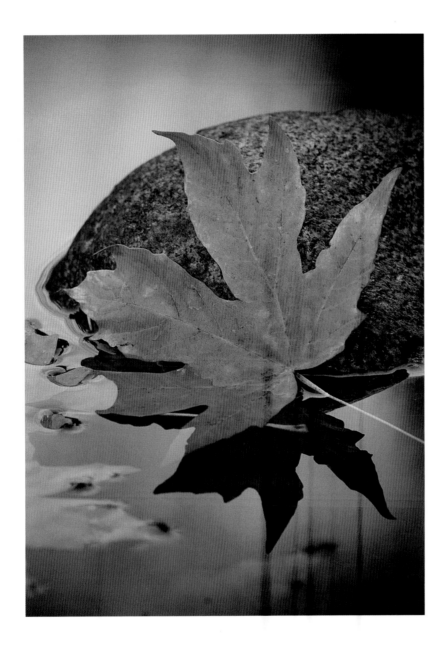

Maple Harmony. It's easy to amble for miles along the Merced River looking for small details to photograph. My favorite time to do this is in the late afternoon when warm light is bouncing off the rocks and domes. My position was really important for getting this image. I had to get my camera down low, close to the water, to capture the reflection of the maple leaf. Somehow I managed to spread the weight of my body over three small boulders in the river. It must have looked ridiculous. Oh well . . .

FINTER

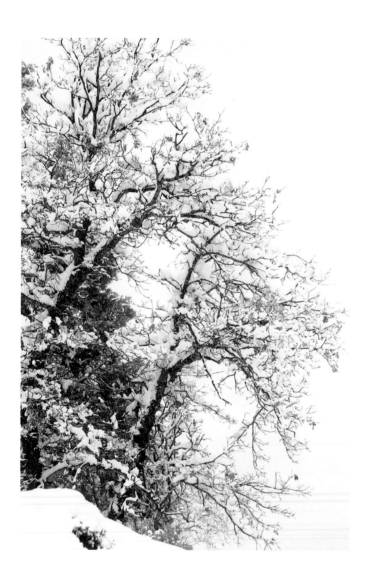

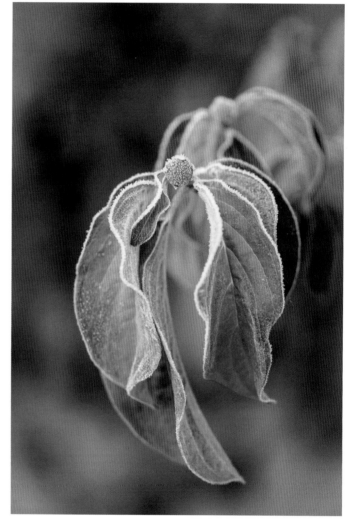

Oak Tree in Finter. Today is the day! Fall and winter have collided and the first snow has arrived, sugarcoating the bright autumn colors. This is my favorite season—and one that I refer to as "finter." It may only last a few hours, but it deserves some recognition.

Right: **First Frost.** With its crimson foliage and clusters of shiny red seeds, dogwoods are perhaps even lovelier in fall than in other seasons. And in finter, a little frost is icing on the cake. Mmmm, it looks good enough to eat.

Opposite: **Three Brothers.** Autumn was always my favorite time of year, that is, until I moved back to the mountains. The short transitional season between fall and winter offers a rare opportunity to see the best of both. An early snow gives Three Brothers reason to celebrate. It's a pastel party in the trees!

Next spread: **El Capitan, Pine, and Oak.** This ponderosa pine and the black oak have shared a home in El Capitan Meadow for over a century. By afternoon, the first snow is fading, leaving only highlights clinging to their branches. Winter will soon arrive and the deciduous trees will lose their fall colors. Goodbye, Finter. See you next year.

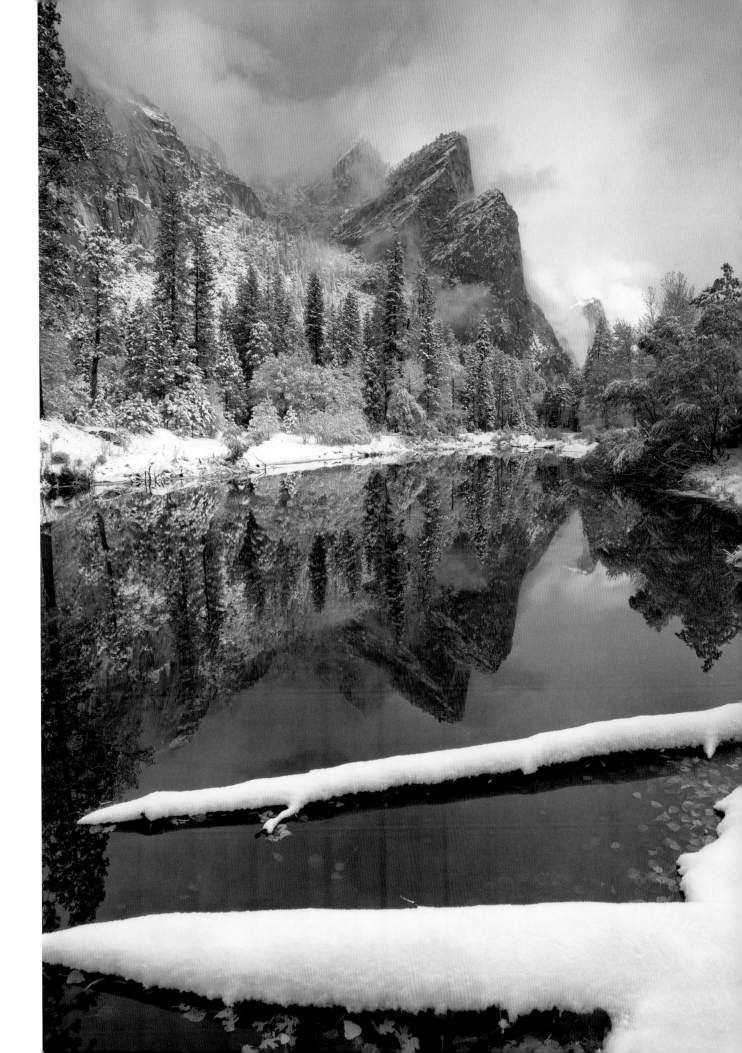

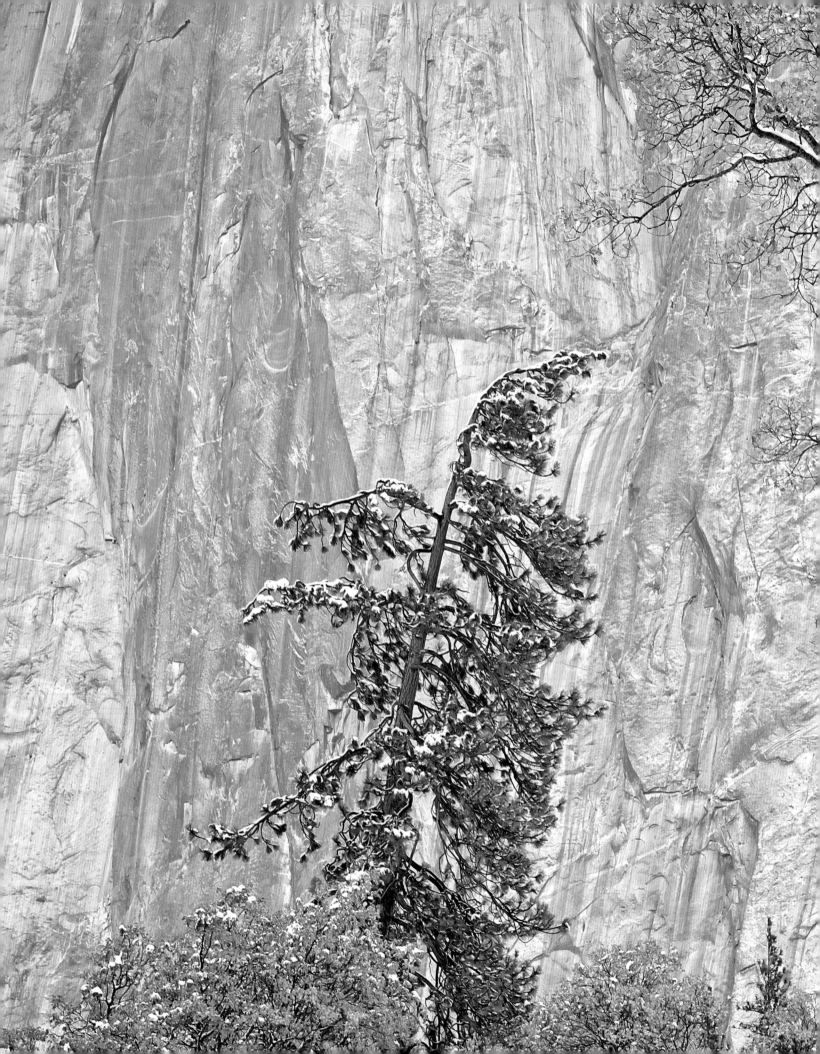

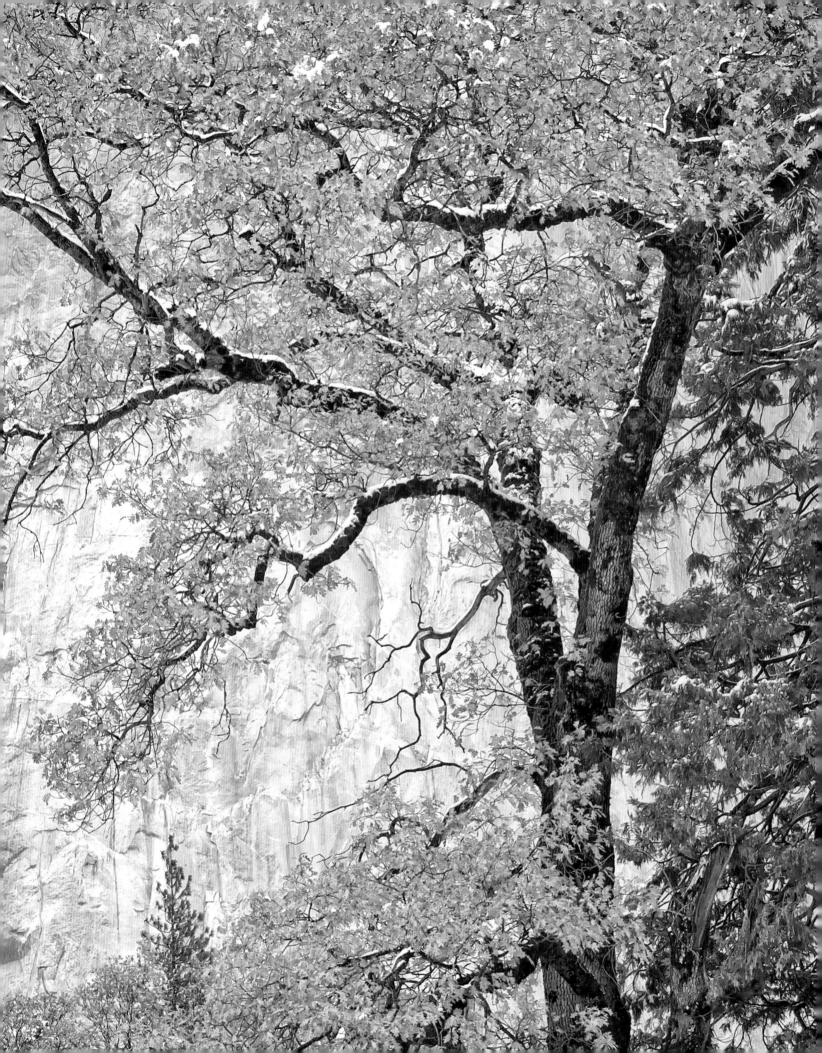

PHOTOGRAPHIC MEMORY

Dear Nancy,

I'm almost hesitant to admit this, but when I look at your photography, I'm reminded of old, tiny black-and-white photographs of my family from the late 1950s. We were hiking in Yosemite, one of the rare summertime trips we took, away from the farm and the harvests. I'm embarrassed to compare them to your inspiring images, but there's a connection. Like your photographic treasures, whenever I look at our photos, the cherished images take me to a place where nature and story meet. Perhaps because we only visited Yosemite occasionally, the family snapshots were gems I could take with me.

When I study them, I see we were dwarfed by Yosemite's huge granite rocks and towering trees. The mountains rose around us. We sat on rocks, our resting place carved out of the wild. I remember the contrasts: the expanse of open spaces and the denseness of the forests; the warmth of granite and the cool of shade; and the enormous boulders that seemed to be planted along our path. We stood on a wooden bridge spanning a creek, joining two banks and connecting my family. For a farm family, nature meant many things. We worked our land daily surrounded by nature. We understood the forces of the wild. We lived and played in the dirt and the rocks and the weather. We drew no lines between inside and outside.

I remember all this, and time amplifies the importance of these recollections. When memories transcend into stories, the simple black-and-white photographs acquire a magical power, much like your images of Yosemite. Ours were personal memories shared publicly, as if a quiet secret could find a voice. Our little moment on a trail or standing on a bridge joins with countless other images and becomes something more: a moment in common that we share with those who have also walked this land called Yosemite. That's what happens with great photography of a natural wonder. We gain memories and grow stories. We are drawn into the outside.

Nancy, thanks for your art. I'll keep my stack of simple black and whites nearby, perhaps I'll copy them to use as bookmarks, flagging my favorite images you've captured throughout this book.

—Mas

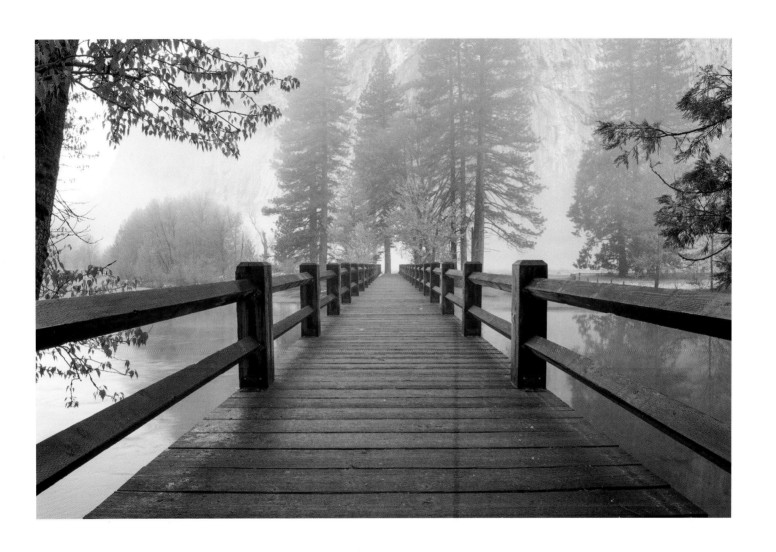

Swinging Bridge (That Doesn't Swing). Mas, do you have any memories of your family standing on this bridge? It was here that I took the Yosemite Falls photograph on page 29. I wonder if we have ever stepped in the same footprints?

BLACK AND WHITE

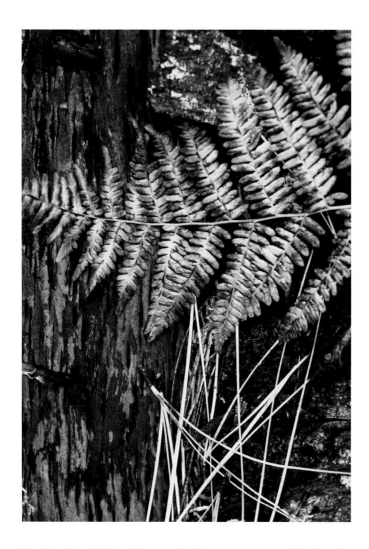

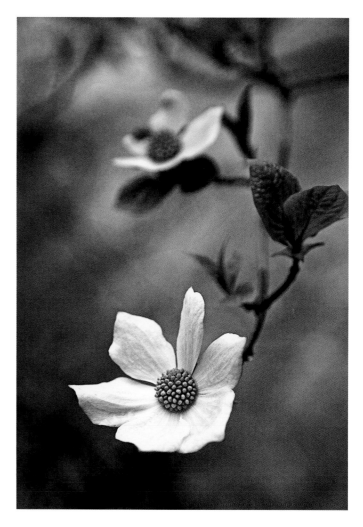

Bracken Fern. Without the use of color, our senses are heightened to the presence of line, texture, and form. Before color photography was possible, photographers relied strongly on these elements to express their artistic vision. Stripped of its golden fall color, the intricate detail of the bracken frond comes forward.

Right: **Pacific Dogwood.** In the spring, the iconic dogwoods bloom all about the Valley in abundance. They attract the eye and lift the heart. You can find dogwoods around every corner or hiding deep in the forest. Their showy scales, or bracts, seem to float down from the sky.

Opposite: **Chilnualna Falls.** Chilnualna Falls is made up of three main falls and many, many cascades. This is the same creek as in "The Power of Spring" (page 20), with a completely different appearance a few months later. When water levels are low, my ledge is accessible and I can hang out with my feet over the precipice. In July, the water seeks out every nook and cranny, uncovering its unique personality. This is when I most enjoy photographing it—and when it is most recognized.

Next spread: **Tunnel View.** This photograph has everything I could ask for. Soft afternoon light, an engaging sky, highlights on the icons, foreground shadows, and my favorite Tunnel View tree in silhouette. The contrast in textures made for a great black and white image.

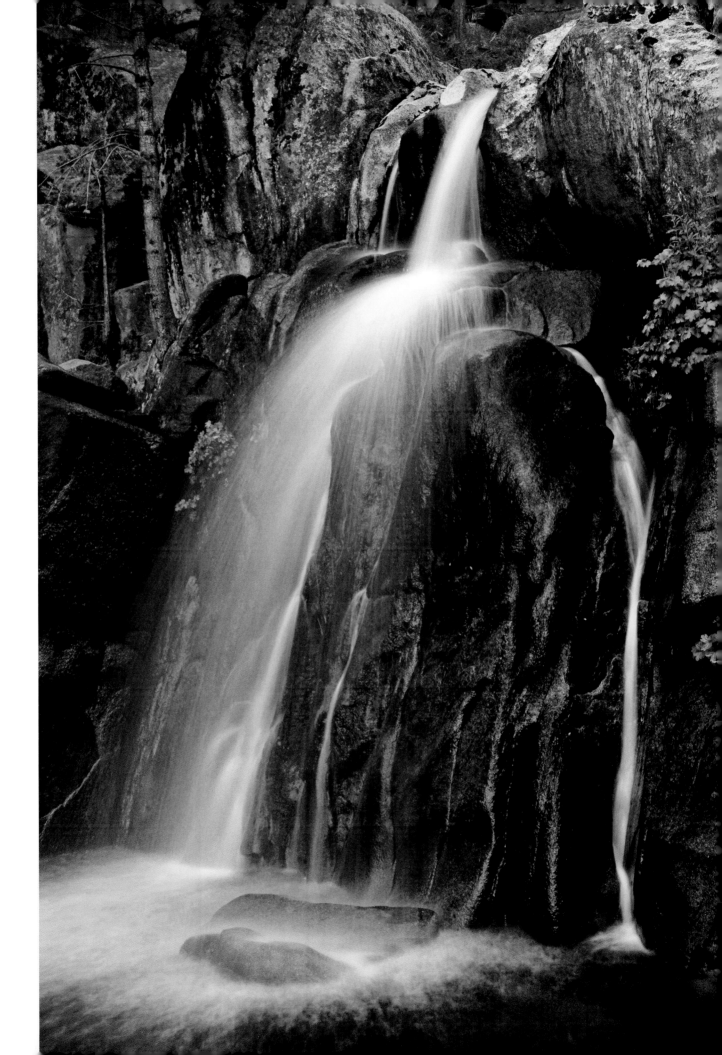

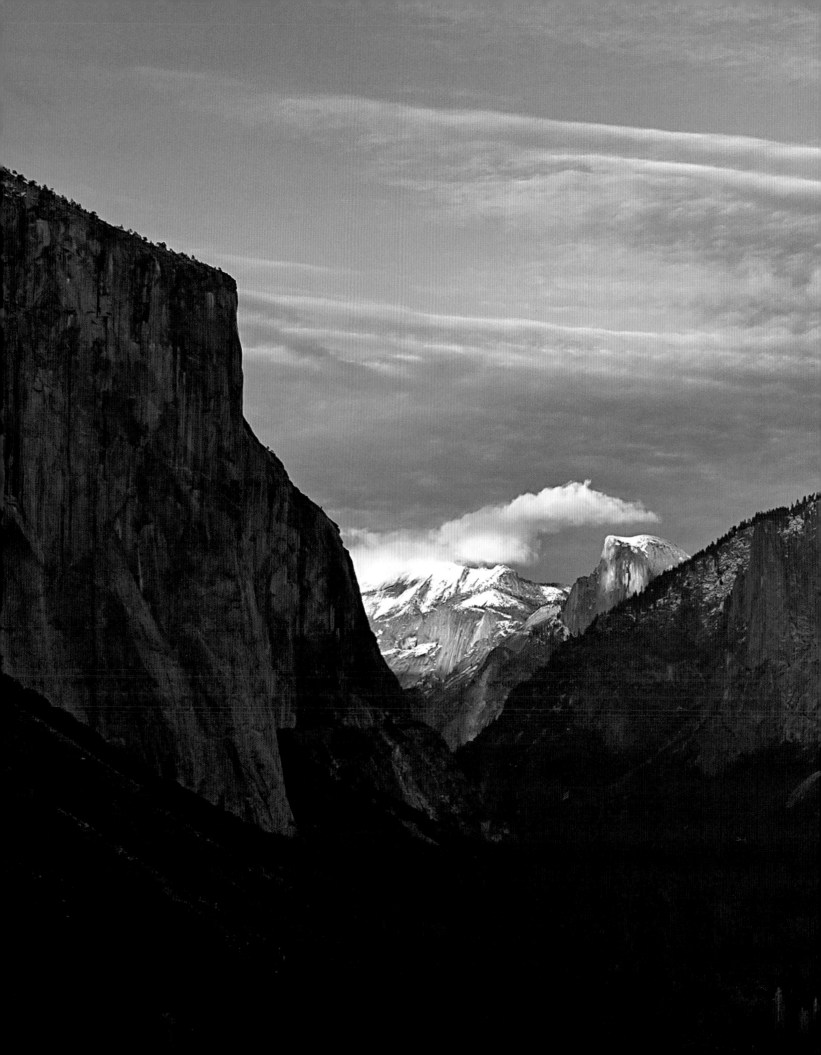

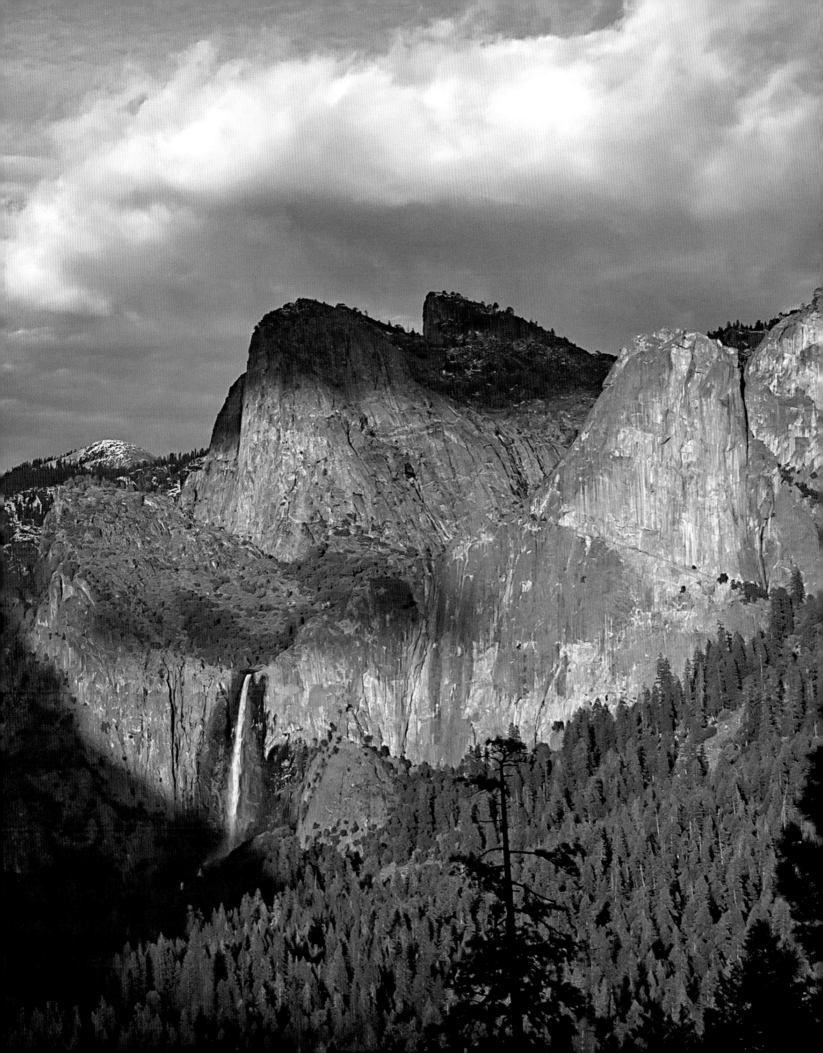

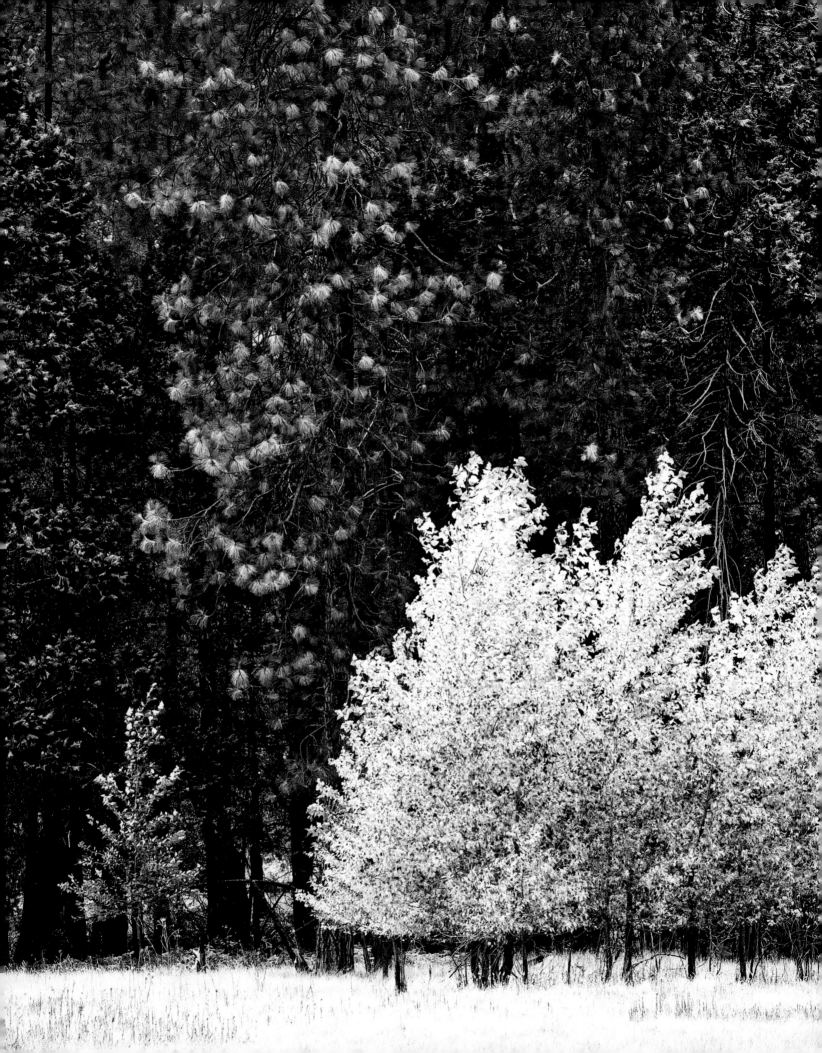

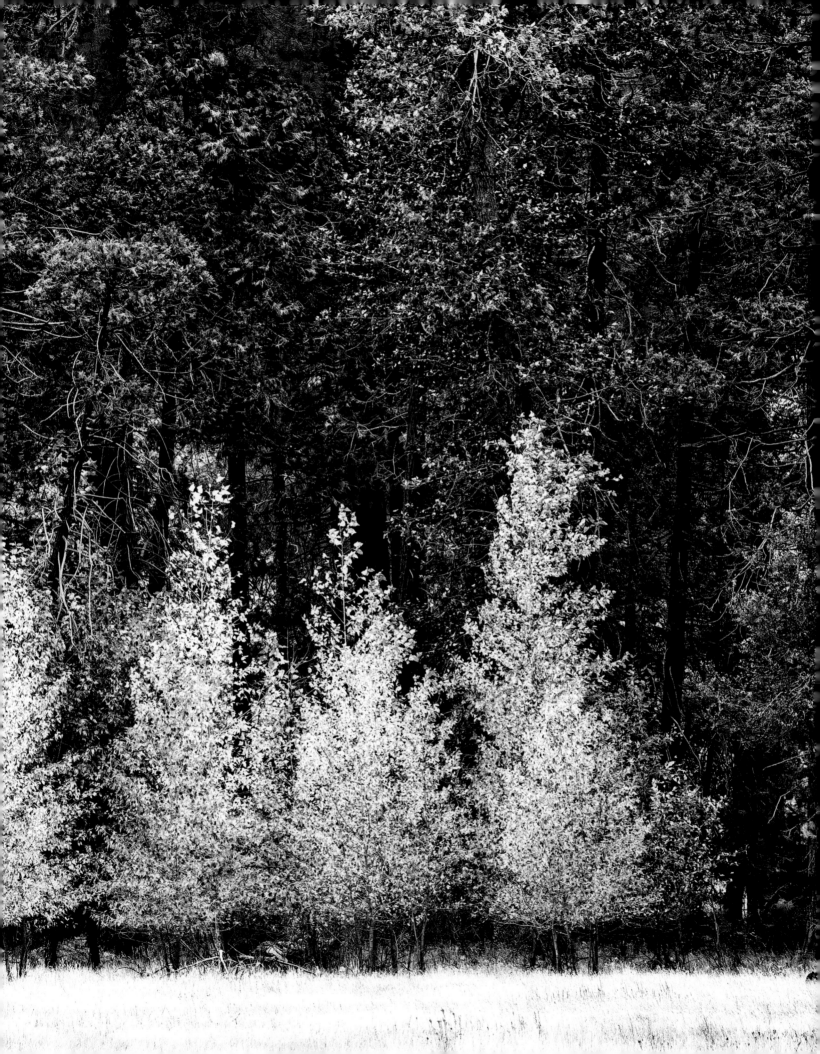

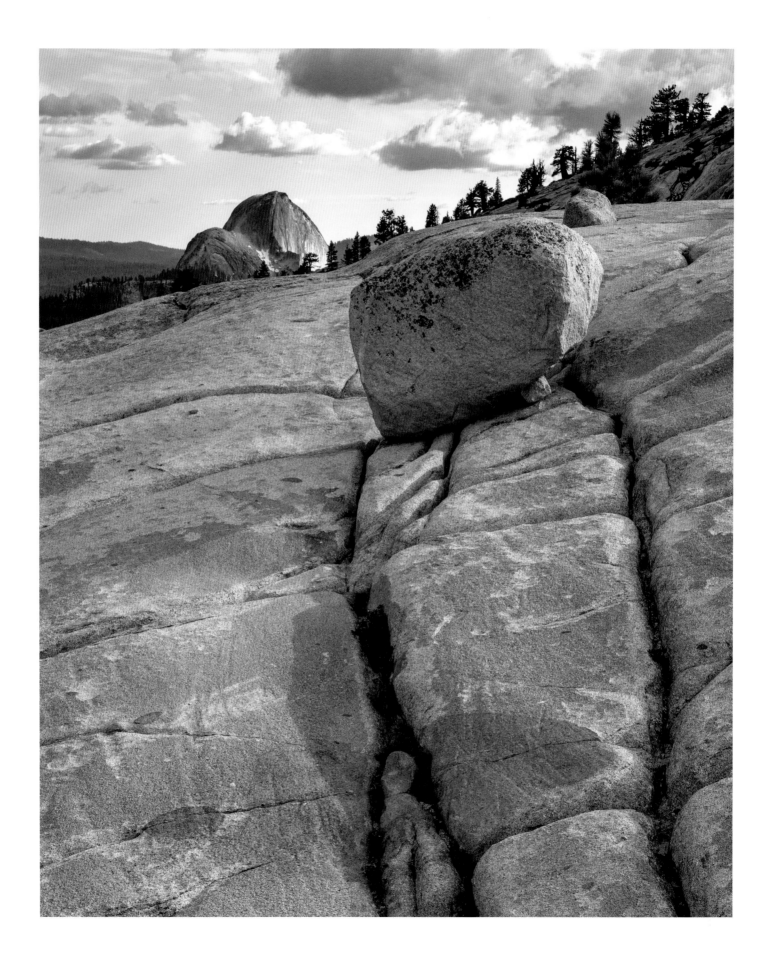

Previous spread: **Cottonwoods.** The contrast of light and shadow attracted me to this tiny grove of cottonwood trees which stand quietly in the corner of Bridalveil Meadow, in the western end of Yosemite Valley. Though I'd passed this spot hundreds of times, the luminosity of the fall foliage definitely caught my eye on this day.

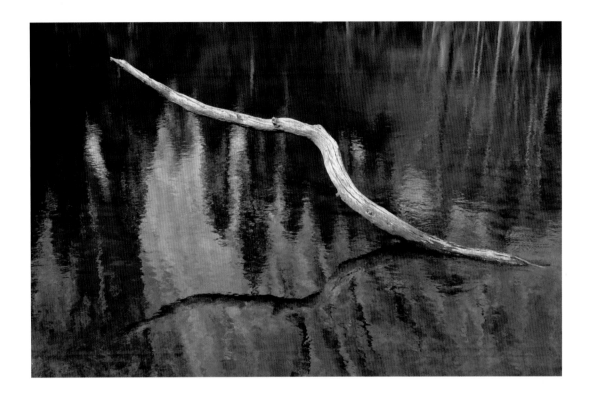

Opposite: **Olmsted Point.** Olmsted Point is famous for offering a view of the east shoulder of Half Dome, seen in the background of this photo. Glacial pressure created many of the bold forms, lines, tones, and textures of the park's granite. The glaciers also dropped off large boulders as they retreated. These rocks, known as glacial erratics, provide mute testimony to the power of nature's forces.

Above: **Simple Stick.** It was a bright but overcast day, so I chose to photograph details along the Merced River instead of the larger iconic scenes. As much as I tried to find another subject, my eye kept coming back to this stick—a simple subject with great light. I would say this is an example of stick-to-itiveness.

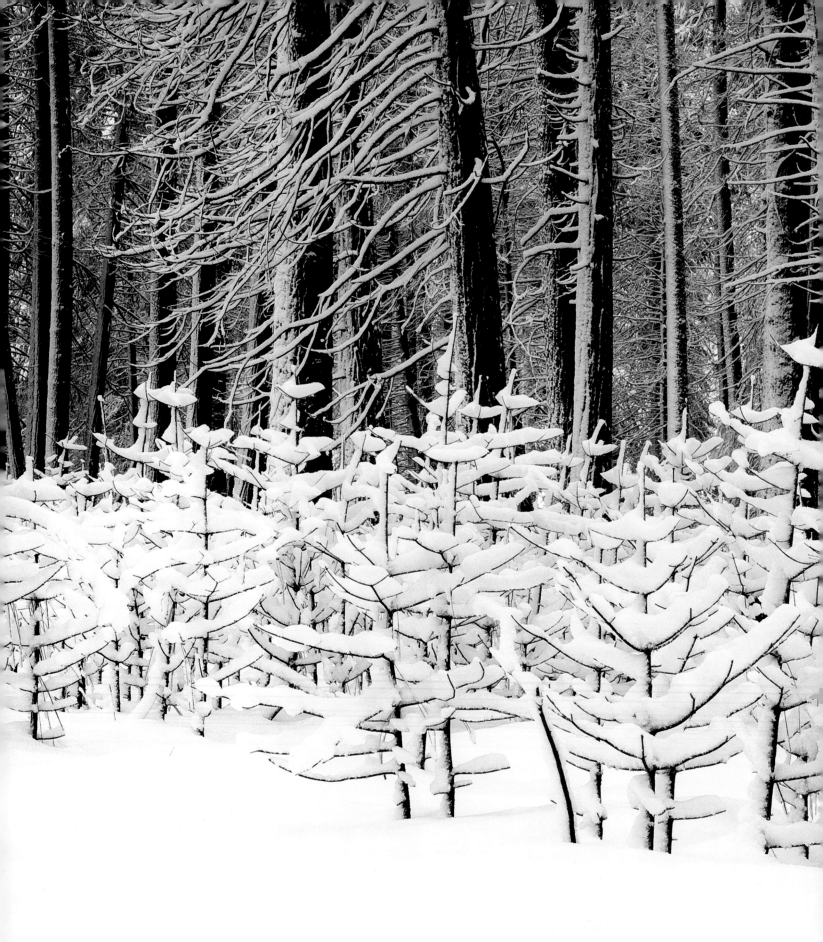

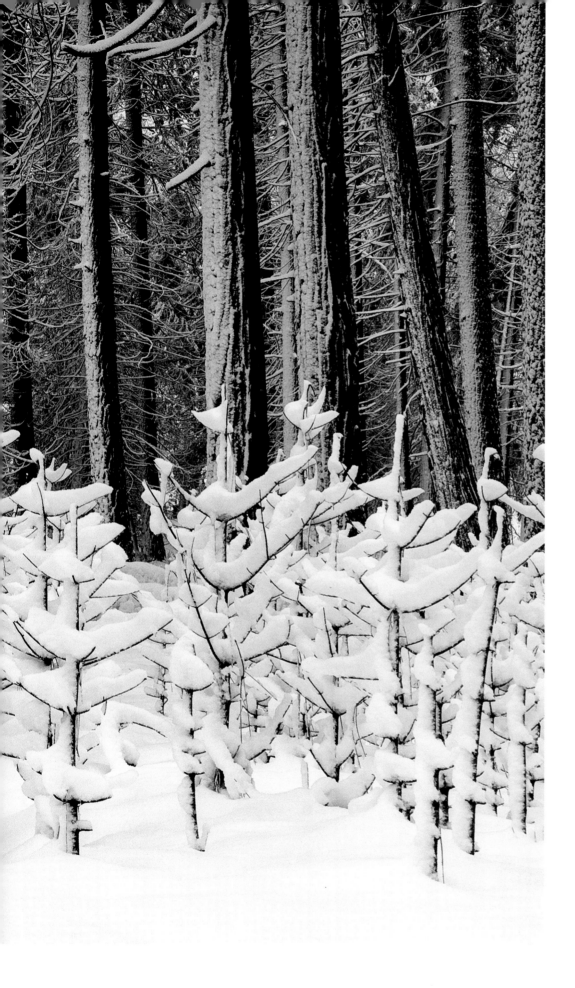

Snow Babies. I pre-visualized this shot more than any other in this book. A prescribed fire on the Valley floor had left these tiny pines bare but still standing, and in stark contrast with the larger skeletal pines behind them. All that was needed was a fresh snow. Black and white finally materialized when the biggest snowstorm of the year arrived—so much snow in fact, that I had to throw my gear, and my body, over a chest-high frozen wall left behind by the plow just to take the photo.

NIGHT

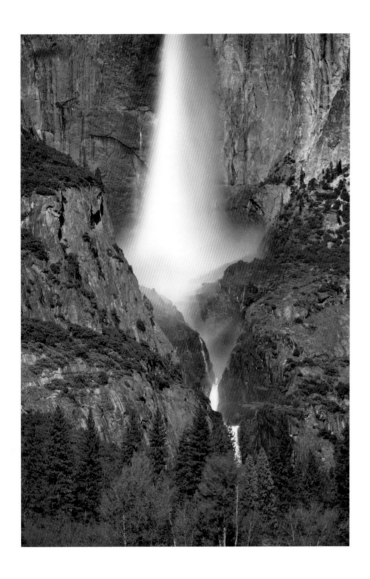

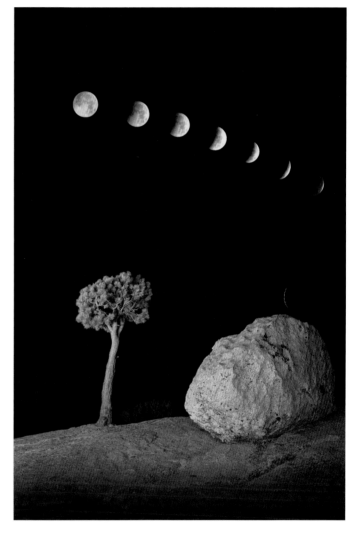

Lunar Spraybow. Rainbows that appear in waterfalls are common by daylight, but much rarer at night. John Muir called these remarkable colors seen by the light of the full moon, "lunar spraybows," also known as lunar rainbows or moonbows. The glow of this lunar rainbow is in the spray of Upper Yosemite Fall. The photo was taken at two in the morning on one of the all-night photography outings I'm prone to.

Lunar Eclipse. Ansel Adams said, "You don't take a photograph, you make it." I made this photograph by combining eight different images taken on the same night from Olmsted Point. I painted the rock and tree with my headlamp during the idle fourteen minutes between moon captures and shivers.

Opposite: **John Muir's Front Yard.** Under a full moon, I exposed this scene for forty-three seconds as I lit up some of the less illuminated areas with a flashlight. John Muir was able to build a cabin and a sawmill very near this location. Not a bad commute—and the views don't get much better than this.

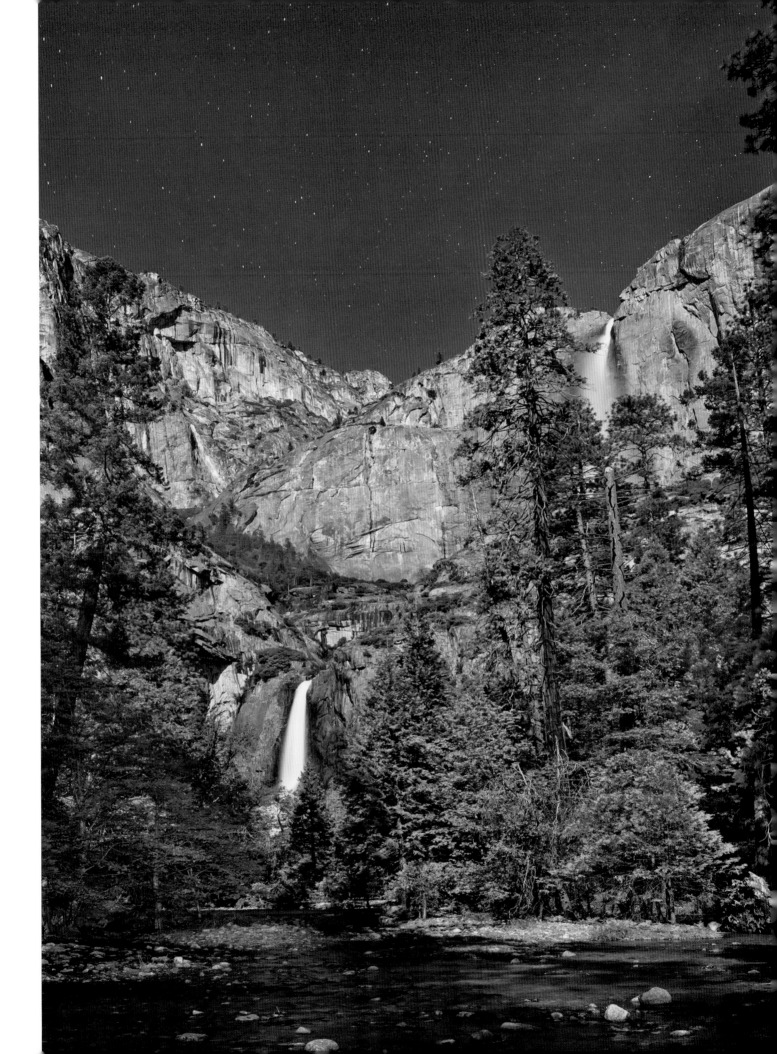

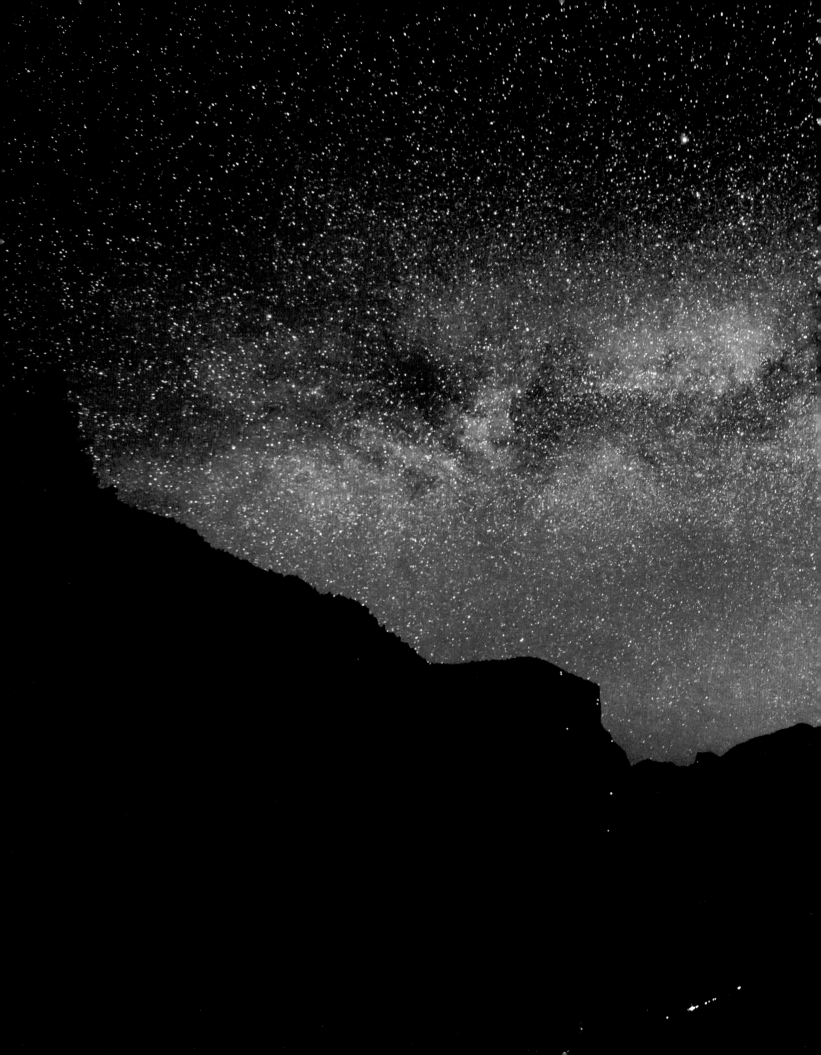

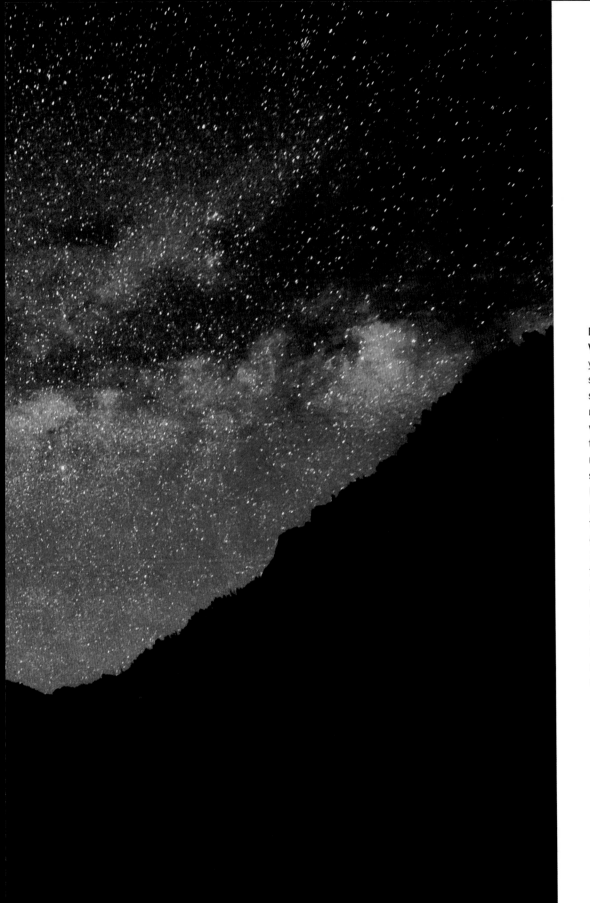

Milky Way over Yosemite Valley. Line and form are all you need to discern that this silhouette is the incomparable skyline of Yosemite Valley, recognizable around the world. While the Valley seems tranquil at night, Yosemite never sleeps. As bright as stars in the sky, the lights on El Capitan belong to climbers partway through their three-to-five-day ascent to the top. You can also see a climber on Half Dome and cars on their way through the Valley. John Muir said, "When we try to pick out anything by itself, we find it hitched to everything else in the Universe." Even the magnificence of Yosemite is dwarfed by the Milky Way on this moonless night. Look up!

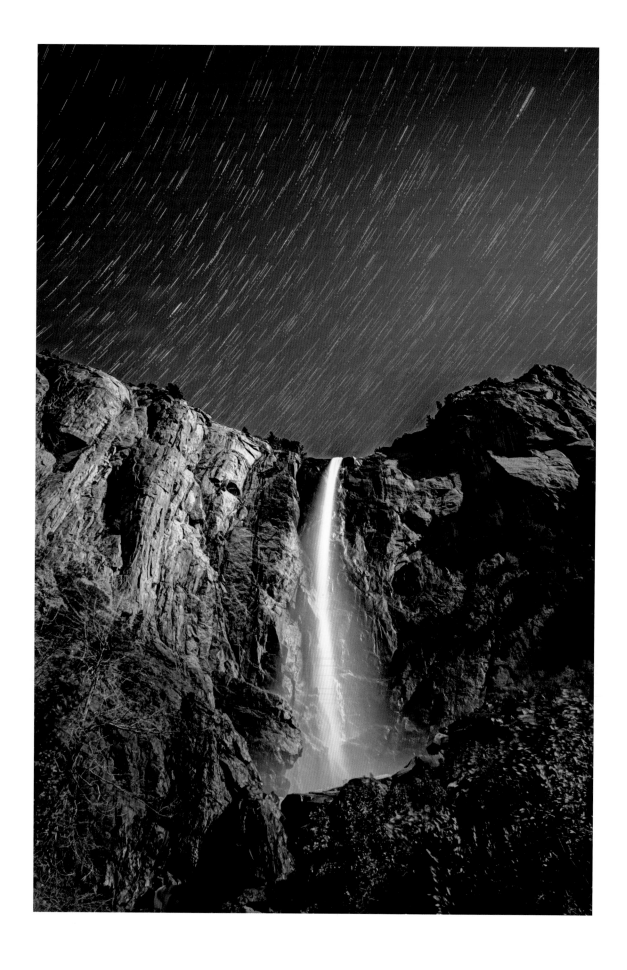

Opposite: **Star Trails above Bridalveil Fall.** This is a compilation of thirty-second exposures taken continuously over the course of a half hour, illustrating our shifting view of the night sky. The photographic technique here is called "star stacking." While waiting out the sequence of photographs on the rocks below Bridalveil Fall, I sipped my chai tea and watched the moonlight glisten off the cliffs, domes, and waterfalls across the Valley.

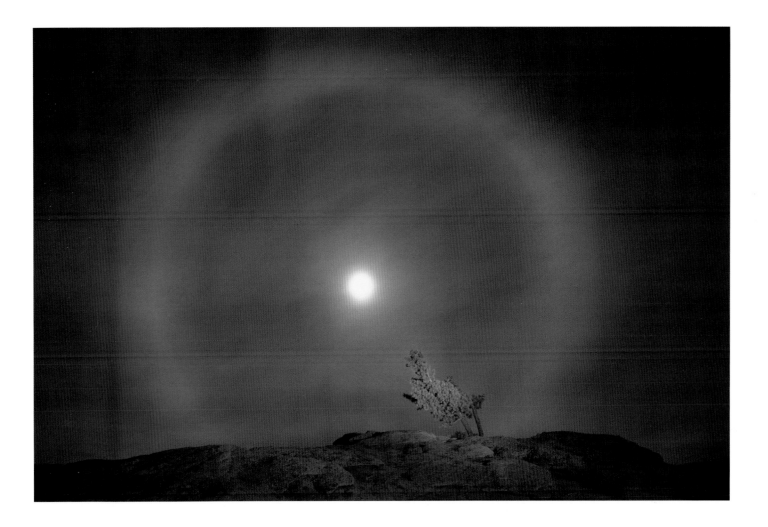

Above: **Jeffery Pine and Lunar Halo.** When conditions are right, the moon can produce a fascinating optical effect known as a lunar halo or moon ring, caused by light passing through ice crystals high in the atmosphere. I made this photograph atop Sentinel Dome after photographing an eclipse with a couple of my young students; lighting the foreground and Jeffery pine was a group effort. A lunar halo is a good indicator that a storm is on its way. Folklore has it that the number of stars inside the ring is the number of days before bad weather will arrive. It rained two days after I took this photo.

Next spread: **Setting Supermoon.** Any full moon that coincides with the time in the moon's orbit when it is closest to earth is considered a supermoon. In 2014, the largest supermoon occurred on August 10. When my alarm rang, I jumped out of my cozy sleeping bag, ready to chase the huge setting moon up on Tioga Road. As I caught up to it just west of Olmsted Point, it appeared closer than 221,000 miles.

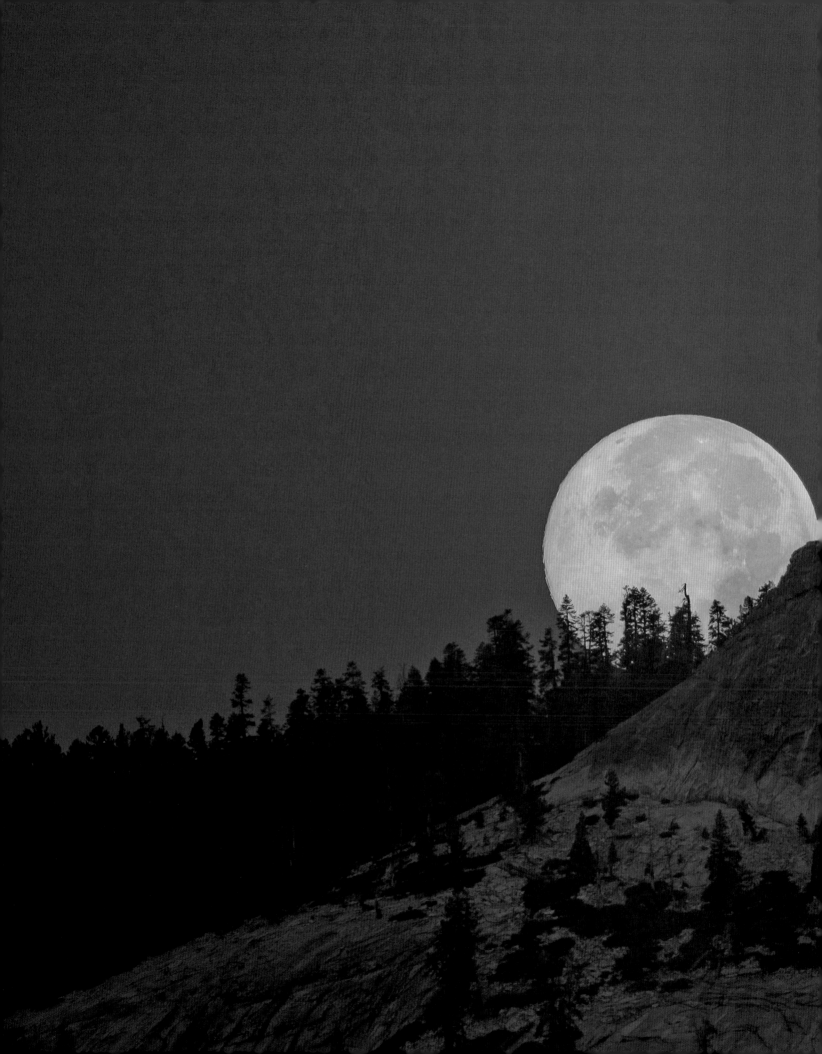

ACKNOWLEDGMENTS

MY PARENTS, Mary and "Red" Robbins, taught me from an early age to enjoy life and the creative process. Our house was always the hub of the neighborhood, where music, dancing, and projects were the norm, sometimes involving the whole community. It was common for a photograph or an 8mm movie to be made to record the event. While taking one of those films to the drive-through Fotomat with my mother, I was handed an entry form for a drawing. The prize was a Kodak Instamatic 124 camera. Wow! How many entries could I make? One a day. No purchase necessary. I was eleven. I rode my bike to the Fotomat every day for a month with a new entry. Winning that camera put my feet on the path I still follow.

The very first time I met Rick Kingsland, he asked me, "Where is your book?" Eight years later the book is reality, and it is due to him that this project was initiated. Thank you, Rick, for your continuing support of my craft, and for believing in me enough to make this book possible. Also, special thanks to Greg, Jennifer, and Chad Johnson, my Yosemite family, for their generosity and friendship. To Rikki Alley, "Yosemite" Pete Smith, and Nancy Thompson, who were instrumental in my move to Yosemite, I will be forever indebted. Four friends leaned over my shoulder and put in their two cents, adding up to way more than eight cents: Kim Ellis, Al Joyal, L. Anne Molin, and Dan Williams: you have made my life richer. To my student, Gregory Royse, who helped align Bridalveil's stars: you rock! Thanks to my family for their patience while I devoted myself to this project; you are always in my thoughts and I'll be seeing you soon!

It is a great honor that Yosemite Conservancy chose my work to adorn their shelves. Thank you! To Mas, it is a privilege to share this space with you. My sincere appreciation to publishing manager Nicole Geiger for shepherding this book. Gratitude is due to Nancy Austin, for her talented design work, and to Jasmine Star, for skillful copyediting.

Finally, thank you to the inspiring people I've met in the park and have formed friendships with, and the cheerful souls I've met along the trail.

—Nancy

• • •

YOSEMITE CONSERVANCY is grateful for the generous support received for this book from:

Debra and Dale Ashlock
Kim and Tom Coull in memory of
 Tom and Martha Coull
Faith and John Hershiser
Roxanne Janson
Maureen Lahiff
Christine Masuzumi
Chris A. Schneider
Clifford J. Walker and Karina Jostol

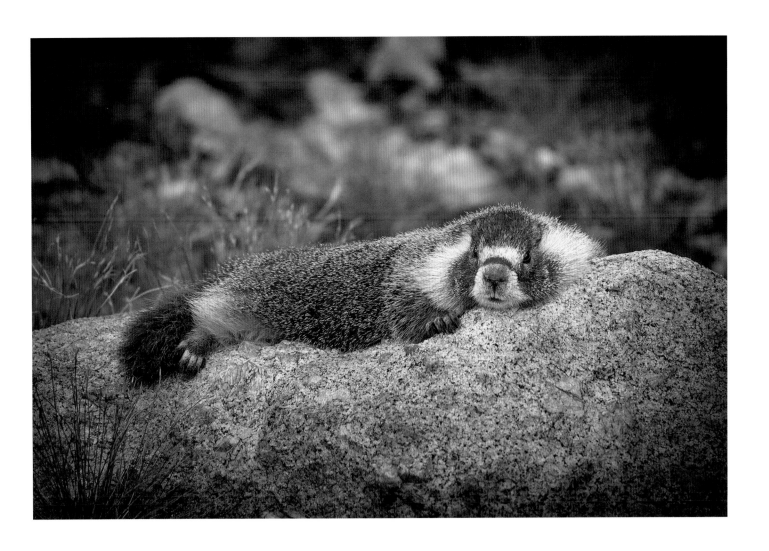

Marmot. I'd like to thank this yellow-bellied marmot for coming out and posing for me. Although our acquaintance was brief and I ultimately disappointed him by not sharing my lunch, if he ever reads this book he'll see that he was much appreciated.

Published in the United States by Yosemite Conservancy.
All rights reserved. No portion of this work may be reproduced
or transmitted in any form without the written permission of
the publisher, except in the case of brief quotations embodied in
critical articles or reviews.

YOSEMITE
CONSERVANCY.

yosemiteconservancy.org

Library of Congress Control Number: 2016938821

Design by Nancy Austin

Hardcover ISBN 978-1-930238-71-8 / Paperback ISBN
978-1-930238-72-5

Printed in China by Qualibre

1 2 3 4 5 6 – 20 19 18 17 16

MIX
Paper from
responsible sources
FSC® C018479

Horsetail Fall, Afterglow:
Moment by moment, Yosemite is in constant change. As the evening turns to night, the scene can alter dramatically. If we could take this chunk of time, a three hour experience, and show it in a still photograph, what would it look like?

I stood in the shadows of 100–foot (30 m) pine trees as the nearly full moon rose over Glacier Point, first illuminating the higher cliffs on the north side of the Valley and eventually bringing its light to the river and trees across from me. Except for the whirl of the restless Merced River, all was quiet. Less than an hour earlier, four hundred photographers could be heard chattering with excitement that Horsetail Fall had put on a great show. Without moving my camera, I remained there alone enjoying the moonlight, waiting for a few stars to appear so I could take my last shot of the evening. The photograph I ultimately created is a compilation of three separate images. It was a gathering of time, a gathering of the senses.

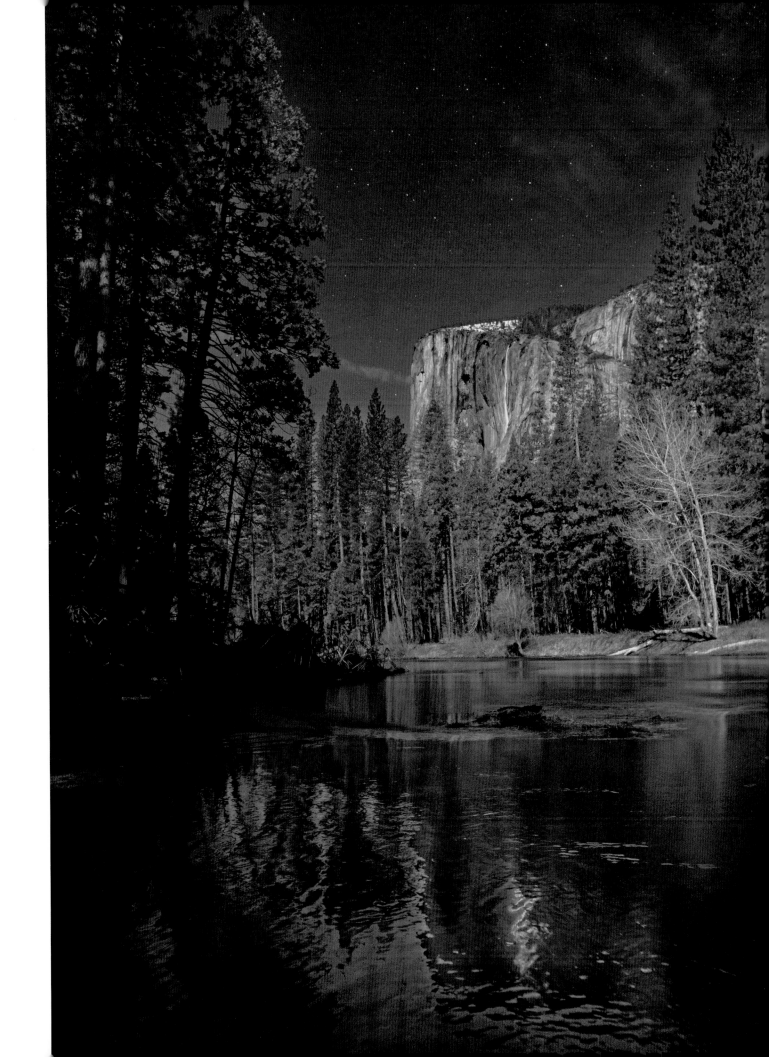

YOSEMITE
CONSERVANCY®

Providing For Yosemite's Future

Through the support of donors, Yosemite Conservancy provides grants and support to Yosemite National Park to help preserve and protect Yosemite today and for future generations. Work funded by the Conservancy is visible throughout the park, in trail rehabilitation, wildlife protection and habitat restoration. The Conservancy is also dedicated to enhancing the visitor experience and providing a deeper connection to the park through outdoor programs, volunteering, wilderness services and its bookstores. Thanks to dedicated supporters, the Conservancy has provided more than $100 million in grants to Yosemite National Park.

yosemiteconservancy.org